Keeping a
Nature Journal

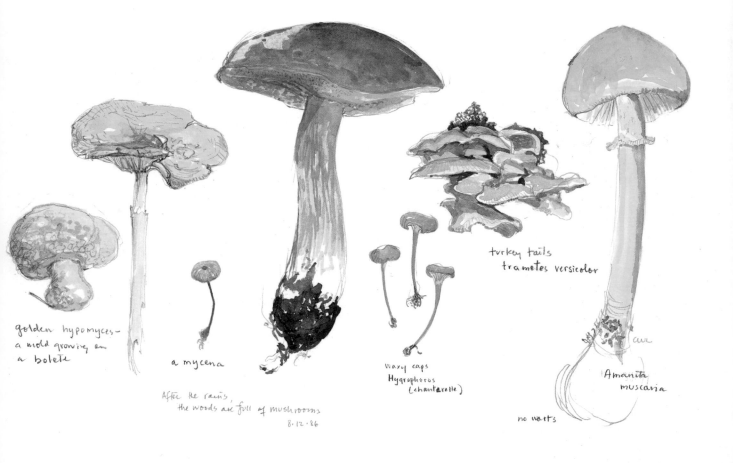

golden hypomyces–
a mold growing on
a bolete

a mycena

After the rains,
the woods are full of mushrooms
8·12·86

waxy caps
Hygrophorus
(chanterelle)

turkey tails
trametes versicolor

no warts

Amanita
muscaria

cup

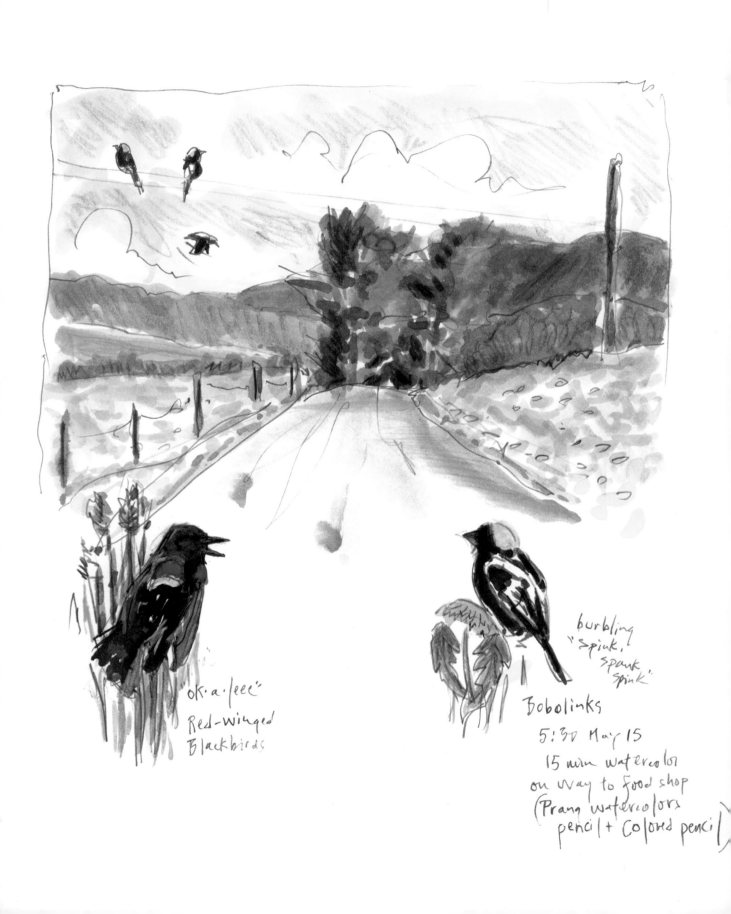

"ok·a·leee"
Red-winged
Blackbirds

burbling
"spink,
spank,
spink"

Bobolinks
5:30 May 15
15 min watercolor
on way to food shop
(Prang watercolors
pencil + colored pencil)

Keeping a Nature Journal

Deepen Your Connection with the
Natural World All Around You

CLARE WALKER LESLIE

Storey Publishing

The mission of Storey Publishing is to serve our customers by
publishing practical information that encourages
personal independence in harmony with the environment.

Edited by Deborah Balmuth and Lisa H. Hiley
Art direction and book design by Ash Austin
Text production by Liseann Karandisecky

Illustrations by © Clare Walker Leslie

Additional illustrations by Ash Austin © Storey Publishing, LLC, 107 bottom; © Lyn Baldwin, 102; Chun Man Chow, 103;
© Eleanor Williams Clark, 97; Karen D'Abrosca, 99 top; Courtesy of Nick Elton, 105 top left; Lisa H. Hiley © Storey
Publishing, LLC, 106; Maria Hodkins, 104 top; Courtesy of Stephen Houser, Jr., 105 top right; © John Muir Laws, 101;
© Sandy H. McDermott, 105 bottom; © Jonah Mateo, 100; © Margy O'Brien, 98; © Jeannine DesVergers Reese, 96;
Rebecca Ries-Montgomery, 104 bottom; Charles E. Roth, v, 67; Lisa Sausville, 99 bottom left; 186 top and center;
Courtesy of Angelique Scarpa, 99 bottom right; © Ilona Sherratt, 107 top left; Ilona Sherratt © Storey Publishing,
LLC, 107 top right; Students of Clare Walker Leslie, 24–25, 62–63, 193

Photography courtesy of Li-Ting Hu, 14; courtesy of Clare Walker Leslie, back cover and 181

Storey Publishing
210 MASS MoCA Way
North Adams, MA 01247
storey.com

Printed in China by R.R. Donnelley
10 9 8 7 6 5 4 3 2 1

Library of Congress Cataloging-in-Publication Data on file

Storey books are available at special discounts when purchased in bulk for premiums and sales promo-
tions as well as for fund-raising or educational use. Special editions or book excerpts can also be created
to specification. For details, please call 800-827-8673, or send an email to sales@storey.com.

Dedication

This third edition of *Keeping a Nature Journal* is dedicated to Eric Ennion, John Busby, Gunnar Brusewitz, and Lars Jonsson, who opened their homes in Scotland, England, and Sweden to me, kindly inviting me to learn alongside with them, how to draw nature.

My first book, *Nature Drawing: A Tool for Learning* (1980), is based on the techniques I learned in 1976 from Eric Ennion and still use today. *The Art of Field Sketching* (1994) could not have been written without the guidance of and long friendship with John and Joan Busby. Gunnar Brusewitz was the first to introduce me to a form of nature journaling that included both word and image, back in 1988. One of Sweden's top wildlife artists, Gunnar called himself a "nature reporter." I think that may be where I first termed myself a "nature journal keeper." The first edition of *Keeping a Nature Journal* (2000) is an amalgamation of the fantastic teachings I gratefully gathered

from these three wildlife artists and excellent teachers. And I want to add Lars Jonsson, as he, beginning in 1984, inspired me to use pencil and watercolor to paint birds and landscapes directly outdoors, urging me not to be concerned with the product but to actively love the process.

Finally, after some 50 years in this field of writing, drawing, exhibiting, publishing, and teaching about seeing and drawing nature, I want to add the many teachers, friends, students, editors, and publishers, as well as all of my family members who have walked alongside me since February 1978, when I opened my first blank book and began wandering outdoors asking the insatiable questions of *where, what, why,* and recording my learning as both artist and naturalist. (This third edition, being worked on in the summer of 2020, has pages from my current nature journal — #55!)

REMEMBERING CHUCK ROTH

It is with deep gratitude that I think of Charles E. "Chuck" Roth, emeritus educator at the Massachusetts Audubon Society, who kindly agreed to coauthor the first edition of *Keeping a Nature Journal.* We had hilarious and fun days together pushing and pulling the science vs. the art. With the fine and wise help of

our editor at Storey Publishing, Deborah Balmuth, we produced a book that has become an international winner. Thank you, Chuck, and thank you, Storey Publishing.

Drawing by Charles E. Roth

CONTENTS

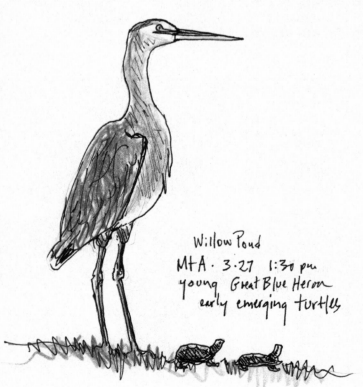

Willow Pond
MtA · 3·27 1:30 pm
young Great Blue Heron
early emerging turtles

Jan 26
Vt out the
Window
@ 10:45 33°
Chipmunk pops
out of hole, down tree
across snow into our house

? They're supposed to be in deep sleep —

An a ha moment!
Mt A.C. - April 15
2:30 pm
50°'s
sunny

Northern Flicker
just returned
finding food
to eat -
ants
between the
pavement
cracks

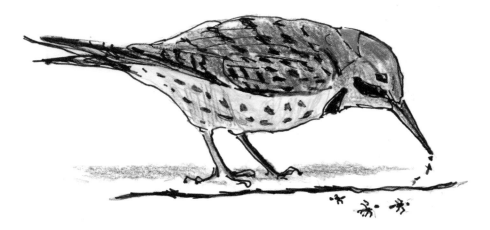

Foreword to the First Edition

WHAT IS NATURAL HISTORY? It is virtually the whole world around you. It is the vista of a great forest from a mountaintop, and a swath of weeds growing along a city sidewalk. It is the breaching of a whale, and the protozoans teeming in algae in a drop of pond water. Everywhere the world is alive, waiting exploration by those who prefer, if only at intervals, real reality to virtual reality. And as to the wonders of modern technology, bear in mind that a sidewalk weed and a protozoan are each more complex than any device yet invented by humanity.

Because humanity evolved in nature over millions of years, there is every reason to expect that we possess an innate capacity to draw deep excitement and pleasure from experiencing it. And because our species has been exquisitely adapted to the razor-thin biosphere covering the planet by this same evolution, our survival depends on understanding and protecting the rest of life. What we must enjoy, including a clean, healthy natural environment, also serves the interest of the human species.

This combination of pleasure and practicality is what makes the kind of illustration promoted in *Keeping a Nature Journal* important. For centuries it has been the mainstay of representing the natural world.

For a time many believed that natural history and scientific art would be supplanted by photography and graphs. But these are merely the extremes available to the human eye, bracketing detailed rendition at one end and abstraction of data at the other. In between and just as enduring is natural history illustration, wherein the observer brings out those features thought most important and interesting in settings difficult for photographs and impossible for graphs to attain. Nature journaling is also extremely flexible. It ranges from scientific figures designed for professional publications to creative art whose principal purpose is to convey aesthetic pleasure.

The art of natural history, as nature journaling shows very well, serves yet another, equally important function. To a degree greater than photography, it involves the illustrator directly in what he observes. The illustrator re-creates what he sees and does not merely record. He expresses what seems important, hence worthy to stress and convey in a single compelling image. He can strengthen his impression with written description and commentary. This creative process is at the heart of natural history observation, and it helps to make the best of experiences also the most lasting in memory for anyone wishing to enjoy it.

EDWARD O. WILSON
Research Professor, Harvard University
Honorary Curator in Entomology,
Museum of Comparative Zoology

Preface

WHEN I BEGAN my first nature journal, back in 1978, I knew very little about nature, and the prospect of the blank page and what to draw were daunting. But I was curious about the outdoors and I knew I felt happier when out wandering fields and woods. So I bought a blank book, found a pen, and began writing and drawing to remember what I was learning. My first drawing, done while exploring an Audubon sanctuary with a friend, was a hesitant description of a goldenrod gall, with the question "Who made this?"

As we walked farther, we found a meadow vole's nest, some rabbit droppings, and a few chewed twigs. A hawk circled above, and it began to drizzle. Rain droplets hung on the old raspberry brambles, and suddenly we could see the world upside down on the lens of those tiny watery orbs.

Some 40 years and 55 journals later, I can return to those early pages and remember the excitement and joy of discovery. I love going back through my journals, looking for patterns of changes — changes in my own life and the life of nature around me, as well as the ongoing consistencies as the seasons revolve, one after the other, year upon year.

When *Keeping a Nature Journal* was first published more than 20 years ago, "journaling about nature" wasn't really a concept. As people have become more aware of the state of the environment, however, the concept of being outside and recording one's observations of nature has become tremendously popular. The original book, written with Charles Roth, has been used all over the United States and in a number of different countries around the world. Over those years, I have had the great pleasure of teaching nature journaling

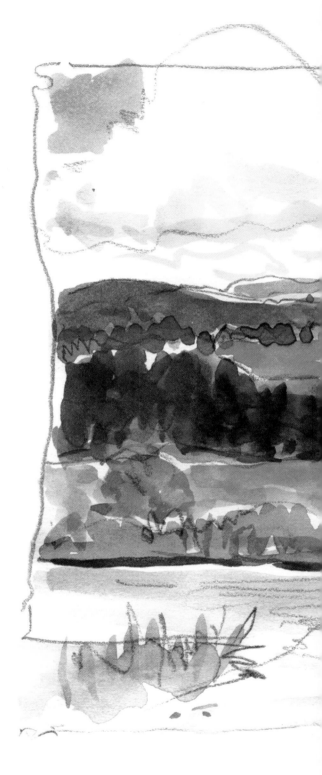

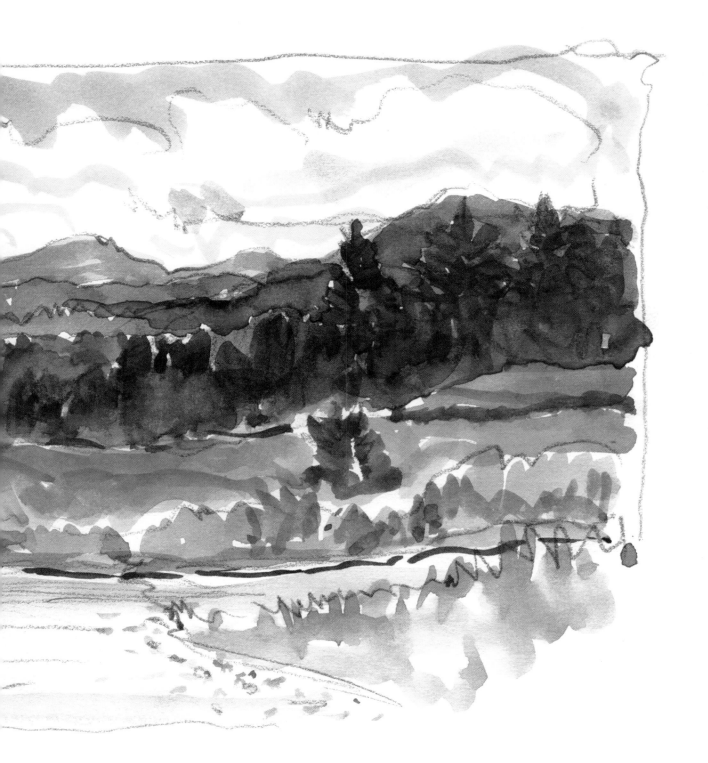

"Why keep a nature journal?"
I asked a 5th grader.
He answered, "Because
it's fun and you learn stuff."

in many places and to many people. Around the world, more and more people are paying attention to their environment and realizing how interconnected we all are and how we depend on every part of this living web that holds together the planet many of us call Mother Earth.

Everyone Can Do It

YOU DON'T NEED TO KNOW anything about nature, anything about drawing, anything about writing, anything about what to use or how to draw to start nature journaling. You can be living anywhere — city, suburbs, countryside — and even be indoors. You can be rich or poor, any nationality, or any age. You don't need to be in super physical shape or even have a car!

All you need is the curiosity to say to yourself "What is happening out in nature right now, right here, right where I live?" And then find out. Nature journaling is a kind of detective work or sleuthing. Begin with very simple questions, like "Are there clouds in the sky?" "Can I hear a bird?" "What's the weather doing?" "What plants do I see?"

Above all, nature journaling is fun. You can do it alone, with friends, with your kids, in a classroom, even when sick in bed. It can be done at any time of day or night, in any season and all kinds of weather. I have students teaching nature journaling in senior citizen homes, in prisons, aboard boats, while hiking and camping, and in many schools across the United States and in other countries.

Take 20 minutes out of your day to get outside (or just look out your window) and make a few scribbles about a leaf, a bird, a cloud shape, sounds heard on a brisk walk — I guarantee

you will come away feeling better about life. As I will keep reminding you throughout this book, don't worry about whether your drawing is "good" or "bad." With nature journaling, it is all about how well you are *seeing* and recording — in both word and image.

SOMETHING ABOUT THIS JANUARY has been different from my first two winters in Williamstown and I don't think it's the weather. I think it's my eyes. . . . Carrying my journal with me around campus and looking closely at the shape of branches, needles, and the patterns of prints in the snow, I started to realize that life was still out there in winter, we just had to look at it differently.

— **Tom Stoddard,** Williams College student

Sandy McDermott
and I late Monarch
both in late
warming October
Sun — MFA
Oct 16

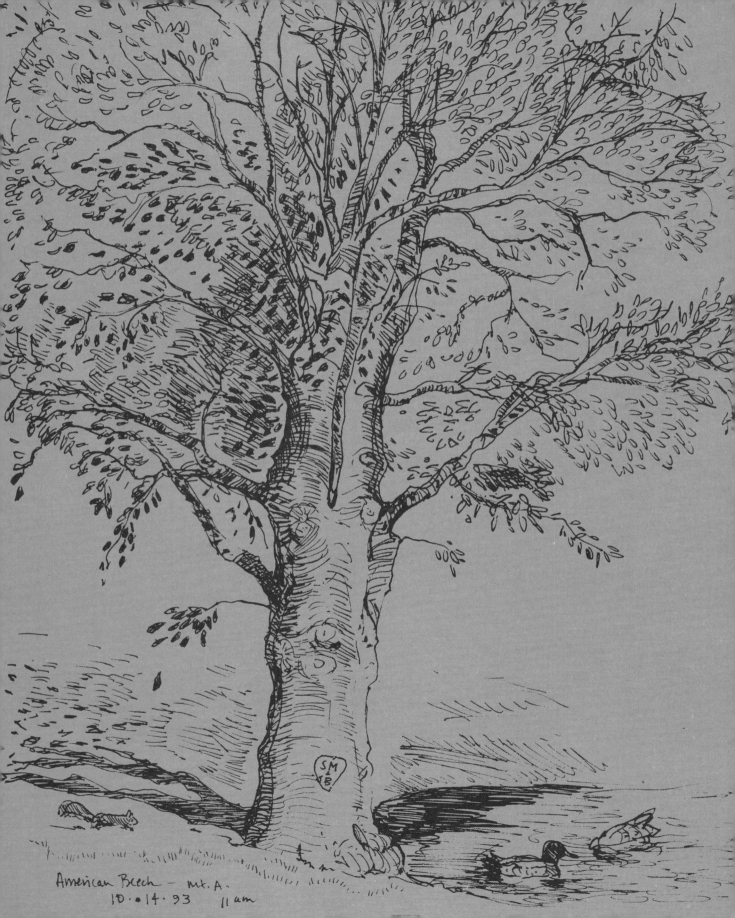

American Beech — mt. A.
10.·14.·93 11 am

GETTING STARTED

In this 20th century, to stop rushing around,
to sit on the grass, to switch off the world and
come back to the earth, to allow the eye to see a
willow, a bush, a cloud, a leaf . . . I have learned
that what I have not drawn I have never really
seen . . . that seeing/drawing become one . . .
and that I constantly rediscover the world.

— Frederick Franck, *The Zen of Seeing*

Why Keep a Nature Journal?

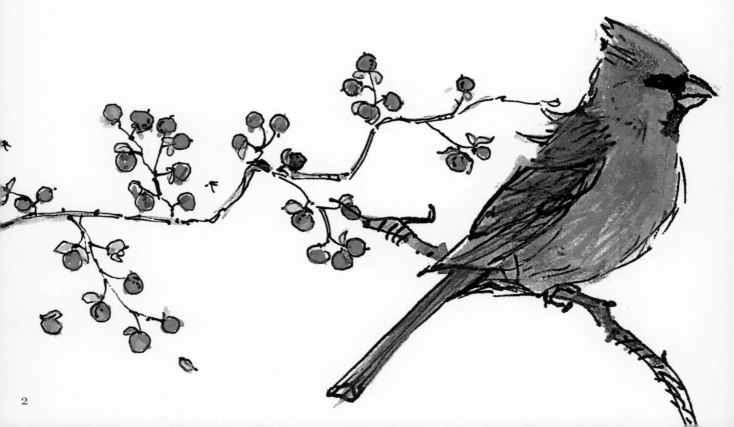

ne 6 1:30 pm
A moment to take my
eye out and just watch waves

Many of us are looking for ways to connect better with nature — to learn its patterns, to help protect its inhabitants, to gain an understanding of what makes our own lives tick. Since the dawn of the human mind, people have sought to know nature better and to know their own selves better. Many of them went out with pen, parchment, paintbrush, and telescope to record their sightings. The nature journal has been the companion for countless men, women, and children with an insatiable curiosity about the natural world.

Nature journaling is your path into the exploration of the natural world around you, and into your personal connection with it. How you use your journal is entirely up to you. I have based my career on my journals. You can be as involved as you wish. Are you a classroom teacher, a self-taught naturalist, an artist who loves nature, a scientist who would love to draw nature, or perhaps someone who finds nature a source for healing, meditation, and connection?

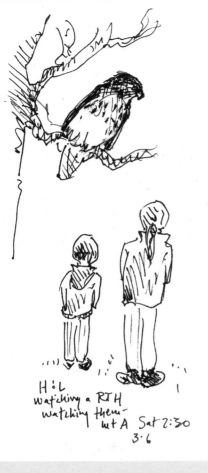

H & L
watching a RTH
watching them —
but A Sat 2:30
3·6

What Is Nature Journaling?

Simply put, nature journaling is the regular recording of observations, perceptions, and feelings about the world of nature around you, with the date, place, time, and weather usually noted in some way. The recording can be done in a wide variety of ways, depending on your age, experience, interests, and time. There is no "correct" way to set up and keep a nature journal. The success of a nature journal is in its flexibility and very personal intention.

Some people write more than draw. Some are very scientific; some very artistic. Some take great care with their journals and use them regularly. Some are more casual, turning to them only occasionally. Photographs, postcards, online information, newspaper and magazine clippings, and other material can be added. I tell my students, "Learn the basic format for a nature journal and then launch off onto your own style and purpose."

Use the many illustrations in this book to inspire you and develop confidence in finding your way. Some were drawn by children, others by scientific illustrators. Some were done as classroom assignments, others in backyards or while traveling in far-off locations. Many were drawn quickly to capture an impression; others took several hours or even days to complete. I also recommend looking at historic nature journals and drawings, such as those by fifteenth-century artist Leonardo da Vinci (see many others in Suggested Reading and Resources, page 197). And there is a growing online presence for nature journaling, with a wide variety of courses and workshops available, as well as opportunities to share your work.

Record Your Experience

A nature journal is less a personal diary and more a recording of your responses to and learning about the natural world. As I explain to students, "You don't moan here about how horrible your life is or how much you hate your sister." This is about getting out of your head and into the world of nature. You can *imply* those concerns, of course, but downplay them. For example you could begin your documentation of the usual date, time, place, and weather with a note such as, "Today is my birthday and I'm taking this time for myself!"

Returning to a Rich Tradition

Nature journaling is not new. In fact, it is one of the oldest methods around: Whether they drew on cave walls, etched marks into sticks, painted stories on vases or tepees, or laboriously inscribed sheepskin manuscripts, humans have kept some form of nature journals throughout history. People have recorded hunts and battles, the passage of time, the success of an exploration, the cycle of planting and harvest. These records may not have been called nature journals at the time, but nature journals they truly were.

For centuries, sea captains have kept logs (another form of nature journal) noting the weather, constellations, passing birds, human behavior, and other items of interest. Many explorers, then and still today, take scientists and artists on their expeditions. Why do you think President Thomas Jefferson hired explorers Lewis and Clark to lead the expedition on the Missouri River to the Pacific Ocean? Yes, they were experienced explorers and skilled leaders, but each also kept meticulous journals containing detailed drawings and writings. Their journals contain some of the best records we have today of their hazardous two-year journey.

In the past, many schoolchildren created nature journals that recorded both the natural world and human life around them. Without textbooks, these became a form of basal reader. Today, many schools and homeschooling groups, nature centers and camps, and even colleges and graduate-level programs are returning to the study of local habitats and moving away from a focus on exotic and faraway ecosystems. Much of this is being fostered by an increasing awareness of global climate issues and a concern for learning how to protect local environments. The surge of interest in citizen science programs and phenology (see page 30) has led to more students discovering that plants, animals, weather patterns, and moon phases exist right around them, not just in the Amazon rain forest or the Artic tundra or the Australian outback.

> A CHILD'S WORLD IS FRESH and new and beautiful, full of wonder and excitement. It is our misfortune that for most of us that clear-eyed vision, that true instinct for what is beautiful and awe-inspiring, is dimmed and even lost before we reach adulthood.
>
> **— Rachel Carson**
> *The Sense of Wonder*

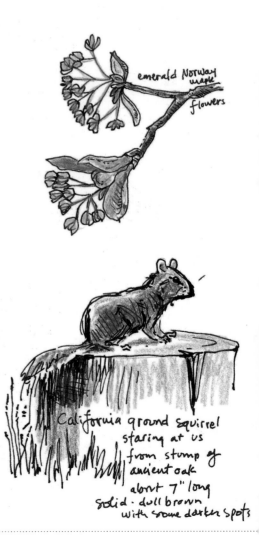

emerald Norway maple flowers

California ground squirrel staring at us from stump of ancient oak about 7" long solid · dull brown with some darker spots

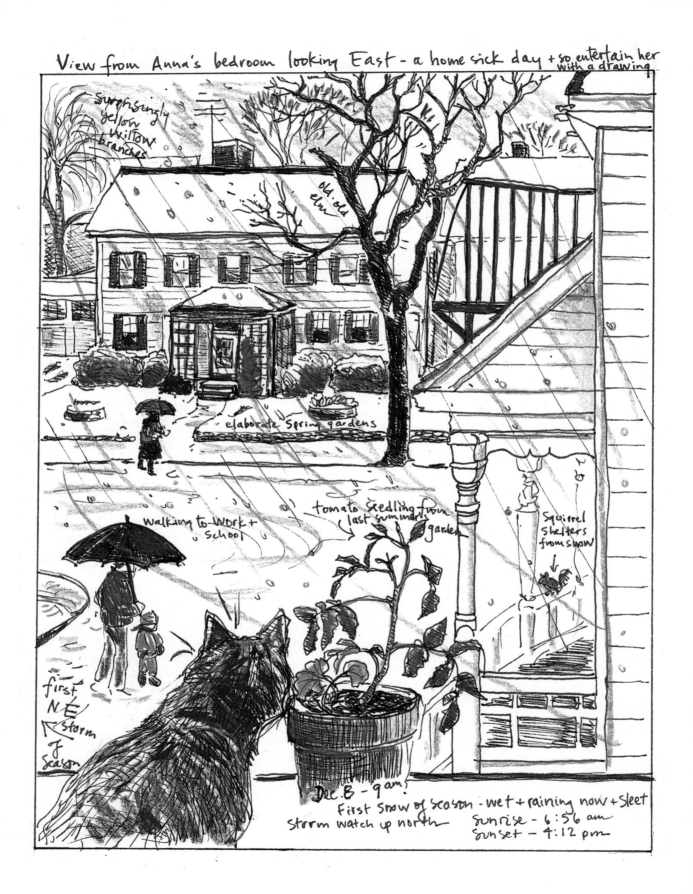

What Is a Naturalist?

The overwhelming majority of men and women — throughout history and across many cultures — who became dedicated naturalists didn't gain their knowledge from formal schooling. Naturalists learn best outdoors, not in a lab or classroom. Naturalists are generalists, interested in everything from ants and sow bugs to daffodils and maple trees, to sea urchins and whales. The foundation for a naturalist's learning is curiosity and willingness to pursue learning in many different ways: watching, considering, recording, researching, asking questions.

When you begin a nature journal, you join the ranks of the great naturalists of the past who spent their days outdoors scratching their heads and asking, "What is going on here?" We can turn to the writings of Pliny, Aristotle, Copernicus, Leonardo da Vinci, Carolus Linnaeus, Charles Darwin, Rachel Carson, Anna Botsford Comstock, Jane Goodall, Edward O. Wilson, and so many others, as well as countless naturalists from other countries and cultures.

THE NATURALIST WANDERS WITH AN INQUIRING EYE, pauses, ponders, notes the bloom of a prairie pasqueflower. It is a tradition that goes back to Aristotle and earlier; observing and identifying earth's myriad life-forms, and discovering the connections that bind them. For those with such interests, said British naturalist Miriam Rothschild, "life can never be long enough."

— John Hay
The Curious Naturalist

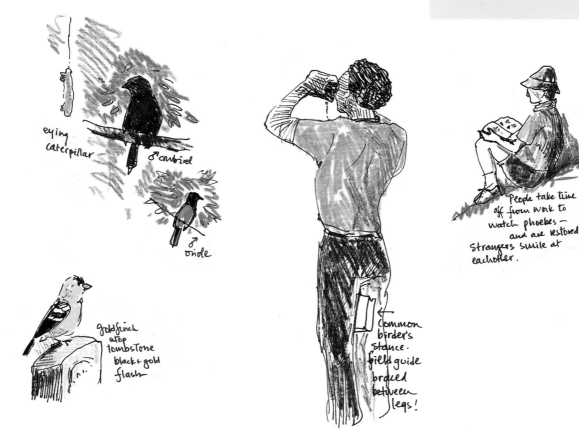

eying caterpillar

♂ cowbird

♂ oriole

goldfinch atop tombstone black + gold flash

common birder's stance. field guide braced between legs!

"People take time off from work to watch phoebes — and are restored. Strangers smile at eachother.

The Benefits of Nature Journaling

Spending time in the world, using the simple tool of a journal to observe and record what you see, is a relatively easy way to establish a connection with nature. A journal offers a great excuse to simply "mess about" outside, noting the day, the weather, and signs of the season. I am often asked if I record in my journal every day. No. Like you, I am busy. However, knowing my journal is nearby, I can quickly jot down what I see out the window while eating dinner. As one eight-year-old said after an outdoor session of nature journaling, "Boy, I have seen the day."

Learning to Unplug and Reconnect

We all have so many distractions coming at us from every angle: job commitments, family obligations, commuting woes, economic worries, and an avalanche of electronic entertainment and information that often feels inescapable. The world can seem overwhelming, yet many of us feel a true hunger to reconnect. Amid the stories of upheaval and unrest around the globe, I find many examples of the solace of nature and the power of being aware of our surroundings.

Over many years now, I have watched people become totally immersed, focused, and happy to be outside — noticing clouds, tree shapes, rain squalls, butterflies, crows, sunsets, turtles, daffodils — and simply recording on paper what they are seeing, hearing, feeling, learning about. Even a few moments of just sitting and watching and connecting quietly with whatever nature is around can relieve stress, refresh the spirit, and provide solace.

Children today have less and less recess time at school and often little outdoor play when home. In my teaching, I repeatedly find that in even a short time outdoors, kids of all ages quiet down, focus, and see things I never could. I watch a class of 15 or 25 and am impressed by how silent they are. Teachers find their students concentrate better in the classroom after spending time outdoors observing, exploring, drawing, and recording nature. They are often amazed at the children's innate interest in nature. One little boy even said to me, "Can't we skip lunch and stay outside?"

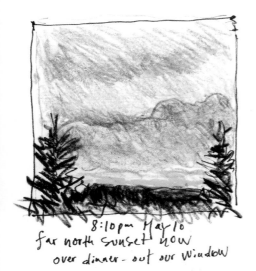

8:10pm May 10
far north sunset now
over dinner - out our window

Response of 3rd graders to finding a wolf spider in the schoolyard, carrying her babies on her back:
"So cool!"
"Brave mom!"

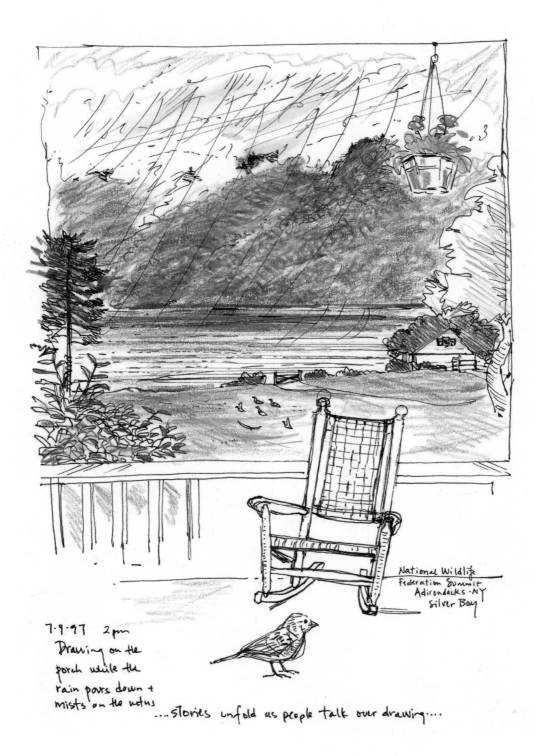

7·9·97 2pm
Drawing on the
porch while the
rain pours down +
mists on the mtns

....stories unfold as people talk over drawing....

National Wildlife
Federation Summit
Adirondacks · NY
Silver Bay

WE DON'T NEED TO STRIKE OUT INTO THE WORLD to feel close to the natural world and receive benison from it. **— Helen Macdonald,** *H Is for Hawk*

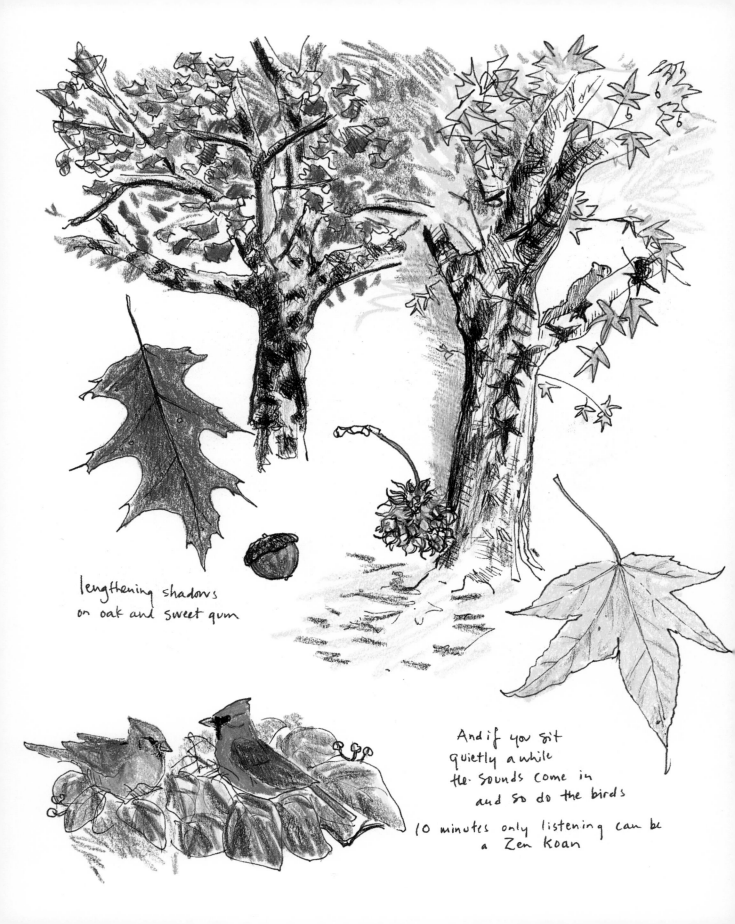

lengthening shadows
on oak and sweet gum

And if you sit
quietly awhile
the sounds come in
and so do the birds

10 minutes only listening can be
a Zen koan

Taking Time to Slow Down

Making the space and time to slow down, observe, and appreciate each day to its fullest is not easy in today's hectic world. Journaling opens up the opportunity (and gives us an excuse!) to make the time, whether it's 10 minutes a day or an hour every weekend, to fully take in the world and reflect on what's happening around us. It also gives us a structure within which to carefully observe our own lives, as well as all the life that surrounds us, both human and nonhuman. The knowledge gained by such observation is highly satisfying, as we are able to bring greater insight and interest to the world we see each day.

How many of us say we do not have time to do the things we really want to do? We do, if we want it! Try blocking out on your calendar little bits of time when you'll be able to draw a few collected objects, the night sky, a vase of flowers, your child's sleeping head, or your dog. It can be 9:00 to 9:15 p.m. on Tuesday or 6:00 to 6:45 a.m. on Thursday. This will give you a moment of silence in your week!

Reflecting on One Place over Time

Nature journaling helps us connect to a particular place and understand our role there. In today's world, so many people move from place to place, often without much thought or knowledge about the actual landscape they live in — how it was formed, what creatures live there besides humans, who lived there in earlier times, and what makes it the place that it is. In urban areas it is easy to forget that this environment, too, is part of nature. We forget to look up at the sky, to feel the warmth of the sunshine, or to really notice the birds. Even those of us living in rural places often spend much time racing about, forgetting to take time to just be and observe the world.

Return often to your journal entries to revisit your feelings; consider if they remain the same, or if they have changed with time. Check out the questions that you raised. Do they provide ideas for new studies and observations you can undertake? Notice changes, like fewer blue jays this year or more plants, like invasive garlic mustard. How does the water flow out of this creek? If a new shopping mall is built near this marsh, how will the ecosystem change? How has your own life changed since the last time you came to this place?

> YOU MUST WALK SOMETIMES PERFECTLY FREE, not prying or inquisitive, not bent on seeing things. Throw away a whole day for a single expansion, a single inspiration of air. . . . You must walk so gently as to hear the finest sounds, the faculties being in repose. . . . Nature will bear the closest inspection. She invites us to lay our eye level with her smallest leaf, and take an insect view of its plain.
>
> **— Henry David Thoreau**

As L & I walk
Marsh Brook, wearing
our masks, a Woodchuck
scuttles across road —
(oblivious to crazy times
in human world —)
May 5 4:30pm
★ Ball point pens cool to
draw with — and handy! ★

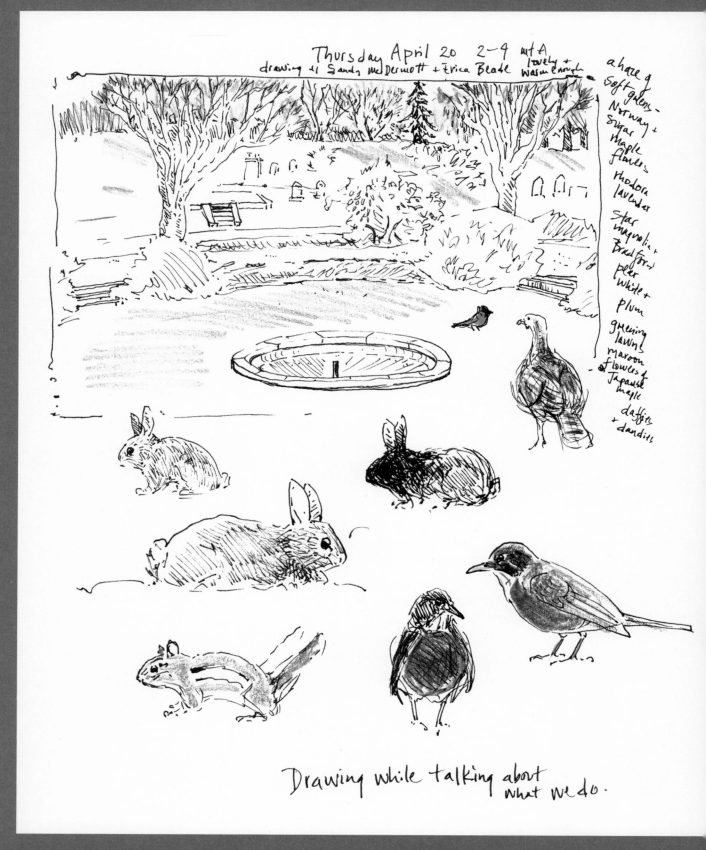

Thursday April 20 2-4 mt A
drawing el Sandy McDermott + Erica Beade lovely + warm enough

a haze of soft greens –
Norway + Sugar Maple flowers
rhodora lavender
Star magnolia + Bradford pear white + plum
greening lawns
maroon flowers + Japanese maple
daffies + dandies

Drawing while talking about what we do.

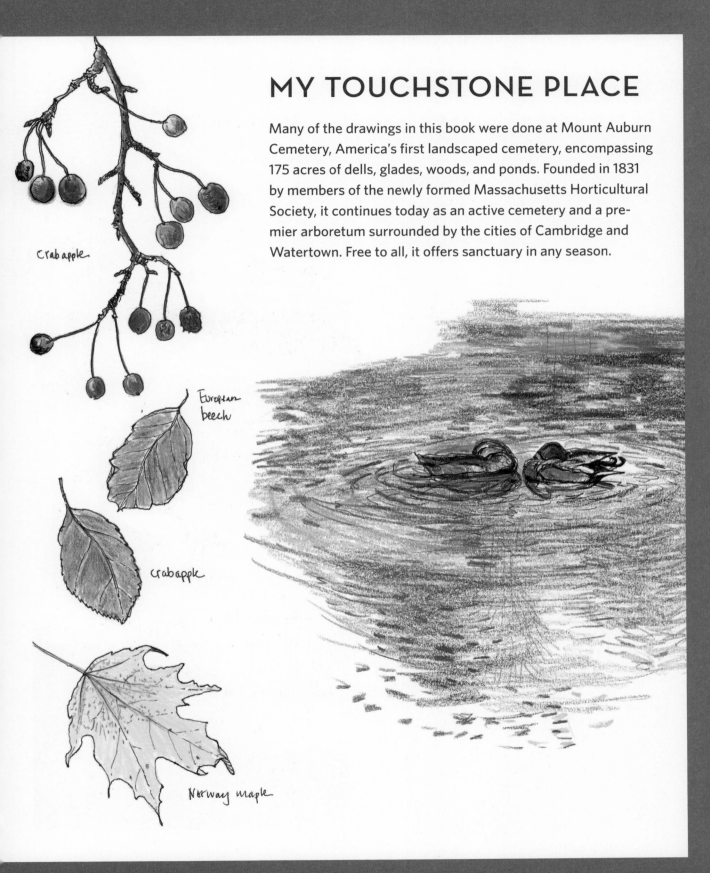

MY TOUCHSTONE PLACE

Many of the drawings in this book were done at Mount Auburn Cemetery, America's first landscaped cemetery, encompassing 175 acres of dells, glades, woods, and ponds. Founded in 1831 by members of the newly formed Massachusetts Horticultural Society, it continues today as an active cemetery and a premier arboretum surrounded by the cities of Cambridge and Watertown. Free to all, it offers sanctuary in any season.

crabapple

European beech

crabapple

Norway maple

I return to this cultivated wildness over and over again for meditation, for my work with nature journal drawing, and for keeping in touch with the pulse of life as it clocks through the seasons, year upon year. I can escape to realms of secluded quiet just six minutes from our Cambridge home.

Garden spiders looping webs, catbirds vocally guarding territories, raccoons lolling in tree holes, resident red-tailed hawks soaring near enough to sketch, and, of course, the famous parade of warblers fluttering through every spring are some of the things that keep me coming back for more. And now I bring my granddaughters, to share with them the joy of feeling connected to a particular place.

Hazel and Lydia love coming to Mount Auburn to explore and draw. Here we are joined by their friend Olé on a lovely spring day.

April 30 - Sunday
Sunrise = 5:41 am
Sunset = 7:43 pm ⟶ 14hrs 02 min of LIGHT
○ moon by night

1. Turtles
2. 2 Canada Geese
3. 2 Mallard ducks
4. 4 Turkeys (and more to come)
5. green leaves coming on
*7. buds swelling
8. star magnolia. cherry. plum. forsythia in bloom
9. We play Hide and Seek in yews and laurel
10. Make shadow shapes
11. early honey bees
and
*6. 1st Spring Azure butterfly!
bunnies

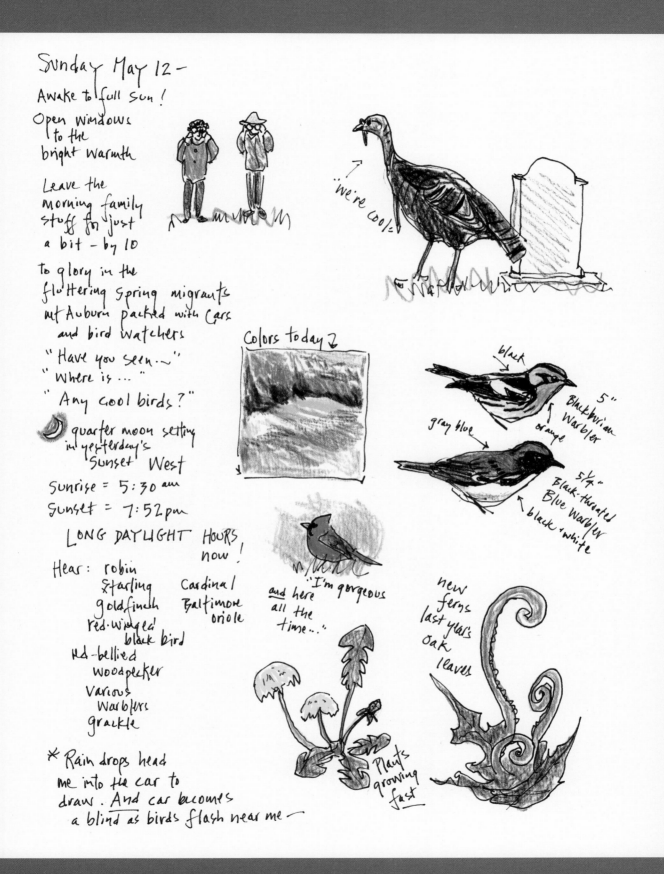

Sunday May 12 –

Awake to full sun!

Open windows
 to the
 bright warmth

Leave the
 morning family
 stuff for just
 a bit – by 10

to glory in the
 fluttering spring migrants
 mt Auburn packed with cars
 and bird watchers

"Have you seen ~"
"Where is ..."

"Any cool birds?"

quarter moon setting
 in yesterday's
 sunset West

Sunrise = 5:30 am
Sunset = 7:52 pm

LONG DAYLIGHT HOURS,
 now!

Hear: robin
 starling Cardinal
 goldfinch Baltimore
 red-winged oriole
 black bird
 red-bellied
 woodpecker
 various
 warblers
 Grackle

*Rain drops head
 me into the car to
 draw. And car becomes
 a blind as birds flash near me —

..."we're cool!."

Colors today↗

black
Blackburnian
Warbler 5"

gray blue orange

5¼"
Black-throated
Blue Warbler
black + white

..."I'm gorgeous
and here
all the
time..."

new
ferns
last year's
oak
leaves

Plants
growing
fast

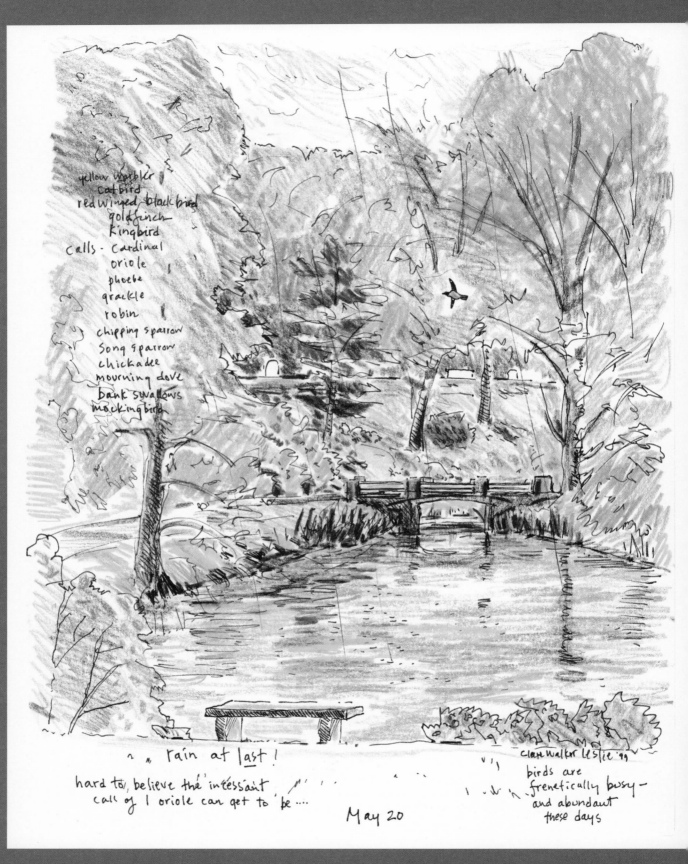

yellow warbler
catbird
red winged blackbird
goldfinch
kingbird
calls - cardinal
oriole
phoebe
grackle
robin
chipping sparrow
song sparrow
chickadee
mourning dove
bank swallows
mockingbird

rain at last!

hard to believe the incessant
call of | oriole can get to be

May 20

Clare Walker Leslie '99

birds are
frenetically busy -
and abundant
these days

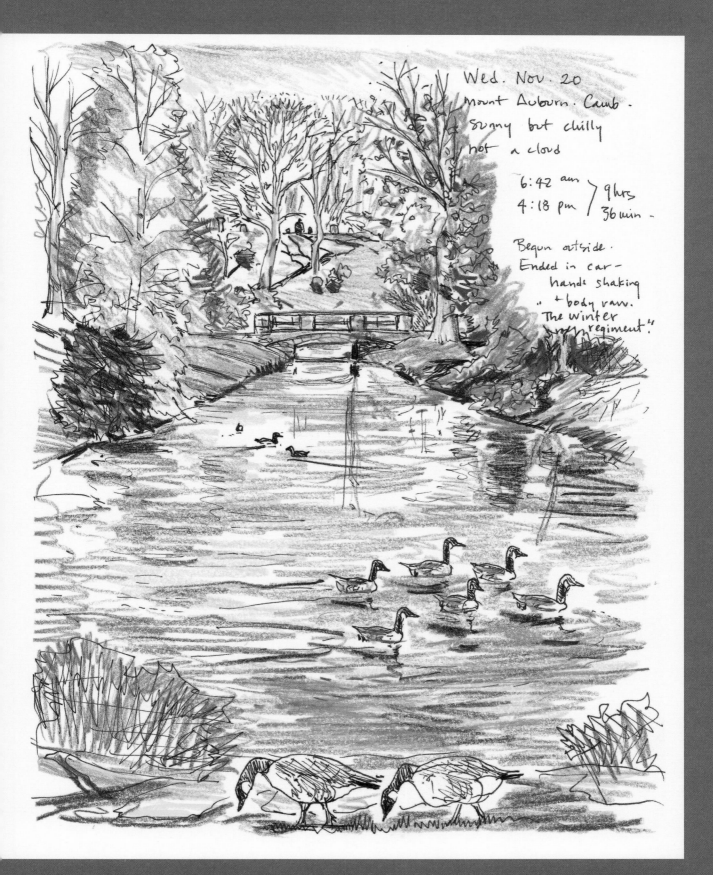

Wed. Nov. 20
Mount Auburn. Camb.
Sunny but chilly
not a cloud

6:42 am ⎱ 9 hrs
4:18 pm ⎰ 36 min.

Begun outside.
Ended in car –
hands shaking
+ body raw.
"The winter
regiment."

Your Own Home Place

You don't have to go to another place to notice nature, either indoors or out. Collect objects on your walks (nothing living or from private property) and bring them home to set on a table, inviting you to draw them later. Nature stories or notes about what you saw can be added later, too.

June 16 6:40 pm
Returning to rain-soaked Cambridge after a long day teaching, I park and get out.
Overhead, the distinct cries of

Nighthawks — circling, flapping, catching insects over the city's buildings. (Haven't seen in several years here!)

3.13
my snowdrops

birch + poplar bark strips + grasses lined with pine needles

x 3/4

Red-eyed Vireo nest Hazel + I collect - 12.30.19 from sugar maple.

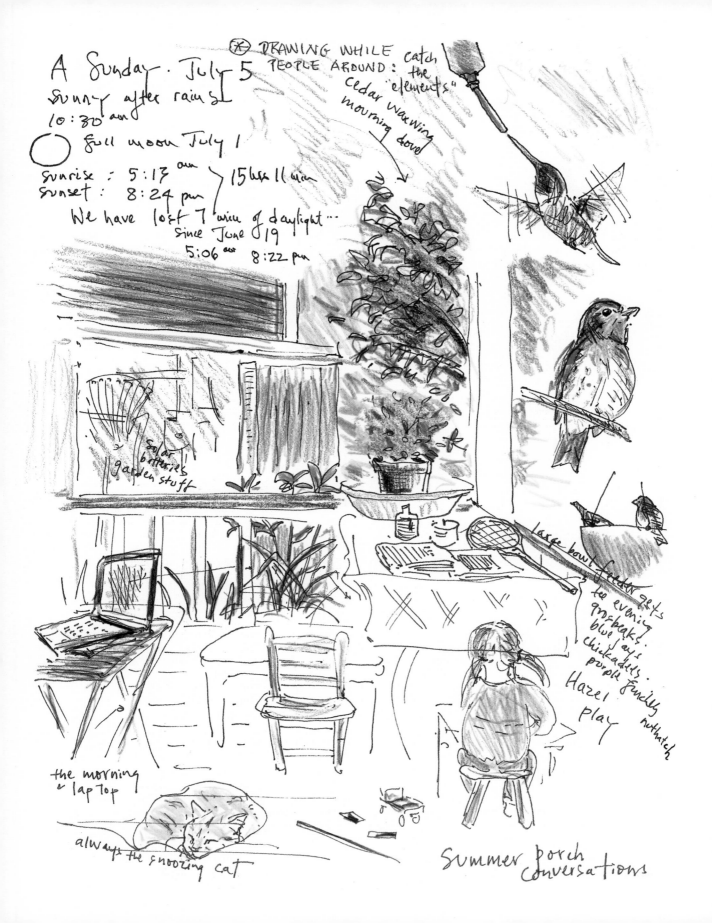

A Sunday . July 5
Sunny after rains
10:30 am

○ full moon July 1

Sunrise : 5:13 am ⎫ 15 hrs 11 min
Sunset : 8:24 pm ⎭
We have lost 7 min of daylight...
since June 19
5:06 am 8:22 pm

✷ DRAWING WHILE catch
PEOPLE AROUND: the
cedar waxwing "elements"
mourning dove

solar
batteries
garden stuff

large bowl feeder gets
too evening
grosbeaks:
blue jays
chickadees:
purple finches
nuthatch

Hazel
Play

the morning
& lap Top

always the snoozing cat

Summer porch
conversations

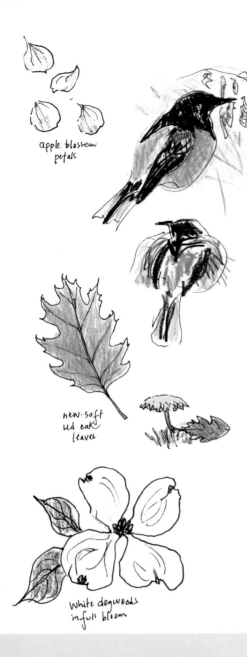

apple blossom petals

new·soft lil oak leaves

white dogwoods in full bloom

Finding a Path to Mindfulness

There is much discussion today about all the stresses in our lives and how to reduce, combat, and relieve them. We pile up the "shoulds" and "oughts" until our heads are spinning. I belong to a local meditation center, but I don't "sit on the cushion" as folks say. My ongoing nature journal provides the wisdom and meditation I often need. I see it lying there saying to me, "Get outside" or "take five minutes to pause and breathe deeply" or just "look up and out." I meditate outside, walking or sitting, journal in hand. Connecting with nature is my mindfulness practice.

The human need to connect with nature is well documented. Nature journaling provides important opportunities to wander outdoors and experience mindfulness, meditation, forest bathing, solace, quiet, wellness, and all those topics in the news now about reducing our increasing stresses.

So often students will say to me, "This calms me down," or "I loved *seeing* that daylily more than worrying about how good my picture is" or "While I was drawing, I watched a tiger swallowtail butterfly come in and take a drink!" Taking the time to notice and really see things is a wonderful way to take a short break from the rest of your day.

A Place for Healing

Although the nature journal is not intended as a diary for personal entries, it is certainly a place where you can record feelings, as influenced by or while connecting with nature. Over the years, I have referred to these moments as nature surprises, "aha" moments, and silver linings, but the phrase that has stuck is Daily Exceptional Image or DEI (see page 82). More recently, I have been writing haiku to capture my thoughts. Writing and/or drawing these moments in my journal helps me remember them later, but I also somehow find comfort in the recording, and even in sharing those moments with others. Students, friends, family, and editors often share their own moments with me, via text, email, or telephone.

Going back over my piles of nature journals, begun back in 1978, it is great fun seeing how the nature around me has changed — or not — year after year. And also how I and my family and life have evolved and changed over the years — or not. I tell folks that my current nature journal is my best friend, who takes it all in, never judging, just accepting What Is. . . .

Friday February 7 — 1pm Mt Auburn for a few moments of quiet reflection

40° raining, warm
(January the warmest month ever — globally)
Warm in Antarctic, large ice sheet melted....
new snows in Vermont

Up early to get edits done, stuff mailed, dinner made for J. A.
Took J.E. H+L to airport yesterday.

Between errands, I can drive into Mt. Auburn, slowly relieving the chatter in my head as I look out now to just winter colors, shapes, silences...

So oblivious they are to people stuff...

And as the ice has recently melted off the pond 5 mallards just floating about — A FIRST for the season — of "late," winter

And from the marsh edge the immature Great Blue Heron flaps across, over the resting duck...
At 1:30pm I find such a regathering of PEACE to send me back out into the day remaining —

This is what I call a "seeing/drawing" page. With no idea what I will find, I am present to anything that gives me a spark of unexpected joy. All I'm doing is responding.

Recording Your Travels

Some people only journal when traveling, recording anything from short weekend hikes to month- or yearlong journeys around the globe. It is nice to have more than photos to take home. Your travel journal can expand your vision beyond what you see in simple snapshots. Try to really observe the habitat by describing the place, sketching animals and plants observed, and labeling everything to help you remember details of what you saw. In essence, these are pages of memories that you can return to long after your journey is over.

Travel journaling is often done in the evening after the day's events are over and you have a moment to reflect and record. You can also journal throughout the day as you travel, even when you're moving. On one trip to Minneapolis, I spotted a woodchuck alongside the road near an overpass. As my sister drove, I made a sketch with a felt-tip pen to capture the moment.

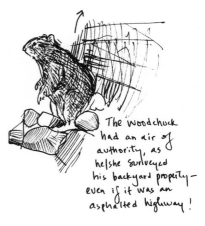

The woodchuck had an air of authority, as he/she surveyed his backyard property— even if it was an asphalted highway!

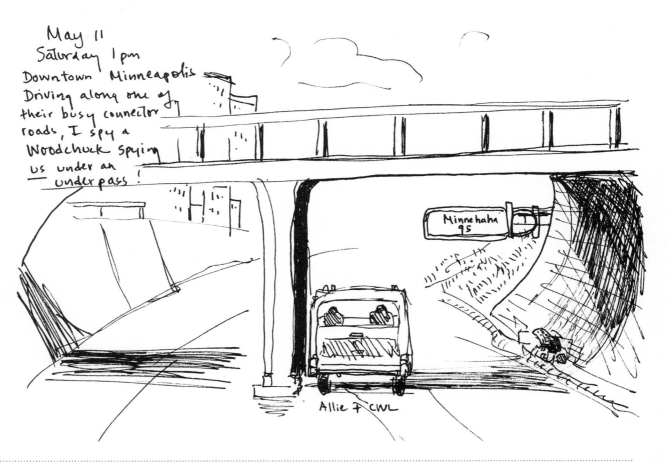

May 11
Saturday 1 pm
Downtown Minneapolis
Driving along one of their busy connector roads, I spy a woodchuck spying us under an underpass!

Minnehaha
95

Allie & CWL

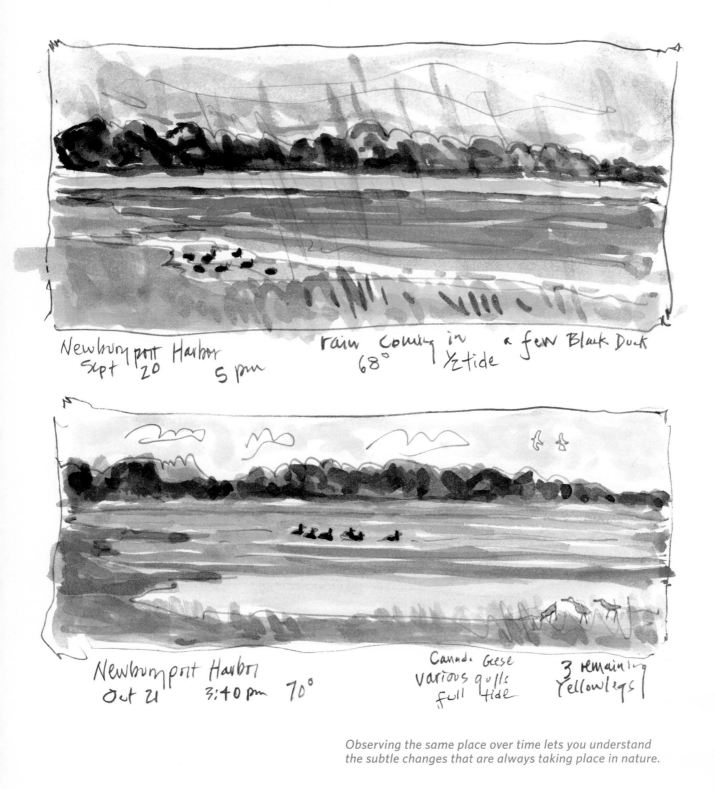

Newburyport Harbor
Sept 20 5 pm rain coming in a few Black Duck
68° ½ tide

Newburyport Harbor
Oct 21 3:40 pm 70° Canada Geese 3 remaining
various gulls Yellowlegs
full tide

*Observing the same place over time lets you understand
the subtle changes that are always taking place in nature.*

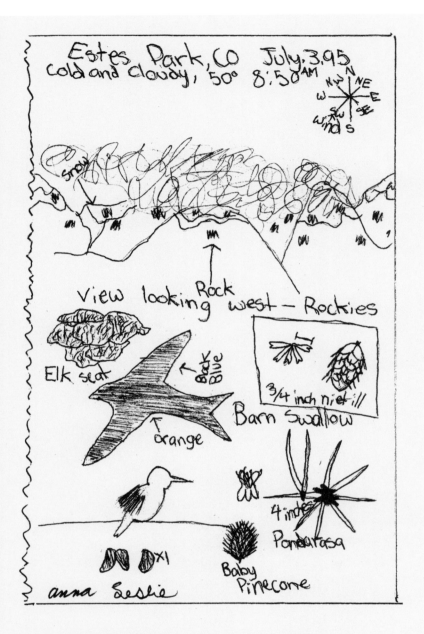

Nature journaling is a great way to engage kids during down time on a trip and to encourage them to notice what's around them and record the things they see.

Group Journaling

If you're traveling with a family or close group of friends, try keeping a community journal. Each person can contribute observations in whatever form they like, which can even be combined into one trip account. Maps can add detail to travel journals, as can postcards, photos, pressed flowers and grasses, and other mementos.

Involving Children

Encourage kids to keep journal pages of things they do and see on a trip that they can later share with others. At age 10 my daughter, Anna, accompanied me to the National Wildlife Federation's Conservation Summit at Rocky Mountain National Park for a week of nature adventures. While I taught, Anna joined a group of kids about her age. They all did some nature journaling, and years later, Anna still has those drawings to remind her of that fun trip.

Better Than a Photo

These examples from Steven Lindell's trip to Monument Valley (right) and Anne Gamble's trip to the Galapagos Islands (below) are great examples of how you can use sketches to remember your experiences. Often sketches let you capture things that photos cannot. They bring a different kind of connection to your observations.

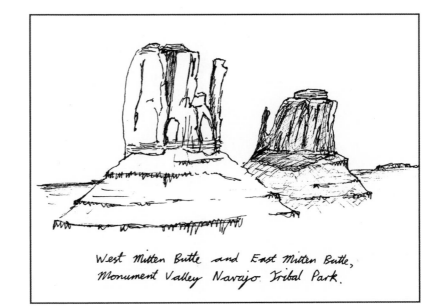

West Mitten Butte and East Mitten Butte, Monument Valley Navajo Tribal Park.

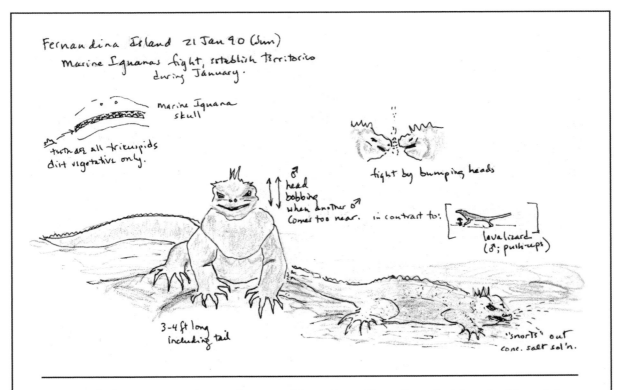

Fernandina Island 21 Jan 90 (Sun)
Marine Iguanas fight, establish Territories during January.

Marine Iguana skull

teeth are all tricuspids diet vegetative only.

fight by bumping heads

♂ head bobbing when another ♂ comes too near.

in contrast to: lava lizard (♂; push-ups)

3-4 ft long including tail

"snorts" out conc. salt sol'n.

Drawing helps me to see better, because I have to really notice what I am looking at. I took a journal with me to the Galapagos and drew everything I saw and I can still vividly recall so many details of the trip. I know that keeping a journal consistently has made this clear memory possible, even years later.

— **Anne Gamble,** nature journaling student

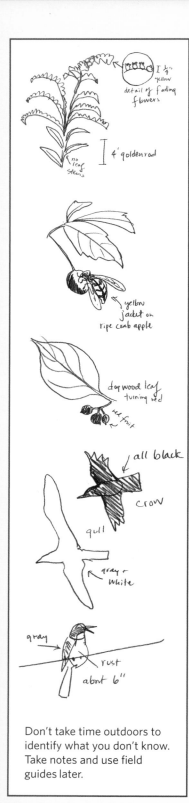

Don't take time outdoors to identify what you don't know. Take notes and use field guides later.

LEARNING TO TRULY OBSERVE

When folks say to me, "Oh, I don't know anything about nature. I don't know where to begin," my response often is, "When I began, I didn't know the difference between an oak and a maple leaf!" It's all about wanting to know more, being curious, and finding ways to learn. Be patient with yourself for NOT knowing. There are lots of people happy to help you out: librarians, the staff at nature centers and clubs, teachers in science and environmental studies departments, even the neighbor you notice filling a bird feeder or carrying a fishing pole. Read nature journals, magazines, and books; join a local or national environmental organization. There are many online resources and groups, as well as apps for identifying almost anything you want.

I began my nature learning journey with books. My earliest teachers included Beatrix Potter, Ernest Shepard, Rien Poortvliet, and Bob Hines for their animal drawings, and Edwin Way Teale, Aldo Leopold, Henry David Thoreau, and Rachel Carson. (I recommend Carson's *The Sense of Wonder* in all my adult classes.)

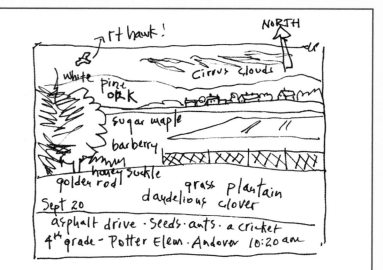

To quickly note a landscape, make a 3 x 5 inch frame. Draw simple shapes and label what you know. (See page 170 for more about drawing landscapes.)

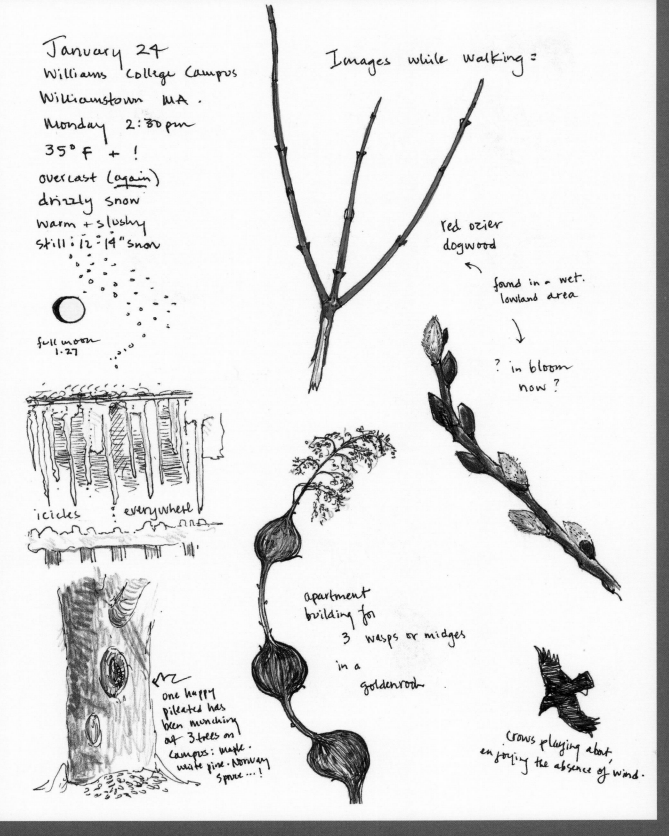

January 24
Williams College Campus
Williamstown MA.
Monday 2:30 pm
35°F + !
overcast (again)
drizzly snow
warm + slushy
still: 12-14" snow

full moon
1.27

icicles : everywhere!

Images while walking:

red ozier
dogwood

found in a wet.
lowland area

? in bloom
now?

one happy
pileated has
been munching
at 3 trees on
campus: maple.
white pine. Norway
spruce ...!

apartment
building for
3 wasps or midges
in a
goldenrod

crows playing about,
enjoying the absence of wind.

CONDUCTING A NATURE OBSERVATION

Ron Cisar, a high school honors biology teacher in Omaha, Nebraska, had his students keep a weeklong journal of their observations. Realizing that "pictures say a thousand words," the students really enjoyed doing these simple recordings and noticing how much more observant they became.

October 10-14

Its about 6:00p.m on a Monday evening. The wind is blowing, the trees are swaying, and the sun is shining. I watch the leaves fall from the trees. As you may notice, the tree is almost bare.

Tues - October 11th. 6:30 p.m.

Today I observe the sky, and I watch some birds fly south. They're in a perfect V shape of ten. I was unable to see what species they were.

Wednesday - October 12th 7:00 A.M

Last night it rained. So this morning observe a drop of rain hanging off a leaf.

Kara Vasquez

Thurs. October 13th 5:45

Today I saw some weird kind of cacoon on a tree. It was gray and fuzzy

Friday October 14th 7:30 p.m

In a near by tree, I watched a spider in its web. Five minutes later, a bug got caught in the web.

Fort Myers
↓

6:40 sunrise am

early morning bird watchers

Sanibel Island-Florida
March 7 NAAEE Conference
6:30 am beach walk w/
Nan JJ
Sounds of rolling, swishing waves
squeaks of shorebirds
blowing palms + sea grasses

willets in winter plumage
13½"

pelicans float past

Reflecting on the Fragility of the Environment

I recorded these studies while attending an environmental educators' conference on Sanibel Island in Florida. While the island is naturally exotic, exquisite, and full of varied bird and animal life, it faces the onslaught of human development. The conference was held in a large and luxurious hotel, complete with air-conditioning and sealed windows. The attendees mostly stayed inside, looking at screens and listening to presentations. Although the conference discussion focused on waking students up to environmental awareness, I wondered if we were paying enough attention to our own presence on that fragile outpost. Drawing what lived on the beach helped me reflect on our impact.

Sea urchin
all life size

PHENOLOGY DATA for
Leslie tree plantation—
c. 12 acres
red pine · Norway spruce
Granville · Vermont

1. sensitive fern
 12" tall
 2016 even more
 8·2 2017
 8·7

2. × 1 new red oak
 seedings
 2016

3. hear: no bird sounds
 1 red squirrel
 1 cicada

4. 1" fast hopping
 dk brown
 Wood Frog

5. Dandelions tall jewelweed
 buttercups * more open
 wood sorrel spaces

On our land in Vermont, we had selective timber harvests in 2006 and 2016. Over the years, I've documented changing conditions and new or different growth in those areas. Doing this helps me to see and list what's there, to notice little changes I might miss just tromping through. This is a good example of what citizen scientists do.

Participating in Citizen Science

Since the original publication of this book in 1999, two terms have emerged into the study of the environment: "citizen science" and "phenology." While there have been citizen scientists (amateur observers of nature) throughout history and around the world, the term is being used more and more in the field of nature study by professionals who appreciate the assistance of volunteers using a particular form of recordkeeping.

Phenology is the ongoing collection of data having to do with seasonal changes in the weather, plant growth, and animal behavior, among other natural phenomena. Amateur and professional observers record specific dates for things like the development of buds on trees and when they burst into leaves or flowers; the appearance of insects in spring; the arrival and departure times of migrating birds, as well as courting and nesting behaviors; and preparations for winter survival by local animals and their subsequent spring emergences.

Why is this data increasingly important? In order to understand and address future environmental challenges, scientists must have this crucial data as evidence of changes, both normal and otherwise. Long-term studies of retreating glaciers and melting permafrost, for example, have established profound evidence of increasingly severe droughts and floods.

Enter You, the Nature Recorder!

Keeping a nature journal gives you the opportunity to become a citizen scientist with your own phenology study. There are numerous centers around the country and the world that are grateful for the assistance and involvement of "regular people" in keeping track of what is going on in the environment. The Manomet Center for Conservation Sciences near Boston and the Cornell Laboratory of Ornithology in Ithaca, New York, are among the many schools, colleges, nature centers, and other organizations across the globe keeping careful records of such climate change indicators as fish abundance, sea level rise, rain cycles, migratory patterns, and much more.

Becoming involved and knowing you are doing something to understand better what is happening to the world around you is a good way to reduce or at least manage the feelings of helplessness and anxiety that plague many of us when we consider the future of our planet.

JOURNALING FOR
SCIENTIFIC STUDY

Massachusetts artist-naturalist Marcy Marchello combines writing and sketching to make a series of detailed observations, such as this study at a great blue heron nesting rookery.

"I love keeping a nature journal because it's such a dynamic, creative fusion of my passions for writing, drawing, and nature. I actually keep three different active journals. One is exclusively for reflection in my personal growth, essentially a diary. Another is for daily written notations about birds and animals that I observe. And the third, my sketch journal, is where I focus on drawing, combined with field writing, which often includes my immediate personal responses.

I've been a journaler in one form or another since adolescence and cherish the ongoing discovery process that journaling both is and supports. It's a natural expressive process for me. I love tracking myself and the natural world through many seasons of change, often reading past entries to compare to current observations and thoughts. This process keeps me in tune with myself and nature to the depth that I need, that feeds my spirit. And best of all, there's always more to discover."

When the young stand up and beg, they are huge!

A pair of Canada geese sit like statues across the water, very alert 2 goslings in tow!

Some ducks fly by singly 3 or 4, in the span of a few minutes.

A beaver makes a quiet, hard sabae water appearance for a minute or two, nibbling on something in its paws.

Just Look Out the Window

Nature can be found out any window. Just look and do a quick count, if you can't make a more detailed record at that moment. Jot down notes for later: new leaves emerging, two robins, one squirrel, daffodils next door, funny-looking cloud. You can do this anywhere, even in your car! This can be a great opportunity for those restricted by disabilities or illness or just by inclement weather.

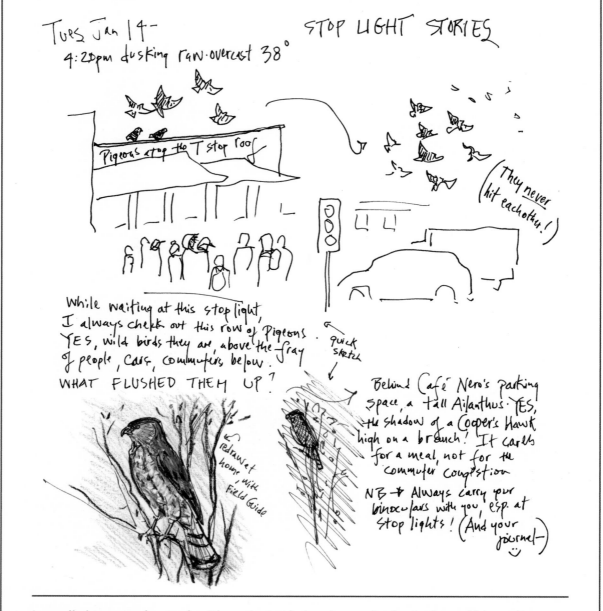

I usually have my day pack with my journal, drawing and color tools, and binoculars beside me in the car so I can make quick sketches and observations even while getting gas or stopped at a light.

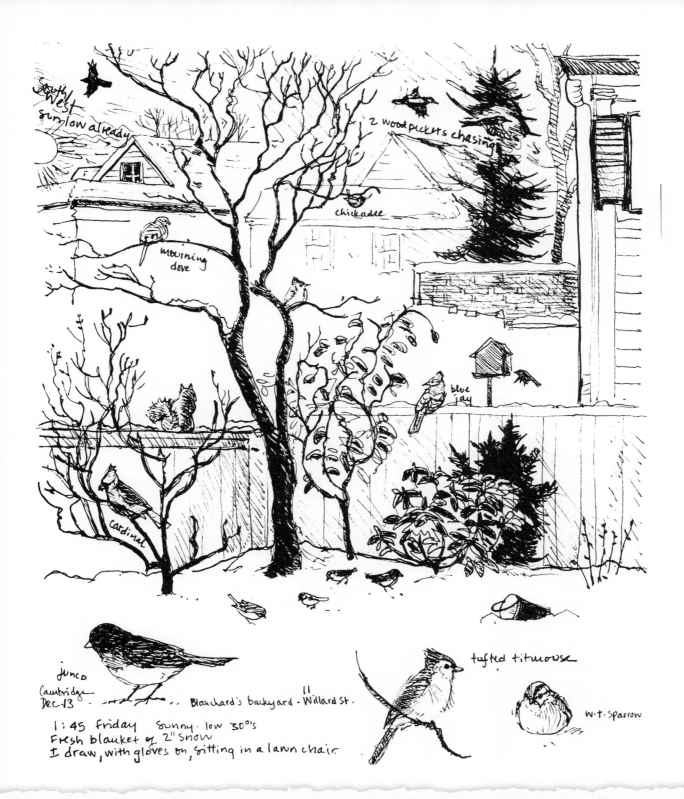

I did this drawing while chatting with a friend in her backyard.
It's amazing how much can be seen when you're looking to draw!

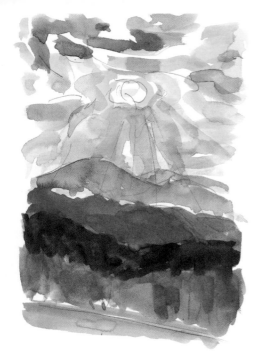

Developing Your Own Style

Journaling challenges you in the most positive way, by opening up opportunities for you to explore your own creativity and express your own observations and experiences of the world more fully. You may feel you are not creative; you don't know where to look. No one is judging your journal. Anyone can draw clouds. Try it! They change. As you draw and write, you are learning about weather.

You may also wish to incorporate news articles, clippings from magazines, and other pieces of media to provide a launching pad for your thoughts or to reflect what you are writing about.

It is OK to sometimes feel sad
worried, even in grief about
someone, recent events our
changing climate. Put this
in your journal, however you
wish!
 When my sister died
I went to Mount Auburn
Cemetery and cried.
Only the greens flashing
sun, robins and chipmunks.
I couldn't draw anything.
So I put brush to
paper and what I
made here helped me.
The darkness of the
shadows here, the
light of the sunshine.
 Try this sometime.

June 7

SEASONAL NOTES

september

Indian cucumber-root's dark berries appear above a whorl of yellow leaves, splashed with a crimson center.

As they feed, orange-and-black **milkweed tussock moth caterpillars** stock their bodies with poisonous cardiac glycosides to protect against predators. As next summer's moths, they'll produce ultrasonic sounds that warn **bats** to stay away.

Bees don't seem to mind how **goldenrod's** sticky pollen clumps in their fur.

Instead of simply changing from green to red, **Canada mayflower** berries have an intermediate phase when they look like fancy speckled jellybeans.

SCARLET WAXY CAPS, BRIGHT AS CANDY APPLES, OFTEN GROW IN MOSS. IF YOU PINCH THEIR GILLS BETWEEN YOUR FINGERS, YOU'LL UNDERSTAND HOW THEY GOT THEIR NAME.

A **black bear** feasts in an apple orchard. Look for scat festooned with red apple chunks.

Blackpoll warblers have been fueling up on late season insects – some have doubled their weight – and they'll soon be on their way. Some will fly as far as the northern edge of South America.

Also producing red berries by the end of this month: **Jack-in-the-pulpit** and **mountain ash**.

Conifercone cap's dainty tan-colored mushrooms rise up from the cones of **eastern white pine**.

There are more **yellow jackets** than at any other time of the year and they don't have much left to do but make trouble.

Late-blooming **fringed gentian** opens only on sunny days. This rare flower grows along riverbanks and other sites with moist soil.

october

That black salamander that you found under a log but can't find in your field book is the dark morph version of a **red-backed salamander**. The species has an extended mating season, from now through early spring.

Carrion-flower's blue berries have ripened. Happily, they don't smell like the summer bloom, which is pollinated by flies.

Pink lady's slipper pods contain thousands of tiny seeds, which are disseminated by wind. The seeds can wait dormant in the soil for years until the right symbiotic fungus comes along.

The semi-transparent, lantern-like husks of **clammy ground cherries** make eye-catching tabletop arrangements. Most of this plant is poisonous, but **wild turkeys** and other wildlife eat the ripened fruit.

Brook trout are spawning. Females often dig their redds near underwater springs.

When out in the woods admiring tree foliage, don't forget to look down. Noticed on one walk: pale yellow **hay-scented fern, purple aster**, and the wildly variegated leaves of **hobblebush**.

THE CATERPILLAR OF SMEARED DAGGER MOTH DELIVERS A BURNING STING. DON'T SAY IT DIDN'T WARN YOU; ITS MARKINGS LOOK LIKE YELLOW, WHITE, AND RED FIREWORKS ALL GOING OFF AT ONCE.

Puff. **Pear-shaped puffballs**, which grow abundantly on dead wood, are ripe and primed for stomping. The fungal spores, which look like yellow smoke, can rise thousands of feet in the atmosphere.

The second-year larvae of **red oak borer** are moving deeper into the tree, tunneling into heartwood. Despite the specificity of their name, they infest several oak species.

Beavers are preparing their winter food caches. They're likely to be pickier about which stems they harvest now, as opposed to the last mad rush when pond ice threatens. **Witch hazel** is a favorite.

THE LAST BRIGHT FLASH OF A FADING FALL: YELLOW TAMARACKS GLOW ON A RIDGELINE.

As snow sets in, **ruffed grouse** eat more tree buds. Poplar, cherry, ironwood, and apple trees are all on the menu.

If you find a **whitelip snail** shell in the leaf litter, it may not be as lifeless as it looks. In cold, dry weather, the snails bolt their door with a thick mucus wall.

Frost sweetens the tubers of **hopniss** – also called **groundnuts**. A wild "super food," they contain up to three times as much protein as potatoes.

By now, **American toads** are below the frost line. They dig their way down rear end first, using the hard pads on their back feet to burrow.

The **white-tailed** buck smiling in the game camera may just be friendly, but more likely that curled back lip is a flehmen response to a doe's pheromones.

Early in the morning of the last day of November, the full moon darkens as it passes through the outer edge of the Earth's shadow. This **penumbral lunar eclipse** peaks at around 4:42 a.m.

Short- and **long-tailed weasels** are completing their autumn molt. Although most of their fur is now white, both species still have black tail tips. This marking may deflect hawks' attention away from the animals' bodies, and wispy tails are hard to grasp with talons.

When **white-breasted nuthatches** visit birdfeeders, they're likely carrying away more than their bellies can hold. They cache food under bark and in other hiding places.

november

Pileated woodpeckers are primarily insect eaters, but it's common now to find them snacking on wild grapes and other dried fruit.

This calendar is approximate. Specific timing will vary by location, weather, and other factors. These photos first appeared in our Reader Photo Gallery. To view current and past galleries and to share your own images, please go to our homepage: northernwoodlands.org. Illustrations by Adelaide Tyrol.

Clippings about nature from local publications can give you somewhere to start your own observations about what is around you. A friend sent me these "Seasonal Notes" from Northern Woodlands *magazine with her added comments.*

Big pile of bear scat at Canoe Meadow, 10/17 Full of apples!

No toads this year, but we did have a tree frog by the porch – now gone!

Lucky to spot this growing at a friend's marshy meadow

Heard pileated wps calling at Cole Field on several walks. Saw pair in tree.

Several of these at feeders, plus a red-breasted one sometimes.

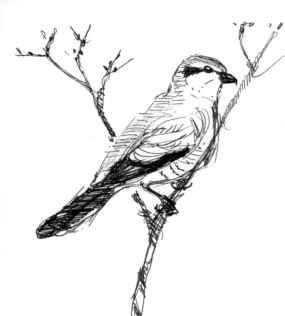

Using the Written Word

Writing is one of the primary forms of communication used by journalists. The more you write in your journal, the more skilled you will become at developing word pictures in prose and poetry. Sometimes you create simple, prosaic accounts of what has happened; other times you can shape your observations into basic stories or poems.

Writing, like drawing, is a skill that requires constant practice over time. Many people use the discipline of journal keeping to improve and sharpen their writing skills. Not only do people who stick with this practice learn to observe better, but they also develop their ability to turn those observations into accurate, more sharply turned poetic and prose phrases. My best

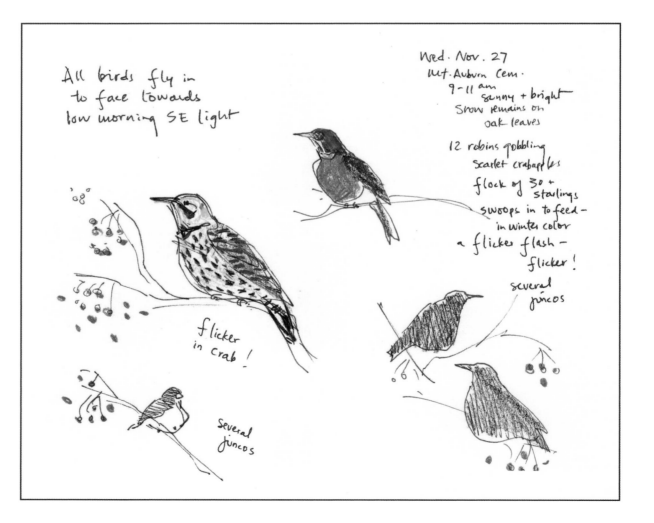

All birds fly in to face towards low morning SE light

Wed. Nov. 27
Mt. Auburn Cem.
9–11 am
sunny + bright
Snow remains on
oak leaves

12 robins gobbling
scarlet crabapples
flock of 30 +
starlings
swoops in to feed—
in winter color
a flicker flash—
flicker!

several
juncos

flicker
in crab!

Several
juncos

suggestion for better writing is the same as better drawing: Write a lot! Also, read as many other writers as possible. (See Suggested Reading and Resources, page 197.)

Drawing What You See

In this book, I focus on drawing as a prime record-making tool because drawing and observing are mutually reinforcing activities. If you've ever taken an introductory drawing course, you may know the experience of really seeing an object for the first time by sitting down to draw it. Drawing helps you observe. It demands that you notice such details as shape, texture, surface, and spatial relationships. You can draw a simple diagram of a shell without being a great artist. Try it and you will see!

However, drawing can also restrict observation by pushing you to focus too narrowly on one object. In so doing, you may not see how your subject relates to other objects around it and to the general environment. Always remember that the context in which an object occurs is a critical part of real observation. If, for example, you are on a beach collecting shells and sea life to draw, take note of the tide height, the makeup of the beach (is it sandy, rocky, narrow, wide?), and the weather, along with nearby birds, smells, sounds, distant views of waves or boats or clouds, even your own random thoughts or moods.

Drawing adds an element to journaling that is different from other techniques. Many people find it to be a useful form of shorthand that takes less time and is less linear than writing. But drawing is like all other skills: It improves with practice and training. It takes practice to become a good basketball player or golfer; so, too, with drawing. Your early drawings may seem crude to you, but as you do more and more, you will be amazed at how your skills improve. And sometimes, drawings are easier and quicker than a written description, as with the quick sketches I made of a chipmunk's clever antics at our birdfeeder (right).

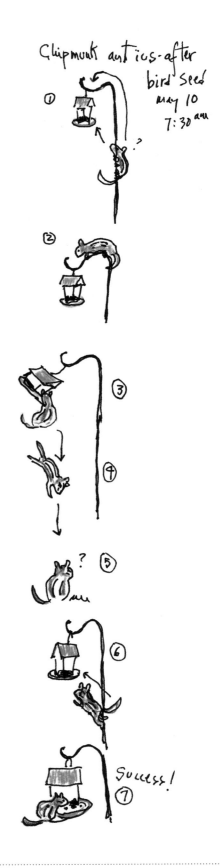

Chipmunk antics—after bird seed
May 10
7:30 am

① ② ③ ④ ⑤ ⑥ Success! ⑦

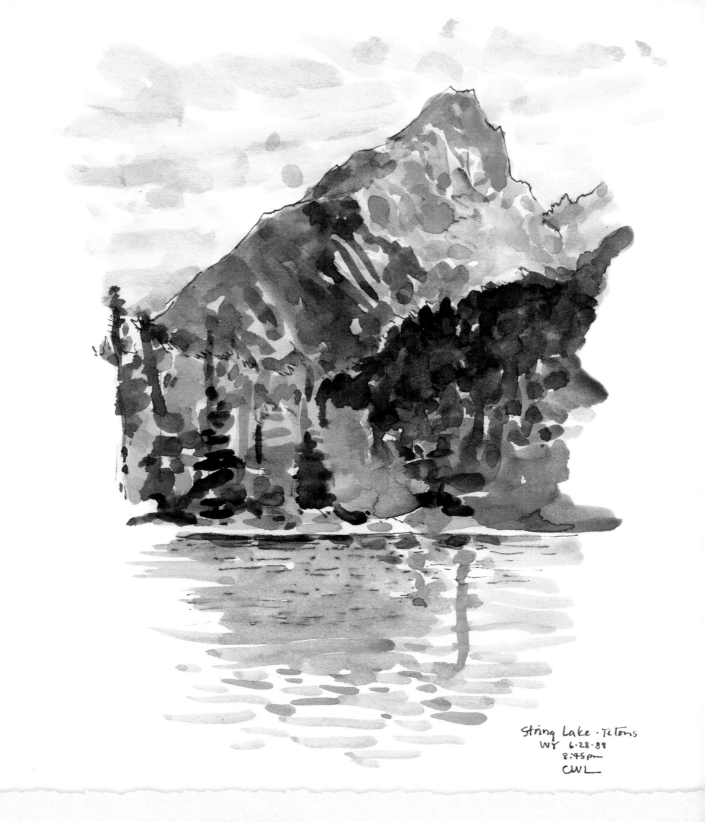

String Lake · Tetons
WY 6·28·88
8:45 pm
CWL

These watercolors vividly remind me of teaching in the Tetons and visiting
Georgia O'Keeffe's Ghost Ranch with my sister.

Your Journal, Your Journey

Journaling might well be thought of as a form of journeying — through the seasons outdoors as well as through your own inner seasons. As we journey through life, our journals become a record of where we have been, what we have seen and attended to, what we have felt as we interacted with our world, what we are sure of, and what we are puzzled by. The thrill of a used journal is that it enables you to go back over its pages and reflect on, process, and marvel at where you have been, what you have thought, what you have seen. A nature journal may get shelved for months or even years. But when you pull it out again, I guarantee that the life within its pages will spring out at you. It was you who was there recording, no one else.

NATURE OFFERS US A THOUSAND SIMPLE PLEASURES — plays of light and color, fragrances in the air, the sun's warmth on skin and muscle, the audible rhythm of life's stir and push — for the price of merely paying attention. What joy! But how unwilling or unable many of us are to pay this price in an age when manufactured sources of stimulation and pleasure are everywhere at hand. For me, enjoying nature's pleasures takes a conscious choice, a choice to slow down to seed time or rock time, to still the clamoring ego, to set aside plans and busyness, and simply to be present in my body, to offer myself up.

— **Lorraine Anderson**
Sisters of the Earth

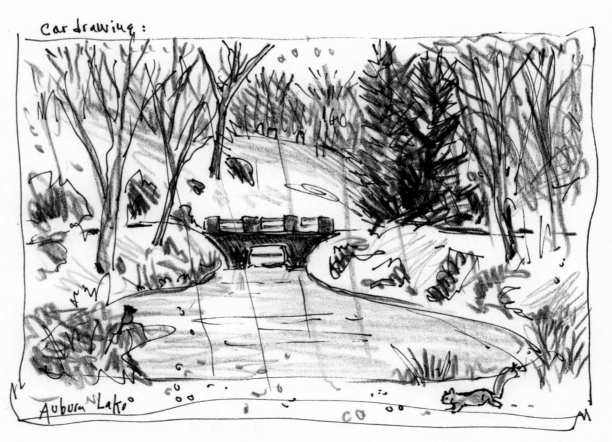

April 10
Wednesday
Mt. Auburn, Camb.
8:20 am
drizzly, raw 46°F
drastic change
over last few days
magnolias

3 duck
fly
over,
quacking

In bloom ~
forsythia
star magnolia
apples
cherries
dogwood - beginning
sugar maples ~
pachysandra
* so good to smell
again!

CHAPTER 2

Setting Up Your Journal

car drawing:

Auburn Lake

When I teach nature journaling, I begin by asking, "What is a naturalist?" We explore the idea that a naturalist is anyone who studies nature — all of nature and mostly outdoors: bees, flowers, trees, fish, frogs, grasses, the sky, the weather. I point out that the observations of citizen scientists are increasingly important in the study of climate change. After all, how can you save what you don't know anything about?

We then set up our first journal page. I need to say here that there are many ways to keep a journal; see A Sampling of Journal Styles starting on page 96. This is my method, based on my art training in Europe and developed over many years. I begin with a very basic format that works well for many people. Do I always follow it? No, but the concepts are the same. This chapter describes my journaling style and discusses the basics of supplies and equipment.

Beginning Steps

The type of journal you use and how you choose to use it are matters for personal decision. Your supplies can be as simple or fancy as you like, or your budget allows. If you are doing a lot of sketching, you may want to buy a small hardbound sketchbook that has smooth, unlined paper. These are available in a range of sizes at art and stationery shops. If you are inclined toward writing as your primary means of observation, and don't mind lines going through your additional sketches, you may want lined paper, in either a hardbound or a spiral notebook.

If you're not ready yet to commit to a hardbound book, or if you're working with a group, individual loose sheets of paper attached to a clipboard or held onto a piece of stiff cardboard with paper clips is fine. Just be careful to keep the completed journal entries in a folder or loose-leaf notebook, organized sequentially by date, so you can refer back to them easily and trace the evolution of your knowledge and style of recording, as well as the ongoing changes of the seasons outdoors.

If you want to record outdoors in wet or cold weather, take along several sheets of paper folded into quarters or even a small pad that you can tuck in a pocket. If they get wet, you can redraw the images in your journal later, adding details or color as you wish. (I often do this myself and with classroom students.)

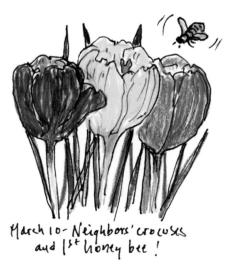

March 10- Neighbors' crocuses and 1st honey bee !

While it may seem that all is in upheaval in human life, crocuses do bloom every year and spring peepers begin trilling about the same time and the sun rises and sets across the seasons in the same sequence.

JOURNAL
#54

Begun on a
snow-free mild
middle winter's day
January 13. 2019

clarewalkerleslie.com

These open pages,
* my companions, my
teachers for
this year —
WHAT? *

Equipment, Simplified

The type of book you select for your journal is related to the way you prefer to organize your journals — something you may not know as you start out. Art and stationery stores are full of enticing hardbound journals — lined and not — of varying sizes. Pick them up, hold them, check the paper quality. Thin paper may bleed ink and color onto the reverse side. Fancy paper or off-white paper may intimidate you. I traditionally look for a simple hardbound 8½ × 11 notebook with unlined white paper (much like the weight and color of copy paper).

The point of a nature journal's versatility is that YOU USE IT, not that it's a beautifully handmade journal that you're afraid to take outdoors. Use a lined notebook or a small drawing pad — anything that you will keep recording in without spending lots of time erasing, perfecting, worrying.

Be prepared for your book to get banged around. My journals all wind up with frayed corners and rumpled pages. Often I keep the current one in the car. I show it to friends and students. It may get wet from rain or snow. My granddaughters draw in it.

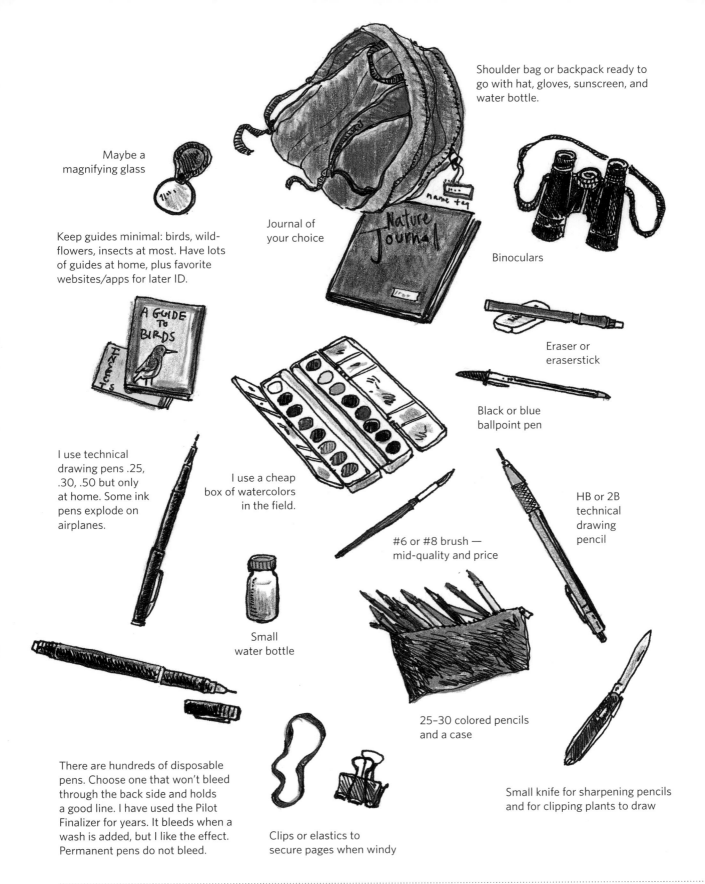

Maybe a magnifying glass

Keep guides minimal: birds, wildflowers, insects at most. Have lots of guides at home, plus favorite websites/apps for later ID.

Shoulder bag or backpack ready to go with hat, gloves, sunscreen, and water bottle.

Journal of your choice

Nature Journal

name tag

Binoculars

A GUIDE TO BIRDS

INSECTS

I use technical drawing pens .25, .30, .50 but only at home. Some ink pens explode on airplanes.

I use a cheap box of watercolors in the field.

Eraser or eraserstick

Black or blue ballpoint pen

#6 or #8 brush — mid-quality and price

HB or 2B technical drawing pencil

Small water bottle

25–30 colored pencils and a case

There are hundreds of disposable pens. Choose one that won't bleed through the back side and holds a good line. I have used the Pilot Finalizer for years. It bleeds when a wash is added, but I like the effect. Permanent pens do not bleed.

Clips or elastics to secure pages when windy

Small knife for sharpening pencils and for clipping plants to draw

.35 technical pen

Pilot Fineliner felt-tip pen with water wash added

#2B pencil

Blue ballpoint pen

Pens and Pencils

Some people have a favorite pen or pencil that makes their writing and drawing most enjoyable. Experiment until you find one that feels just right in your hand, has the type of tip and thickness of line you like best, and moves smoothly on the paper surface. Pens, as well as pencils, respond differently to different kinds of paper and for different folks.

I prefer a fine felt-tip pen or ballpoint because I write a lot of notes. I primarily use colored pencils to complete my drawings (see pages 49 and 70 for more about that). A pen works better for me because it doesn't smudge and is easier to see on the page. Also, there's no lead to break or need sharpening, and I always have a pen handy, whether at the kitchen table or in the car. I've found that many students draw better with an inexpensive black felt-tip pen, even if they're terrified at first about making mistakes! They tend to draw more carefully and can see their lines better.

Pencils come in many types: HB (hard, firm lines for plants); 2B (softer graphite for plants and birds); 3B (softer still for birds and animals); 4B, 5B, and 6B (very dark and soft for landscapes and tonalities, but they smudge and need to be sprayed with a fixative). If you're using a pencil, you'll also need a good eraser or eraser stick.

Sharpeners vary in quality. The best is either a knife or a battery-run motorized pencil sharpener. Technical drawing (automatic) pencils work well for outdoor drawing (leads 2B and 3B preferred). These leads don't need sharpening, do not break in a packet, and are ready with a sharp point if a hawk flaps past.

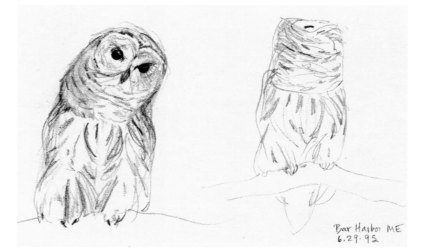

Bar Harbor ME
6.29.95

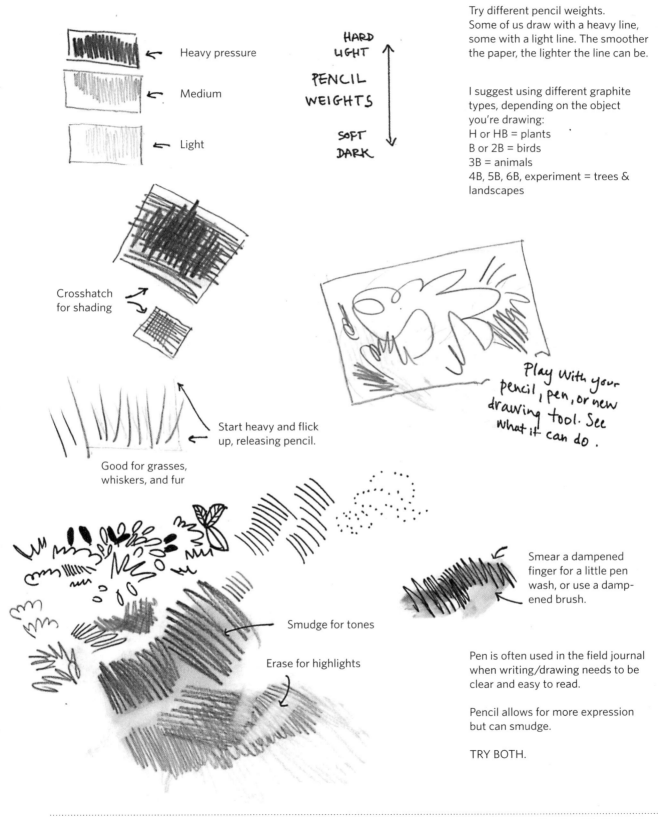

Heavy pressure

Medium

Light

HARD
LIGHT

PENCIL
WEIGHTS

SOFT
DARK

Try different pencil weights.
Some of us draw with a heavy line,
some with a light line. The smoother
the paper, the lighter the line can be.

I suggest using different graphite
types, depending on the object
you're drawing:
H or HB = plants
B or 2B = birds
3B = animals
4B, 5B, 6B, experiment = trees &
landscapes

Crosshatch
for shading

Play with your
pencil, pen, or new
drawing tool. See
what it can do.

Start heavy and flick
up, releasing pencil.

Good for grasses,
whiskers, and fur

Smudge for tones

Erase for highlights

Smear a dampened
finger for a little pen
wash, or use a damp-
ened brush.

Pen is often used in the field journal
when writing/drawing needs to be
clear and easy to read.

Pencil allows for more expression
but can smudge.

TRY BOTH.

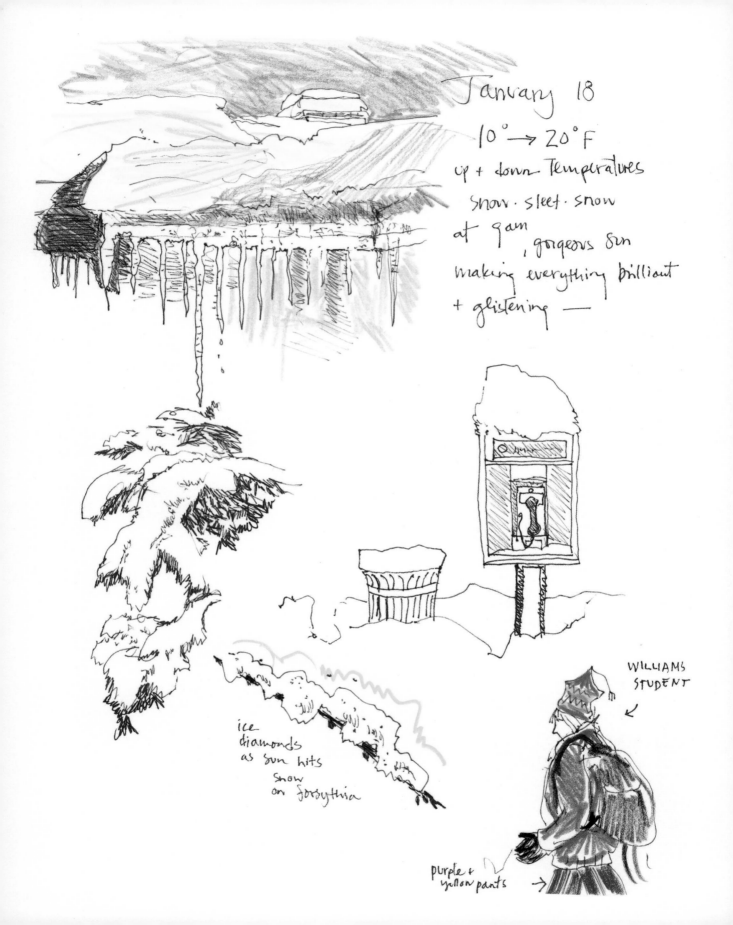

January 18

$10° \rightarrow 20°F$

up + down Temperatures
snow · sleet · snow
at 9am , gorgeous sun
making everything brilliant
+ glistening ——

ice
diamonds
as sun hits
snow
on forsythia

WILLIAMS
STUDENT

purple +
yellow pants

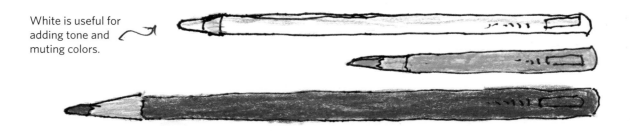

White is useful for adding tone and muting colors.

Colored Pencils

I have long preferred colored pencils to watercolors for adding color to my journals, especially in the field. I don't have to carry water or worry about spilling or waiting for a page to dry.

I find students love experimenting with colored pencils, as they are still drawing but without the complexity of watercolor. The colors are already mixed, and they can experiment with blending and density.

A set of Prismacolor pencils will last a long time. There are other brands and even watercolor pencils. Experiment and find what you like.

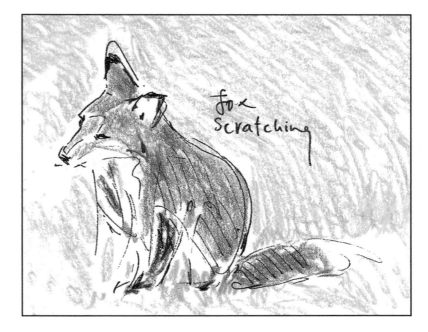

fox scratching

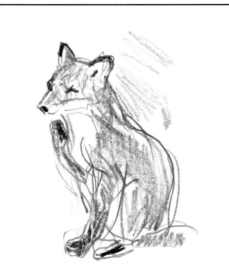

Above: Felt-tip pen and colored pencil

Left: Pencil and colored pencil

A Mont Auburn
witness to HOPE :

A new Amer Beech
Sapling just
planted to replace
lost Copper Beech
(Much debate as to
what ...)
to plant

The First Page

It is useful to establish a stated reason why you want to start a nature journal. Many possible reasons are discussed in chapter 1. You may have no other purpose than to learn about where you live, or to observe and record the daily weather, or to document the inhabitants and activity in a local wetlands. The more you use your journal, the more these purposes will change and unfold. If you're uncomfortable marking up that first title page, experiment on inexpensive computer paper first.

As you begin (or continue!) your path to nature journaling, it may help you to follow the journal-entry format I've used over many years. The format can be used by folks from 6 to 60 to 96. Try the sequence that you'll find on page 53; it may help you put something down on your paper right away, reduce any writing or drawing block, and jump-start your thinking process.

FILL YOUR PAPER with the breathing of your heart.

— **William Wordsworth**

... A gathering of
stories, wanderings,
accounts through a year
of seasons.
May there always be
places to explore, love,
wonder about and draw ...
Begun May 6, 1993
Cambridge, MA
book #16

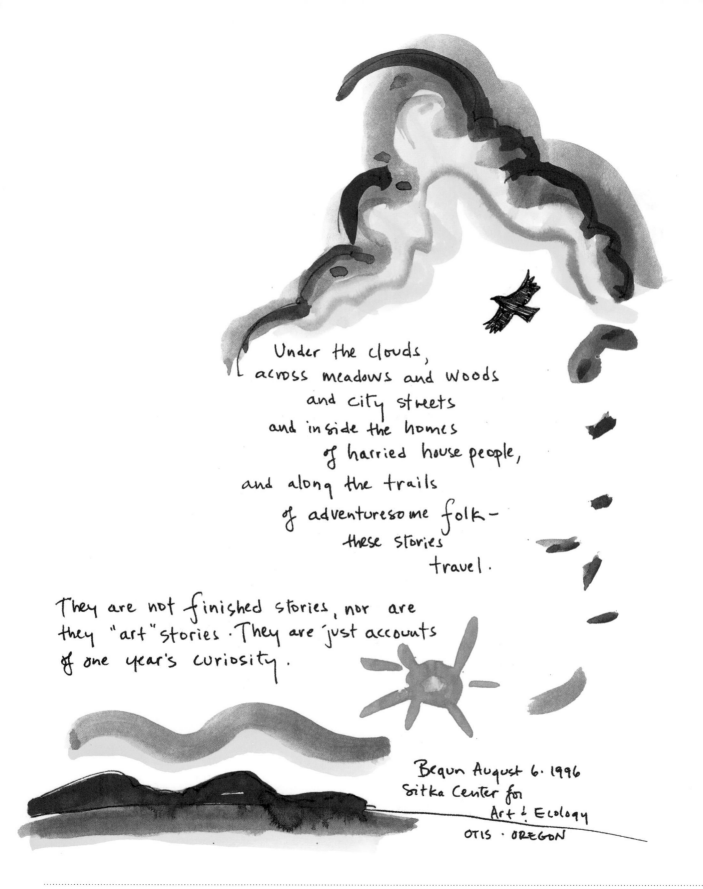

Under the clouds,
across meadows and woods
and city streets
and inside the homes
of harried house people,
and along the trails
of adventuresome folk —
these stories
travel.

They are not finished stories, nor are
they "art" stories. They are just accounts
of one year's curiosity.

Begun August 6. 1996
Sitka Center for
Art & Ecology
OTIS · OREGON

Monday June 18
Mt Auburn
4:15 pm
96° + humid!

Sunrise = 5:07 am
Sunset = 8:24 pm
15 hrs 17 min

Sounds: wind in leaves robins . grey tree frog
red winged blackbirds 1 or 2
1 bluejay
chipmunks full flower = mountain laurel
 Kousa dogwood
The land in full summer green sits silent

Such a contrast
to March 8

Entering Observations

You are ready to begin recording your observations. Although there are numerous ways to format a journal, the following is the way I always teach as a place to begin. In an upper corner of your page, record the following, using both written word and illustration, as appropriate and desired.

DATE. This establishes the season and month in relation to the year.

TIME. This can be simply "early afternoon," "late morning," or a specific time.

SUNRISE AND SUNSET. These minutes are always changing as the seasons continually roll along. Everything in nature is affected by this cycle of light, but we can go for days without noticing the changes. This information can be found in local newspapers or *The Old Farmer's Almanac* or any online weather site. Recording this data helps keep you aware of monthly and annual astronomical cycles.

PLACE. Where are you making your observations? Draw a map if you want. Talk about who and what lives here now in this season and this habitat.

WEATHER. Record the temperature, which affects animal activity and plant growth. Is it sunny and clear, or cool and overcast?

WIND DIRECTION. Locate and draw the points of the compass. Then add wind direction by looking at which way flags or even your hair is blowing.

CLOUD PATTERNS AND SKY COLOR. Record cloud patterns and the sky by making a small box and adding an image of what you see. Write a description of the sky near the box. Add the names of the cloud types, if you know them; if not, look them up later. Put the moon in, if you see it, or note the current phase.

FIRST IMPRESSIONS. Take a few moments of silence to orient yourself. Make a quick list of what you see and hear, or note your own mood. Walk around for a while just listening, watching, and connecting.

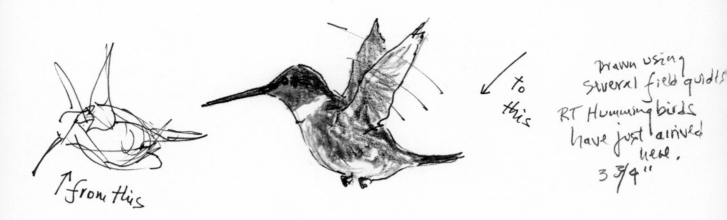

Drawn using
several field guides
RT Hummingbirds
have just arrived
here.
3 3/4"

to this

from this

Introduction to Drawing

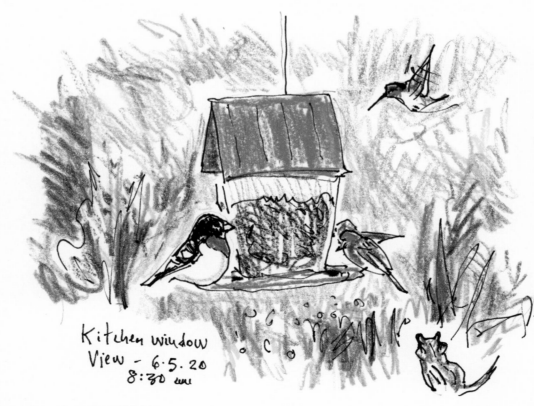

Kitchen window
View - 6.5.20
8:30 am

R.B. Grosbeak
2 Purple Finches
Waiting chipmunk
garden
sunshine
and
a red confused
R.T.
Hummingbird
♂

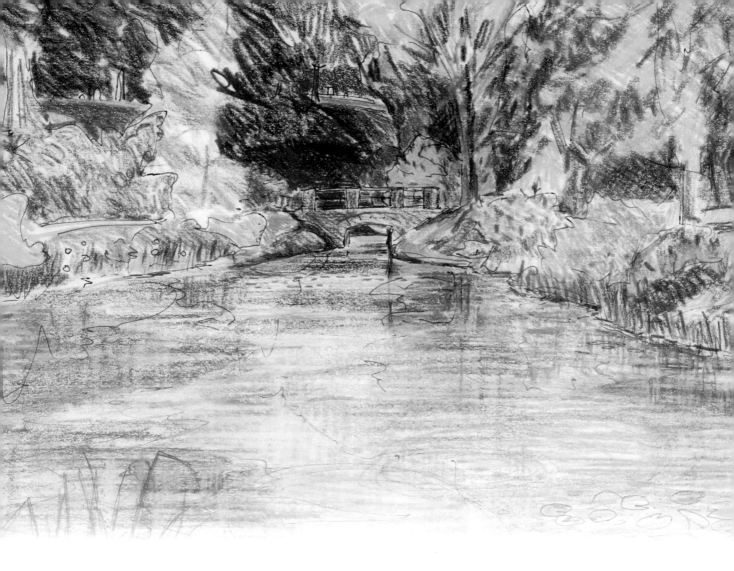

Children are taught to write early in school but rarely given instruction in drawing. Growing up, I drew all the time but didn't take it seriously until I was an adult and wanted to draw birds, flowers, landscapes. I had to learn from scratch!

Many people panic at the thought of making sketches in their journals. Even the early field scientists wrote more than they drew. They hired artists to accompany them on their voyages to record images. Charles Darwin is quoted as saying, "My greatest regret is I never learned to draw well."

If you believe you can't draw, consider your first marks on paper as just that, not "drawings." As with all skills, you'll get better the more you practice. This chapter offers beginning and basic exercises that are used in art classes everywhere.

Contour of our cat

Practice using simple objects around you — a piece of fruit, a seedpod, your coffee cup, even your cat.

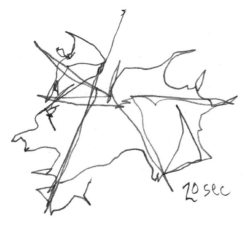

20 sec

Beginning Exercises

There are a number of tips and tricks that will help you gain confidence with basic drawing skills. In any skill training, warm-up exercises are highly encouraged. (Think of athletes, musicians, dancers, singers, actors.) The following eye-hand exercises, long used in drawing classes to get students to relax and have fun, are a great way to loosen up and tune in to really looking at the form of an object before you begin actually drawing.

You can do them all in about five minutes. They are best done in sequence, beginning with the blind contour. If you choose not to do them all each time you begin a drawing practice session, at least do one blind or modified contour exercise. Try them out, then modify and rearrange them to fit your interests and journaling style. Once you've mastered these, or if you are ready for more advanced techniques, you'll find more suggestions for drawing various natural objects in Part 2.

When you first try these drawings, you may find yourself laughing and thinking your drawing is silly. It is! But notice that you have captured the basic form. This is right-brain, not left-brain, work, so just let your creative side lead the way.

EXERCISE 1 Blind Contour

Blind contours are done in one continuous line without ever looking at your paper. They're good for capturing the shape of an object and helping with foreshortening (see page 66). Try this technique when you first see an object. It's a good way to loosen up and get focused.

Without looking at your paper at all, keeping your eyes only on your object, "trace" in a continuous line across your paper recording everything you see. Don't look at the drawing, lift your pencil, or stop until you have gone all around the form from left to right, right to left, or top to bottom. Go slowly and look very carefully at your object. Don't peek at your paper! Think of yourself as a spider threading out a line.

Try this exercise for varying times: a few seconds, one minute, two minutes (no more). Change the angle of the object and try again.

EXERCISE 2 **Modified Contour**

Modified contours allow you to peek a bit at your paper, while still moving your pencil in one continuous line. This is just another way for beginning/seeing. Draw the same form (or a different one), this time allowing yourself to look at the paper, but still without lifting your pencil off the paper. Draw using a continuous line, going slowly and stopping when you feel you have fully captured your object. Complete the exercise in no more than two minutes.

Compare the blind and modified contour drawings. Do you prefer one to the other? You may be surprised at how loose yet accurate your two kinds of drawings are — and fun!

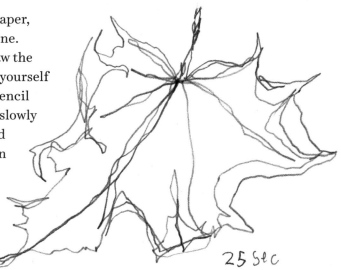

25 sec

MIX IT UP A LITTLE

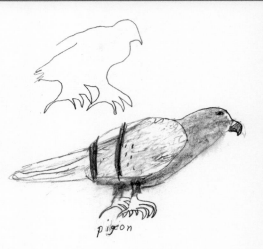

pigeon

Contour drawings often make people laugh. Everyone's looks about the same, no matter the age, experience, or intention! Look carefully, though, and you will see the essence of what you were drawing. Doing blind and modified contours can quickly give you the confidence to move on to a more finished effort.

Try doing a blind or modified contour with your opposite hand. Do your drawings standing up, with your paper at arm's length from you on a table, or draw with your paper on the ground. Switch from pen to pencil, or vice versa, and see what happens. As you draw, notice how loose and strong your drawings are getting. Have fun!

At age 7, Sam couldn't sit still. The contour drawing slowed him down so he could really look. I was amazed at the pigeon he then drew!

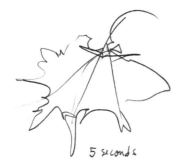

5 seconds

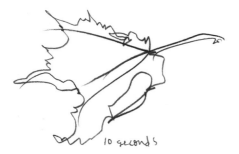

10 seconds

EXERCISE 3 **Quick Gesture Sketches**

Quick gestures are sketches of the complete form, done as quickly as possible. This is a classic art class exercise, where the model keeps moving and you have to keep drawing the changing positions. It's a very useful technique for field artists because much of what you're drawing moves quickly! I probably do more quick sketches in my nature journals than other forms.

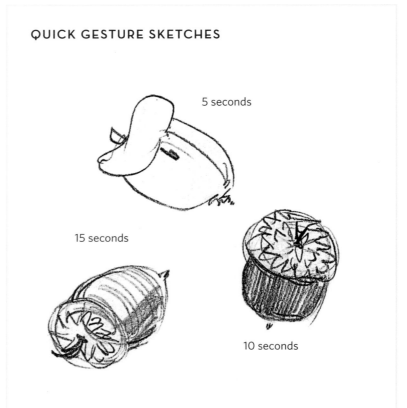

QUICK GESTURE SKETCHES

5 seconds

15 seconds

10 seconds

Looking back and forth at your paper and the object and lifting your pencil as needed, scribble down the whole form as fast as you can for 5 seconds; then do it in 10 seconds; finally, take 15 seconds to get your sketch down. Try to get the major sense of the form by looking and drawing at the same time. You may only get part of the form. Just begin again. I use this method, for example, if a bird at a feeder keeps returning to the same posture.

EXERCISE 4 **Diagrammatic Drawing**

Diagrammatic drawing involves much detail of a particular specimen. This technique is useful when you spot something you want to identify, but you don't have a field guide with you, can't take a specimen home or take a picture of it, or are with a group that doesn't wish to linger. This is a common technique used by field scientists who are not interested in the drawing as much as they are recording the observation. I call these "proof-in-court" drawings because they can prove invaluable evidence of things seen but not collected.

Make a simple line drawing, as if for a field guide identification. Add notes of the object's size, color, shape — enough to help you identify it later. Complete in three to five minutes. Try using a pen, not pencil.

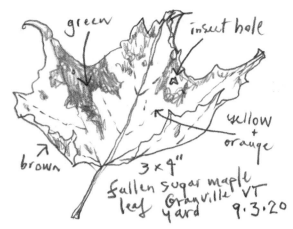

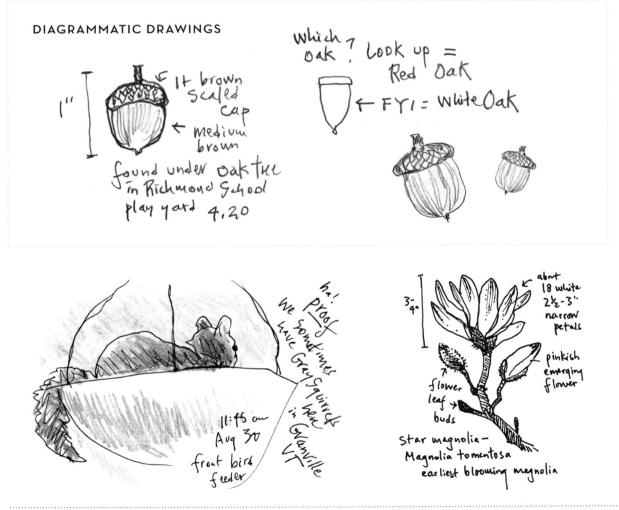

DIAGRAMMATIC DRAWINGS

10 min

EXERCISE 5 "Finished" Drawing

The finished drawing is used when you wish to produce a more completed work; it takes from 10 minutes to 10 hours!

Use this technique to produce a more complete drawing. Add volume, shading, and the various surface details of the shell, leaf, banana, rabbit, or whatever it is you are drawing. Take no more than 15 minutes at first.

Of course, as you become more experienced, you may want to take more time, try different medium, or add color. See Part 2 for more advanced techniques and tips on drawing specific things, like plants or birds.

FROM CONTOUR TO FINISHED DRAWING

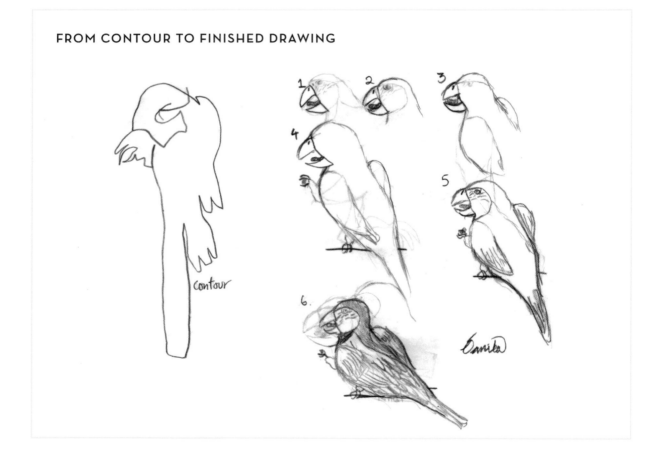

contour

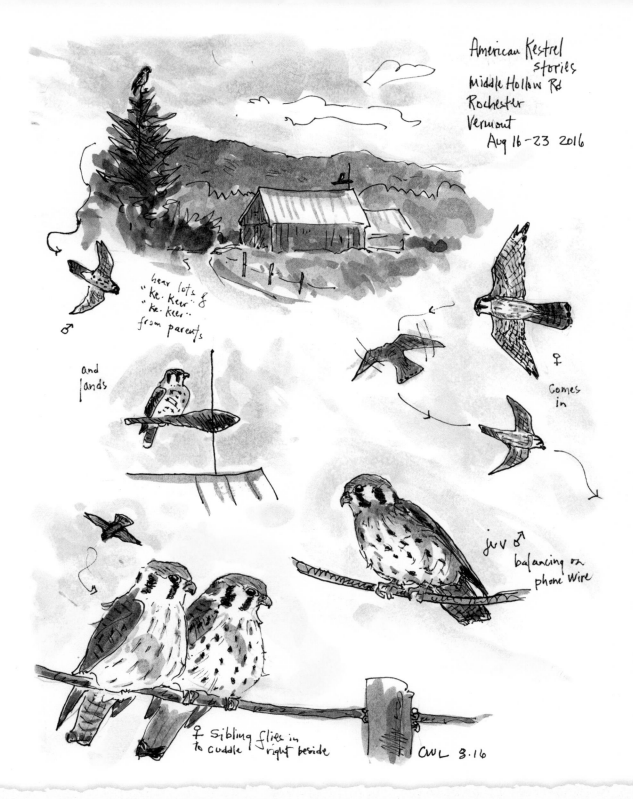

American Kestrel
stories
Middle Hollow Rd
Rochester
Vermont
Aug 16-23 2016

hear lots of
"ke-keer"
"ke-keer"
from parents

♂

and
lands

♀
comes
in

juv ♂
balancing on
phone wire

♀ Sibling flies in
to cuddle right beside

CWL 8.16

One summer we had a family of kestrels nearby. After weeks of sketching,
I compiled this finished watercolor study. All my practice drawings helped
me accurately capture the birds in my final work.

M.H. 9/29/95
Dover Ma. 11:00 am
cool sunny gray squrles

red oak
<1 in.
smooth leaf black berry

poison ivy white pine

egg of wasp
?→ <1 in

canode
Mayflover

mikey Hepburn

OVERCOMING FEARS OF DRAWING

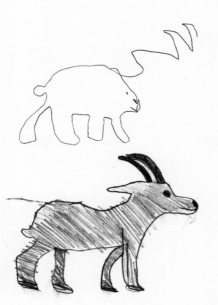

A 4th grader's blind contour and his finished drawing

In one outdoor journaling session I taught, the teacher, Mrs. Jay, said she preferred not to draw because she was "no good." Teachers are obvious role models to students, so I encouraged her to try. (Students like to see their teacher struggling with what they might do more easily.) Seeing how engaged her students were in drawing, and feeling the safety of my support, Mrs. Jay, giggling, joined her class and drew the November oak tree in their schoolyard. Afterward she said, "This is the best tree I've ever drawn!"

We all have these fears of failing. As adults, teachers, friends, we need to keep saying, "That's cool. Keep going. Do it again." I find we can learn from kids, who are often too busy and too curious to worry about how "good" their drawings are.

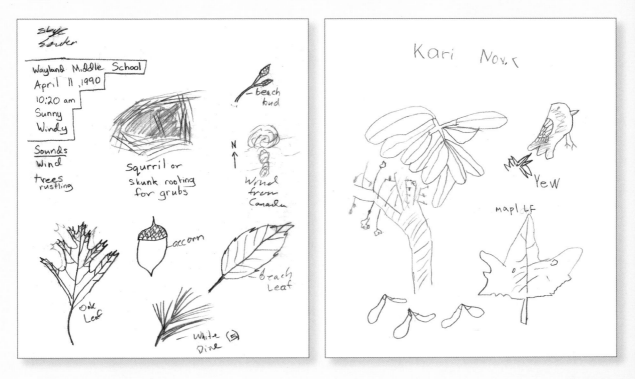

2nd grader

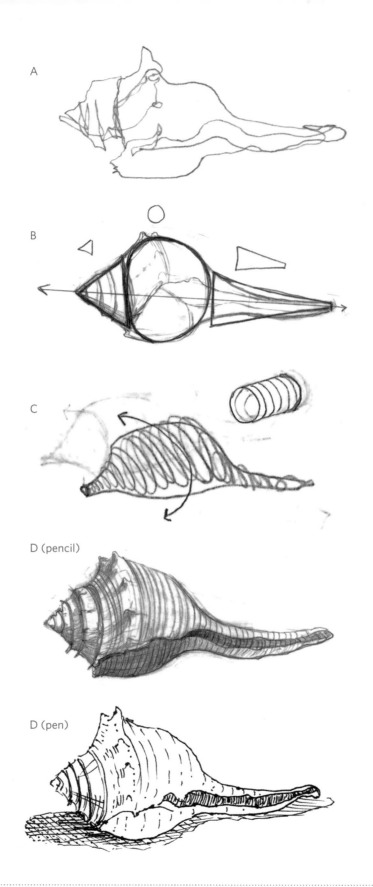

A

B

C

D (pencil)

D (pen)

Capturing Basic Shapes

Before you begin drawing, look at your object to see what geometric shapes you can find within the form. Including these shapes within one or two blind or modified contour drawings (A) can help you get a handle on the real form. Draw over your contour to identify the major triangle, circle, or square shapes you see in the object (B). Draw an axis line if it helps. This will also help you with perspective issues. Connect the lines around the geometrics to get the overall shape of the object.

Next, try doing a gesture sketch using the knowledge you have of the geometric forms in your object. Thinking of forms as cylinders will help you understand the third dimension or roundness of an object, such as this shell. This will also help you decide which direction you should use for shading lines (C).

Finally, do a finished drawing (D). Whenever applying pencil or pen, use lines or dots to show how your form curves and what is in shadow and what is not.

Adding Shading

Shading can be done in pen with lines (parallel or cross-hatches) or by using lines or dots placed close together for dark shading and farther apart for light shading. Pencil shading can be done the same way, or by rubbing with a finger, using greater pressure to create darker areas.

When shading, be sure to choose a direction from which light is coming, or from which you are going to assume light is coming. Be consistent about this light source throughout the drawing.

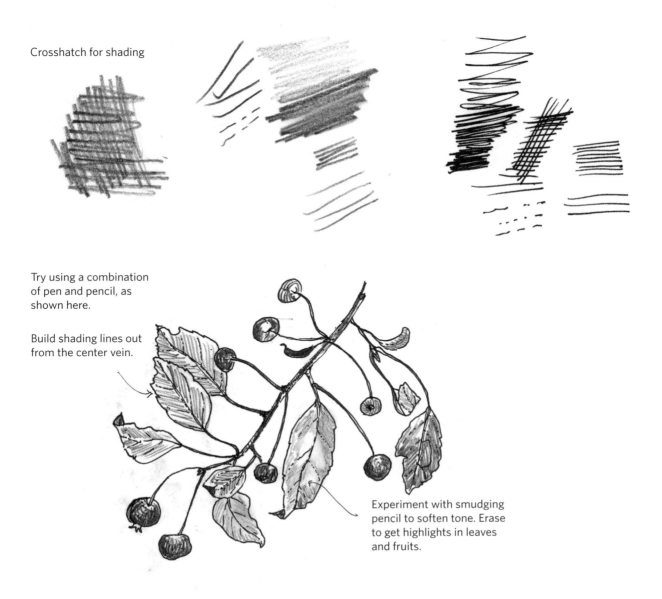

Crosshatch for shading

Try using a combination of pen and pencil, as shown here.

Build shading lines out from the center vein.

Experiment with smudging pencil to soften tone. Erase to get highlights in leaves and fruits.

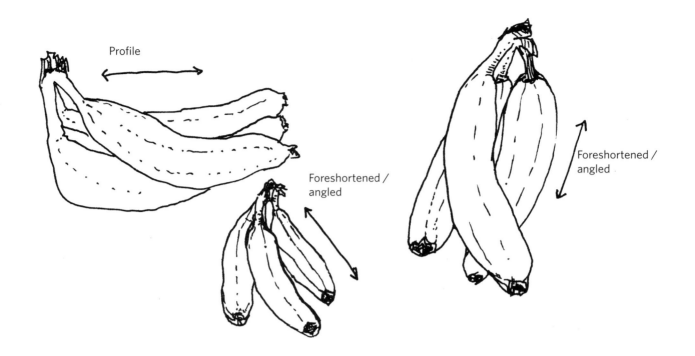

Profile

Foreshortened / angled

Foreshortened / angled

Foreshortened / angled

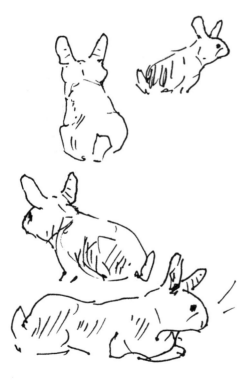

Practice doing foreshortening sketches of household objects: a salt shaker, toothbrush, shoe, even a pet.

Foreshortening of Natural Objects

Objects will not always be in full profile. Try drawing them at an angle, or foreshortened, to see how their shape appears to change. Squint to flatten your depth of field, or use a contour drawing to see those "new" shapes.

Getting the Right Perspective

One of the trickier things to accomplish in a drawing is the proper perspective. When you view something from the side or directly from the front you can re-create the basic shape fairly easily. When you view the same object from different angles, however, the shapes change. Earlier you were encouraged to look for geometric shapes within your object. Now you need to gain some experience drawing the basic shapes — circles, cubes, and cylinders — from different angles. For more about perspective, see Landscapes, page 170.

Circles

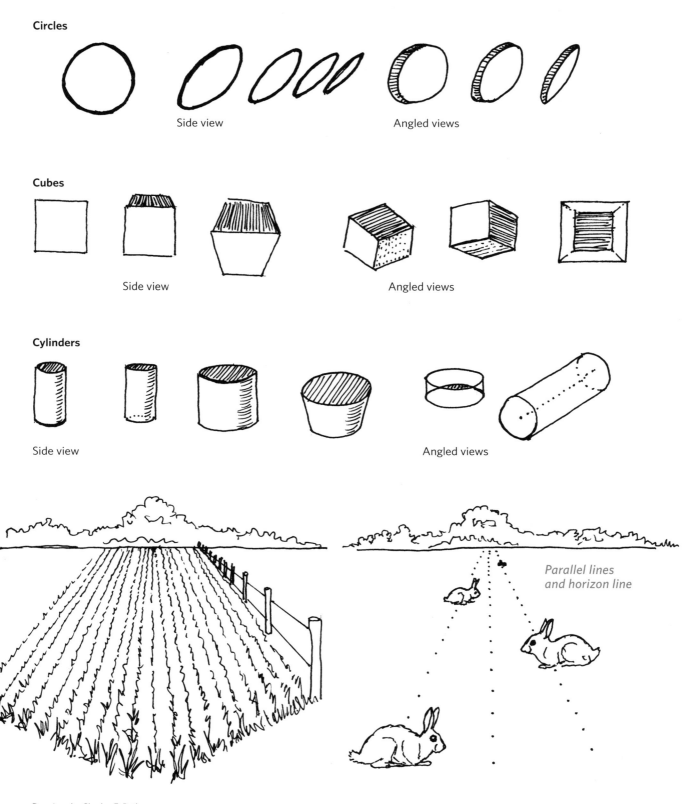

Side view Angled views

Cubes

Side view Angled views

Cylinders

Side view Angled views

*Parallel lines
and horizon line*

Drawings by Charles E. Roth

BASIC RULES
OF PERSPECTIVE

- Surfaces that are parallel to the picture plane appear in their true shape.
- Objects appear smaller in relative proportion to their distance from your eye.
- Receding parallel lines seem to converge away from the eye at a common vanishing point.
- Surfaces are foreshortened in relative proportion to their angle away from the picture plane.
- A circle that is parallel to the picture plane appears as a circle.
- A circle observed at an angle to the picture plane is foreshortened and appears as an ellipse.
- An object appears less distinct in proportion to its distance from your viewer's eye.

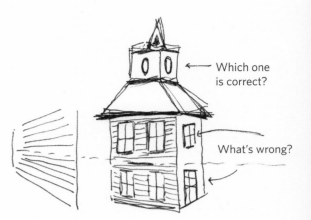

Which one is correct?

What's wrong?

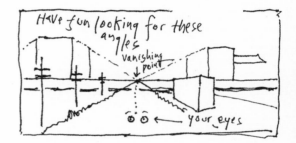

Have fun looking for these angles

vanishing point

your eyes

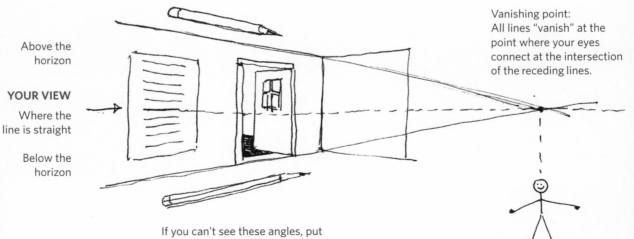

Above the horizon

YOUR VIEW

Where the line is straight

Below the horizon

Vanishing point:
All lines "vanish" at the point where your eyes connect at the intersection of the receding lines.

If you can't see these angles, put your pencil or finger along the edges and copy onto your paper.

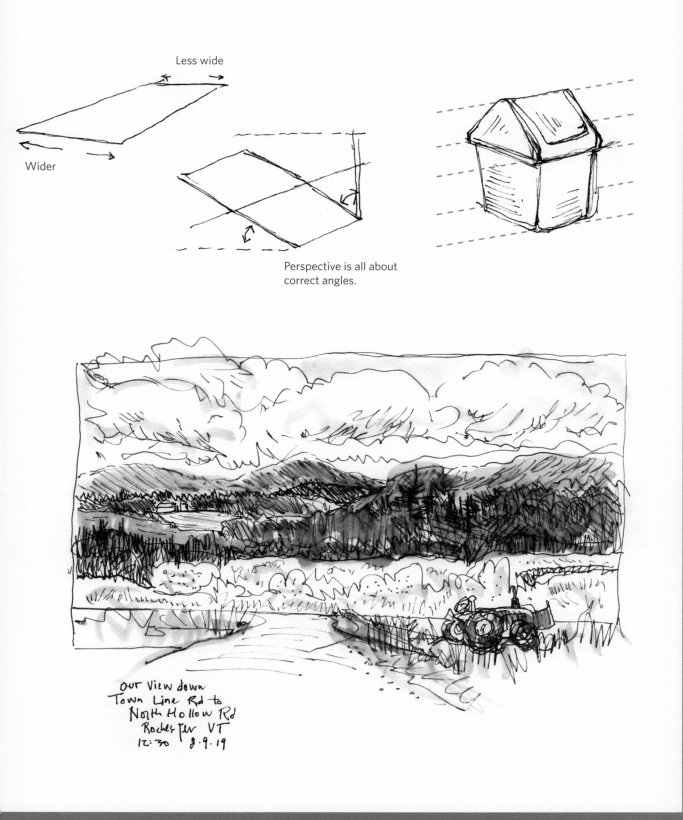

Less wide

Wider

Perspective is all about
correct angles.

Our View down
Town Line Rd to
North Hollow Rd
Rochester VT
12:30 8·9·19

Adding Color

Colored pencils are a great way to add color. You can use them much the way you do crayons — just color in green for leaves, red for flowers, yellow for bumblebees, and so on. The colors are already mixed in the pencils. If you want to mix and vary your colors, just layer one over the other in various weights (color densities). Thick lead pencils are richer in color than the thin leads, and the waxy texture of the lead allows the colors to blend nicely. The white or cream colors are good for softening or highlighting.

You can mostly erase colored pencils if you make a mistake. You can also mix them with other media, such as watercolor, watercolor pencils, crayons, and pen and ink. Colored pencil is better added to a pen-and-ink drawing than a pencil drawing, since the pencil edges can smudge and make the colors muddy. *The Colored Pencil* by Bet Borgeson is a very useful book.

When teaching, I recommend that beginners use colored pencils. Watercolor paint is great but presents many complexities. See A Note about Watercolor, page 72.

have been listening to this downy. ♂ - eating away

Have fun experimenting with color. See how many shades you can use to make a more realistic image. Then play around with colors — look at art books and visit museums to see what other artists have used.

baxberry flowers in bud

Shade out from center, layering colors light to dark.

Add a little red to the green and green to the red to help connect colors.

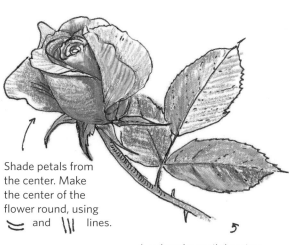

Shade petals from the center. Make the center of the flower round, using ⌣ and ⫴ lines.

A colored pencil drawing can take from 10 minutes to 10 hours to complete.

With colored pencils, the colors are blended, rather than mixed as they are with watercolor.

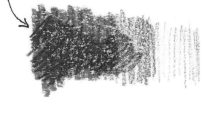

blue gray

black

black

buffy

black

? nuthatch
about 5"
on sugar maple
Williamstown 1·10

Colored pencils are used a great deal in the field for quick color notations, as done here.

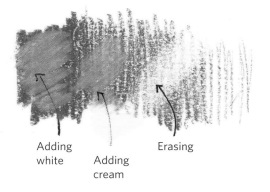

Adding white

Adding cream

Erasing

A **NOTE** ABOUT WATERCOLOR

I don't teach watercolor techniques in my workshops, because I feel it critical to learn how to draw first. Using watercolors is an entirely separate topic and too big to cover here. However, if you're intrigued or have some experience already, there are many inexpensive and perfectly good boxes of paints to experiment with. In the field I use a Prang set with 16 different opaque color sections. I often add watercolor to my journal drawings and the copy paper weight of my pages holds just fine. Use brushes with good fine points that don't flatten out. Some people like the brushes that hold water in their handle.

There are many good books on how to use watercolor for landscapes, plants, and wildlife. If you want to take a course, I suggest you first find out how the teacher uses watercolor and if that technique matches your interest.

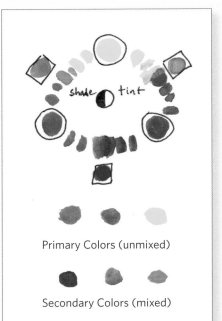

Primary Colors (unmixed)

Secondary Colors (mixed)

Tips for Getting Started

- Apply watercolor pencils the same way as colored pencils, then brush with plain water to blend in the wash (see the top illustration on page 79). Use a permanent ink or pencil, so the line will stay. The trick is not to have too much water on your brush, or the colors will puddle.
- Learn how to mix colors, and what colors result. For example, mix red, blue, and yellow together. What do you get?
- Do a pencil drawing, laying in major shapes. Then develop tones and color washes, adding layers of paint and varying the amount of paint and water on your brush. Brush size, type of paper, and the amount of water in your brush all make a big difference in your results.
- Experiment. Make mistakes. Learn from others. Have fun with it!

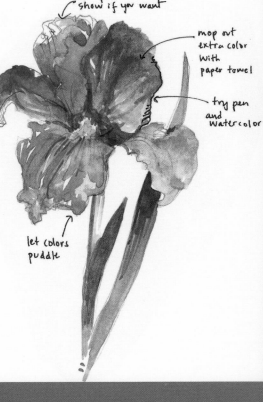

let pencil lines show if you want

mop out extra color with paper towel

try pen and watercolor

let colors puddle

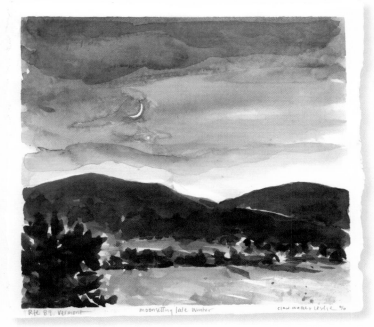

Rte 89. Vermont moonsetting late winter Claw Walker Leslie 96

Try using watercolor abstractly, just to enjoy the effects. I love creating a palette of the seasons or of a particular day. I painted the scene on the left from memory. For the one below, I pulled over and painted while sitting in my car.

Rte 89 - Mount Kearsarge late winter storm NH drive Claw Walker Leslie 96

Snowy owl
1·27

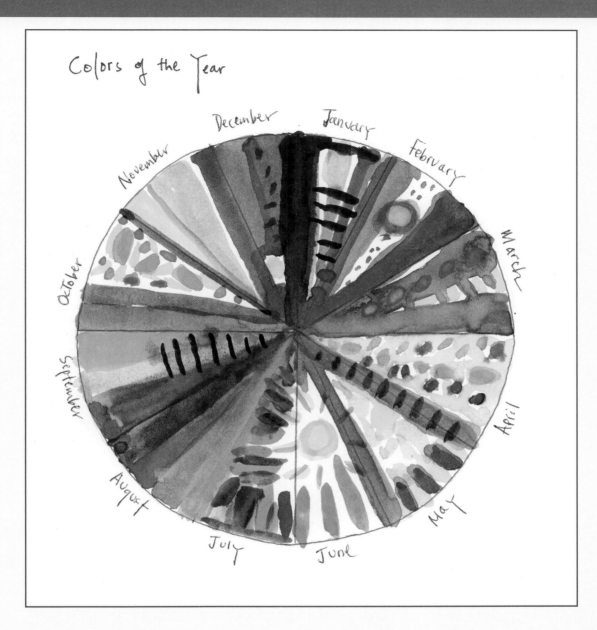

Colors of the Year

Finding Your Own Way with Watercolor I have used watercolor for many years, studying color theory and playing around with color. My best teachers? John Singer Sargent, Winslow Homer, David Hockney, Lars Jonsson, John Busby, and many others, as seen in museums, art books, and even on friends' walls.

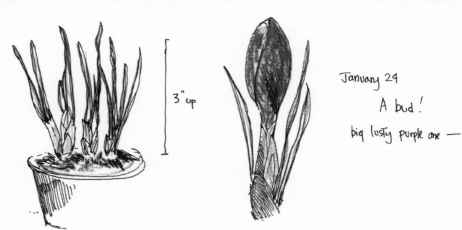

January 16 –
on a cold day,
bought a pot
of crocuses
– 3 bulbs

3" up

January 24

A bud !

big lusty purple one –

CHAPTER 4

The Ongoing Journal

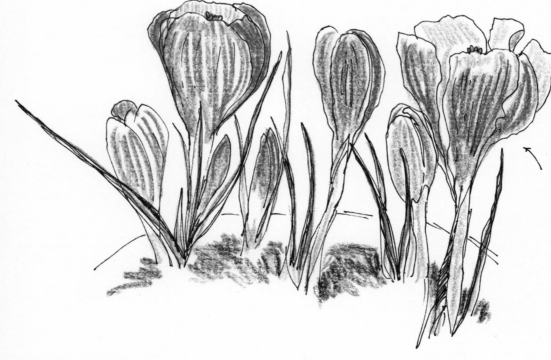

January 28 –

A garden of
bloom on the
windowsill

beginning to fade
but more still
to come

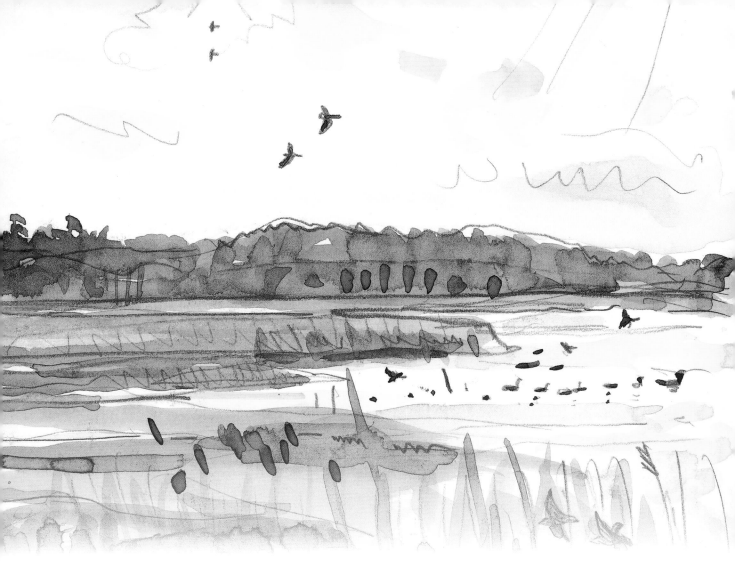

Nature journaling can be done just about anywhere, indoors or out. Wherever there is something living, you can begin to observe. You may feel, "How can I begin observing nature? I don't know the answers to any questions. I don't even know what questions to ask." We were all once beginners, barely knowing a robin from a sparrow. Your beginning questions may be very basic ones, such as "What season is it?" Curiosity will lead you to answers.

Think also about why you even want to draw nature and keep a journal. If you start feeling obligated and are not enjoying the process, don't draw, don't record. But do still get outdoors, if just for a few minutes, to watch, listen, and pay attention. One of my students told me, "I used to be depressed until I picked up a journal and started noticing nature everywhere around me."

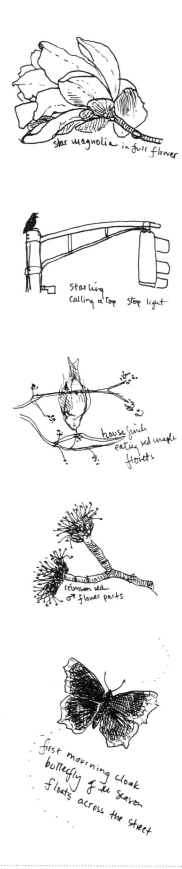

star magnolia in full flower

starling calling atop stop light

house finch eating red maple florets

crimson red ♂ flower parts

first mourning cloak butterfly of the season floats across the street

If you want to learn more about nature in your area, seek out others who might have answers, check out books in your local library, and enroll in courses and workshops at your local nature or educational centers.

You likely have access to a number of places where you can begin sharpening your observational skills and developing a new sense of that place. Start in your own backyard or garden. Visit a local park, woodland area, or nature center. Take a walk along a nearby river or pond. Think about nature as you walk your dog or commute to work. You might be surprised at how much life you can spot at a bus stop or even from a moving car.

Most anyone can access nature from inside as well. Whether you are stuck inside with a bad cold or waiting for an appointment, you can watch the sky, cloud shapes, rain, or sunshine from any window. Are there birds flying around, trees moving in the breeze, flowers blooming, or a bumblebee passing by?

Really Pay Attention

As you observe, allow yourself to fully enter into the scene, paying attention to every detail. As you sit, ask yourself:

- What light, colors, shapes, and patterns do you notice?
- What plants grow here? What trees? Learn to identify them.
- What things affect their growth?
- What birds live here and why?
- What insects live here?
- What other nonhuman creatures live here? Can you see them, or only evidence of their presence?
- What creatures are seen during the day; what others are only active at dawn or dusk, or perhaps at night?
- How have people influenced this place? How recently and why?
- How might this place have looked 50, 100, or 200 years ago?
- How and why might the plant and animal life have changed over time?
- How might climate change be affecting nature here?

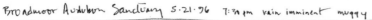

Broadmoor Audubon Sanctuary 5·21·96 7:30 pm rain imminent muggy

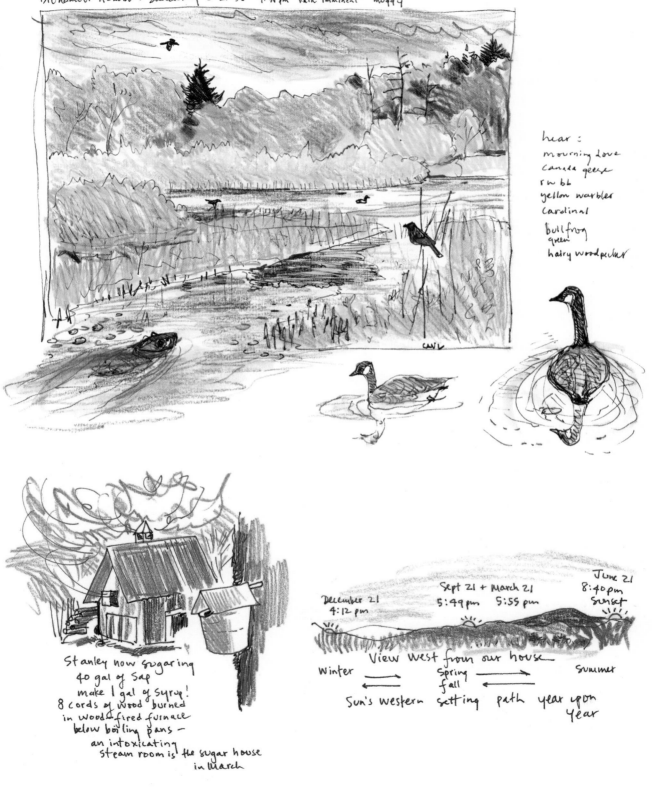

hear:
mourning dove
Canada geese
r w bb
yellow warbler
Cardinal
bullfrog
green
hairy woodpecker

Stanley now sugaring
40 gal of sap
make 1 gal of syrup!
8 cords of wood burned
in wood fired furnace
below boiling pans —
an intoxicating
steam room is the sugar house
in March

December 21
4:12 pm

Sept 21 + March 21
5:49 pm 5:55 pm

June 21
8:40 pm
sunset

View West from our house

Winter Spring Summer
 fall

Sun's western setting path year upon
 Year

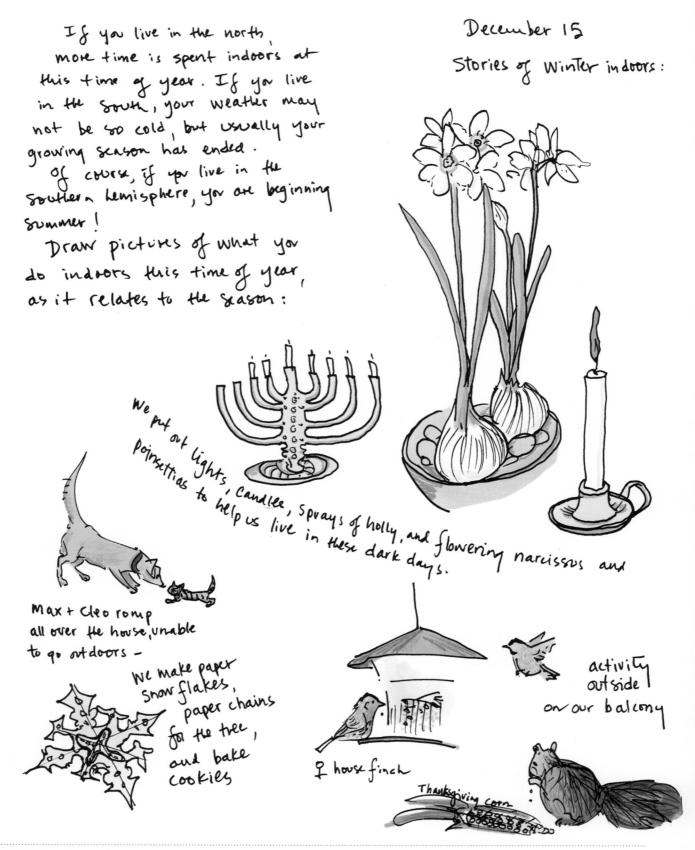

If you live in the north, more time is spent indoors at this time of year. If you live in the south, your weather may not be so cold, but usually your growing season has ended.

Of course, if you live in the southern hemisphere, you are beginning summer!

Draw pictures of what you do indoors this time of year, as it relates to the season:

December 15

Stories of Winter indoors:

We put out lights, candles, sprays of holly, and flowering narcissus and poinsettias to help us live in these dark days.

Max + Cleo romp all over the house, unable to go outdoors –

We make paper snowflakes, paper chains for the tree, and bake cookies

♀ house finch

activity outside on our balcony

Thanksgiving corn

Recording Daily Sequences

If you record regularly and return to reflect on your earlier observations, your journal becomes a rich resource for detecting nature's ongoing changes, day by day, season by season, year by year. Here I created a sort of chart, tracing the flow of daylight and darkness. By December in the Northern Hemisphere, the early sunsets, long nights, changing daily moon phases, and weather and temperature fluctuations can be fun to reflect on. Come early January, the days may be the year's coldest, but the nights are also getting shorter as you move inevitably toward spring.

Whether you live in the North, South, East, or West, or even below the equator, seasonal changes influence how you spend your time. Whether we notice or not, we are always all part of these cycles. In the North, winter has us spending more time indoors, bundling up to go outside, shoveling snow, and enjoying the glow of festival lights. Create a drawing or prose journal page of what a particular day of the year means to you.

A WATCHFUL EYE, a little extra attention to detail, and a sharpened sensitivity to seasonal changes can uncover a veritable Serengeti park just beyond the bedroom window. All you have to do is learn to see.

There is a popular belief abroad and in this country that holds that the most interesting things in the natural world can only be found in faraway places or specifically designated areas.

— John Hanson Mitchell
A Field Guide to Your Own Back Yard

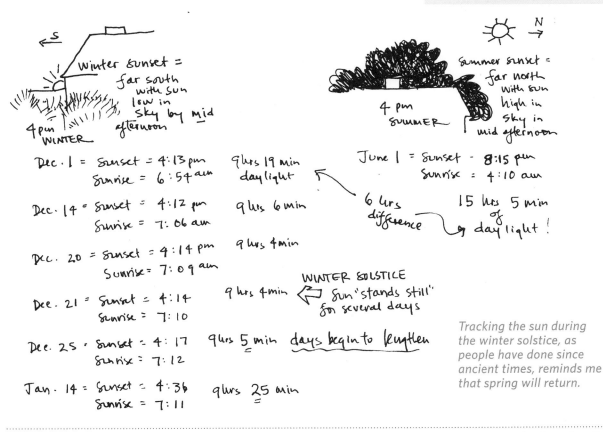

Tracking the sun during the winter solstice, as people have done since ancient times, reminds me that spring will return.

DAILY EXCEPTIONAL IMAGES

For years, I have made a habit of looking for Daily Exceptional Images (DEI) — some gem from the outdoors that I can latch on to when feeling distracted, dulled by routine, or deeply worried. As I worked on this third edition in 2020, it was an intense time of viral pandemic and global awareness of racial and political injustice, which I documented in my #55 nature journal. No matter what is going on, noticing the world around us, even — or especially — in the midst of despair, grief, anger, or just boredom, can shift our moods and rebalance a day seemingly going wrong. Of course, these images can also enhance moments of peace, happiness, and gratefulness.

When my mother was dying and my children were too young to understand, I needed lots of these moments, these gems. It was the whole string of them that kept me strong enough to be with my mom and care for my kids with a three-hour drive between them. To this day, I have no idea where the term "DEI" came from. It began back in that summer of 1993 and has continued, always giving me jump starts of gratefulness.

As I've grown older and learned to cope with more sadness, more loss, it has become more and more important for me to seek out these moments of reassurance that at least in the world of nature, all continues on. These Daily Exceptional Images are free, easy to find, take no talent, and are always there.

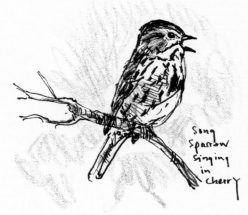

DAILY EXCEPTIONAL IMAGES - Begun Aug 1 Granville

(Drawn/written from memory, at day's ending)

As a daily ritual, pacing me through the coming tough days of my mother's dying. I cling to these like a fulcrum balance!

8·16- Jeweled raindrops hanging upside down on a pine beside food store. In drawing/seeing I can breathe again evenly!

8·17 - Heard odd cheeping - sounds from back room in post office Rochester! ! ! Asked - A large box of almost 50 chicks arrived from Pennsylvania for Valerie Brown's chicken farm! Chirps sent us all laughing...

8·18 - As I drove home from teaching in Woodstock, a broad-winged hawk flapped down to pluck out from road edge what seemed like a vole. So close I caught glint in its eye! What does it know of life?

8·19 - ♀ bluebird alighted on top of wood lawn chair over at Bread loaf. Terry Tempest Williams + I were talking of losing mothers and hard pain, when along came this spark of blue and momentarily set us a fire.

8·20 - Raining off + on. muggy. dense cricket sounds. Roads awash in puddles. Today I learned my mother has terminal cancer and the weeks are few left. What do I look for to hang onto today? Mists washing low gray over darkened mountains - ah, a lone raven circles - High over mists below.

8·23 - ☽ Waxing summer moon rises to E over highway and MacDonalds where we eat on way back from hospital. Later, a bat winks past car as we pull into driveway.

8·24 - Eric + Anne fall asleep. I can't. Sit on steps listening to deep throb of meadow crickets. Even pulse joins my breathing. Coyotes barking.

8·27 - What was the image today? Anna chose it. A crimson rose, so sweet smelling, down in Molly + Bobbi's garden. My mother's favored perfume.

8·28 - Talk with my mother over the phone as the moon full is rising over our ridge. She asks what it looks like. I describe the image and we both know the years we have watched that rising orb together - and will keep watching for many years more...

A Story today - Thurs Aug 15
Cambridge

→ Moral of which:
Never go erranding
w/ out binoculars!

2:30 pm 86° sunny
Walking down Frost
towards intersection
with Roseland
I hear a familiar-
but out of place-
loud and distinct
"Kli-Kli-Kitty"
"kli-kli-kli-kli-kli"
(Dave Sibley)
Not RTH & very
persistent

Z off taking
Z to H+L
etc 5pm

Get down to Lesley U.
parking lot when on
top of a lamp post

could see
th distinct
sideburn
markings

American
Kestrel

excitedly
moving body
up + down
while calling

wondering if it
wasn't well, I stood
near & clapped my hands.
Off it flew over rail tracks
into Somerville.
Nesting where?
who was the
mouse for?

Not interested in
pigeons or starlings
passing over

molting
tail feathers

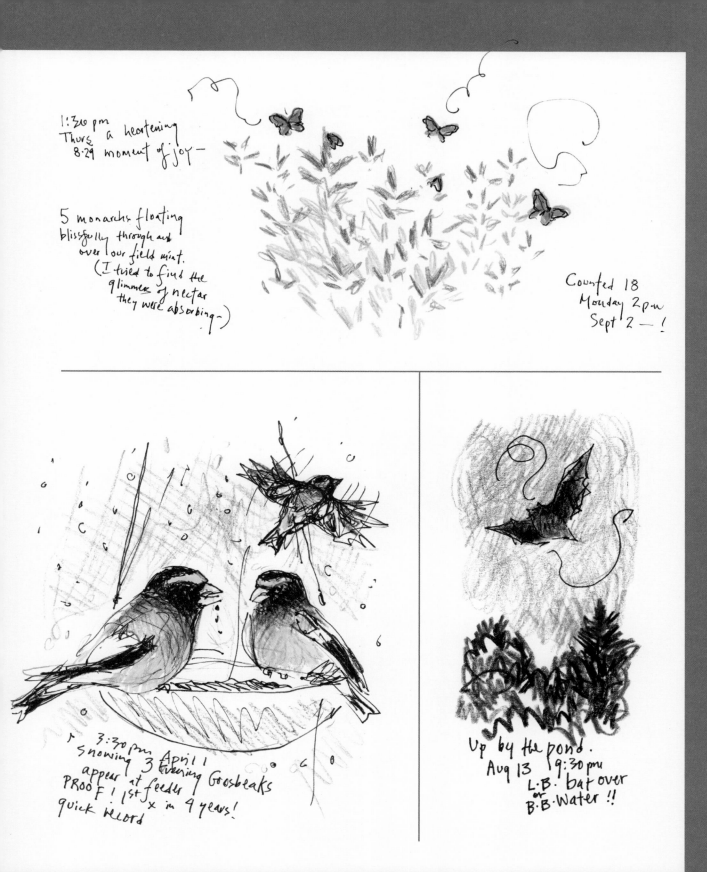

1:30 pm
Thurs a heartening
8·29 moment of joy —

5 monarchs floating
blissfully through air
over our field mint.
(I tried to find the
glimmer of nectar
they were absorbing—)

Counted 18
Monday 2 p·m
Sept 2 — !

3:30 pm April 1
Snowing 3 Evening Grosbeaks
appear at feeder
PROOF ! 1st x in 9 years!
quick record

Up by the pond.
Aug 13 9:30 pm
L·B· bat over
or
B·B· Water !!

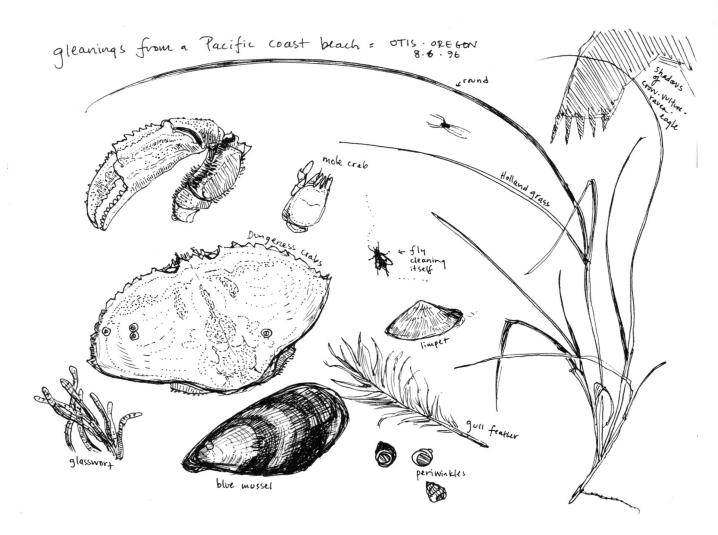

gleanings from a Pacific coast beach = OTIS · OREGON 8·6·96

ground

shadows crow · vulture · raven · eagle

mole crab

Holland grass

← fly cleaning itself

Dungeness crabs

limpet

glasswort

blue mussel

gull feather

periwinkles

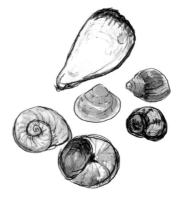

Look at the Details

A fun project is to gather five or six objects when you're out roaming on the beach, through the woods, or along the side of a country road. Back indoors, when you have a few moments, draw them in your journal. I may do this after finishing dinner, while others are watching TV, or even while talking on the telephone. This is a good opportunity to draw more carefully while looking at the details of each object. Take no more than 5 or 10 minutes per drawing. (See chapter 3 for more about drawing, especially doing blind and modified contour drawings to warm up.)

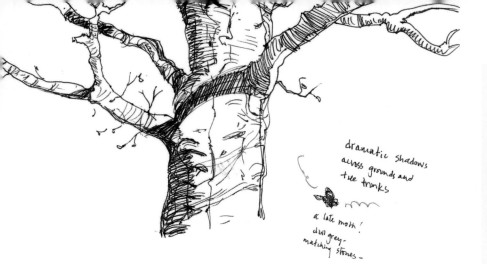

dramatic shadows
across grounds and
tree trunks

a late moth!
dull grey-
matching stones –

* July 20
Lonesome Lake Hut
AMC
Franconia Notch
NH 1·15 pm
partly sunny
68°

<u>birds</u>
chickadee
parula + btg warblers
wt sparrow
r·eye
vireo
winter
wren
raven
hawk –
merlin?
raven

Take a Hike

Yes, it is a challenge to draw and make notes while hiking or standing up, especially if conditions are cold, wet, or buggy. Rather than carrying your main journal, take a small one or even a few sheets of folded paper. Make quick notes that you can transcribe later.

While you're walking, stop and draw what first catches your attention that is less than 3 inches in size. Then draw objects from different levels: ground, waist-high, treetop, or sky levels. The time you take for each level will depend upon your intention and curiosity.

You can also make a quick drawing of a location, with a list of the elements you notice before moving along. Later, you can make more detailed drawings from a field guide and add them to your journal entry.

Drawn along the trail

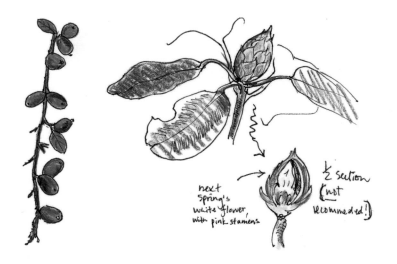

next
spring's
white flower
with pink stamens

½ section
(not
recommended!)

Tuesday April 18
A Cambridge Spring Walk
1:50 - 3:30 pm
(Flung off all the indoor stuff
to get out - endless e·mails etc...)

Sun. balmy. lovely ☀
people out about coats...
Workers scraping house paint
everywhere

Cardinal strong call

Up Lancaster Street ↘

Sitting on a stool up
Sun on my back - moving
up into North of sky
Calm sitting

○ waning moon
Sunrise = 5:58 am 13½ hrs
Sunset = 7:29 pm light!

blue sky
Sun
little clouds

Norway maple
flowers out

late
winter
shadows

honeysuckle

dogwood

crimson

forsythia
gorgeous

huge bees
are out +
about!

cabbage
butterfly

×2
inspecting
my paper

Nature in the City

Even in urban spaces, you can note signs of the season: sky condition, position of the sun, type of vegetation and stage of growth, animal evidence and survival. I made these drawings during a 45-minute session with a group of elementary school-children in Cambridge, Massachusetts. All were amazed at how much nature could be found right around the schoolyard. Journaling is a great way to confront unfounded fears about nature as well. Once the children spent time drawing and learning about earthworms, they were no longer afraid of them.

buds getting bigger

Norway maple

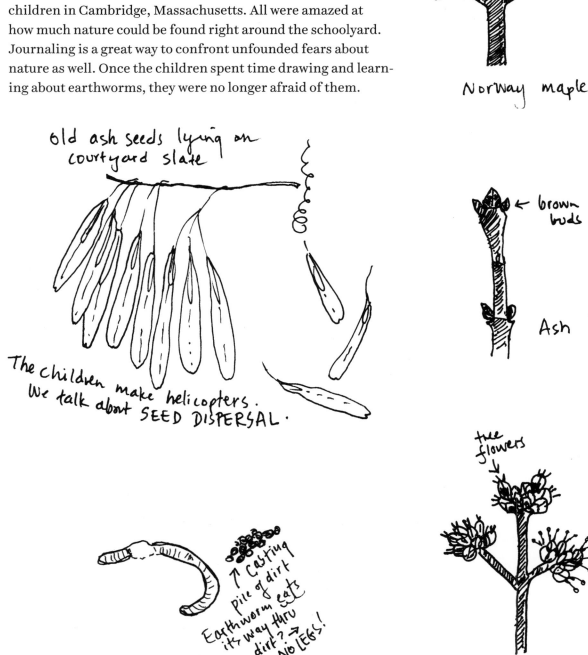

old ash seeds lying on courtyard slate

The children make helicopters. We talk about SEED DISPERSAL.

← brown buds

Ash

tree flowers

↑ casting pile of dirt
Earthworm eats its way thru dirt? → NO LEGS!

Silver maple

Walk around the Block

Take a walk in the same place once a week and record changes over a month, several months, a year.

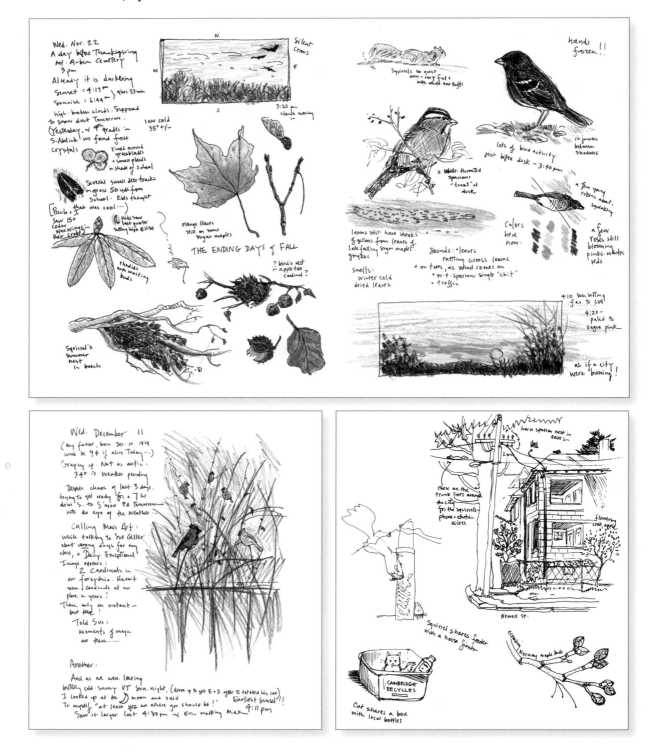

Appreciating Home

Devote a journal page every now and then to reflecting on what is happening in and around your home. You might record your thoughts of the season, changes you see in your yard and nearby surroundings, or what has been happening to you and your family over the past month, week, or day. These pages are fun to refer back to and reflect on over the year, just like a page of old family photos.

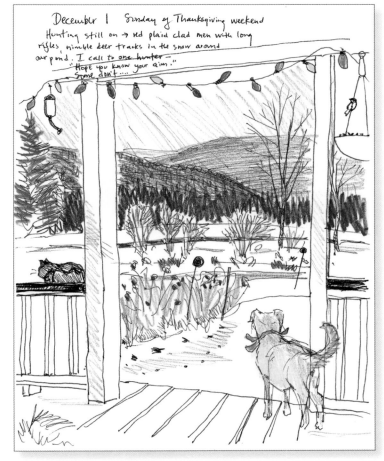

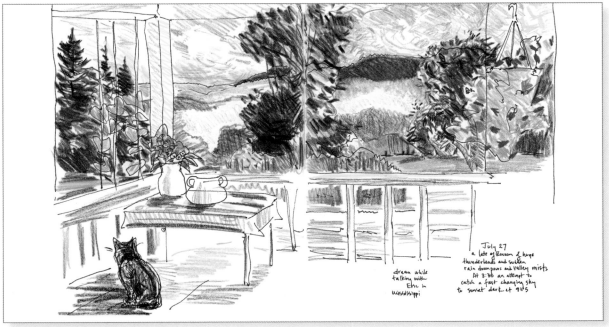

Make Your Journal Your Sidekick

Keep your journal by your side as much as possible, no matter where you are or what else you are doing. You never know when an opportunity will arise for observation and recording. It might just be a fleeting moment when you happen to look up at the sky or stop to take a deep breath and stretch your legs. While on a three-day writing retreat near Cape Cod, I had my journal resting near the window and was able to quickly record the view across the saltwater and this pheasant marching through the field. (Citizen science note: Pheasants are no longer found there.)

glaucous gull
in harbor—
2nd winter

all white!

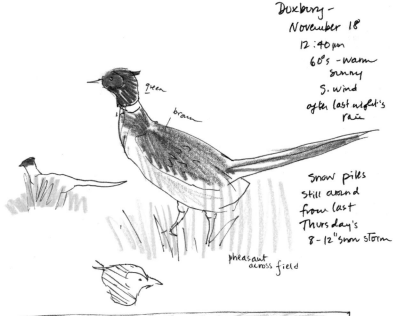

Duxbury—
November 18
12:40 pm
60's—warm
sunny
S. wind
after last night's
rain

green

brown

snow piles
still around
from last
Thursday's
8–12" snow storm

pheasant
across field

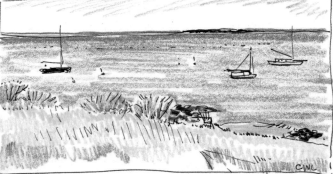

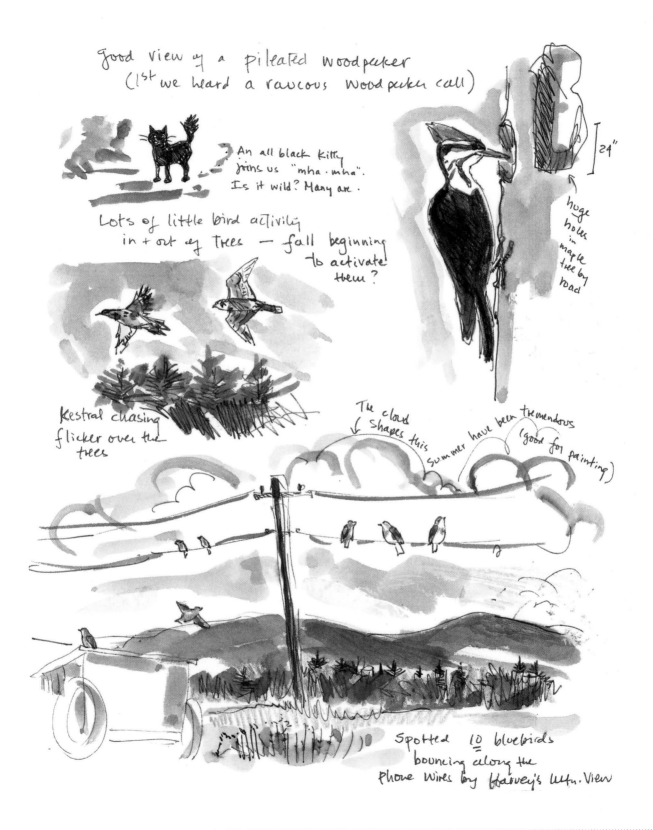

Good view of a pileated woodpecker
(1st we heard a raucous woodpecker call)

An all black kitty joins us "mha·mha". Is it wild? Many are.

Lots of little bird activity in + out of trees — fall beginning to activate them?

Kestral chasing flicker over the trees

24"

huge holes in maple tree by road

The cloud shapes this summer have been tremendous (good for painting)

Spotted 10 bluebirds bouncing along the phone wires by Harvey's Mtn. View

SEASONAL GUIDEPOSTS

A seasonal journal is essentially your personal record of riding planet Earth through one annual journey around the sun. That journey takes us past four key marker points — the two solstices and two equinoxes.

Within each of these periods, there are always natural objects and events to observe and record. See the box below for some ideas of natural activities, objects, and changes to study at various points in the year. These are general suggestions that I use for where I live in New England. You may wish to add your own, depending on where you live and what your interests are.

SUBJECTS TO OBSERVE, DRAW, RECORD THROUGHOUT THE SEASONS

SEASON	BIRDS	ANIMALS	
AUTUMN	• Observe change in activity and preparations for winter or migrations south among starlings, hawks, geese, shorebirds. • What fruits are robins, mockingbirds, and sparrows eating?	• Look for signs of winter preparations, including butterfly and dragonfly migrations, and changes in cricket, cicada, and grasshopper calls. • Salamanders, slugs, spiders, sow bugs, and fish all head for dark places.	
WINTER	• What birds stay through winter, and where can you find them? • Observe the habits of feeder birds: cardinals, house sparrows, mourning doves, blue jays. • Look for wilder birds: owls, hawks, turkeys, ducks, vultures, crows.	• What creatures stay active? • What do they eat? • What creatures disappear to hibernate or die? • Observe animals that are active: houseflies, spiders, centipedes, rabbits, red and gray squirrels, foxes, raccoons, deer, elk, and moose. • Look for tracks in the mud or snow.	
SPRING	• Watch for the first birds returning from the south: bay and sea ducks, warblers, sparrows. • Observe activities of nearby nesting birds: starlings, house sparrows, crows, robins, cardinals.	• Focus on the birth, awakening, or return of butterflies, earthworms, chipmunks, insects, frogs and toads, salmon, herring, caribou, many birds.	
SUMMER	• Learn to identify birds by their calls and habitats. • Read bird guidebooks and practice drawing bird shapes: blue jay, chickadee, magpie, red-tailed hawk, song sparrow, mallard duck, herring gull, common loon.	• This is the height of productivity for frogs, toads, snakes, salamanders, turtles, spiders, and earthworms. Document who is doing what. • Focus on night sounds: crickets, owls, mice. • Learn your local animals and draw them, learning about their habits.	

PLANTS AND TREES	WEATHER, SKY, LANDSCAPES	SEASONAL CELEBRATIONS
• Which plants bloom the latest: asters, goldenrod, chicory, marigolds, or butter-and-eggs? • What trees and shrubs lose their leaves, turn colors? • Observe and draw the varieties of tree seeds, nuts, and fruits.	• Watch for weather changes. • Draw cloud shapes, sunsets, rain patterns. • What sounds in nature are changing? • Notice when the days start to become shorter where you live. • Draw a little landscape scene showing tree shapes and color changes.	• Autumnal equinox • Sukkot • Halloween • Thanksgiving Day • Fall festivals • Year's End in Celtic calendar
• Draw silhouettes of winter trees. • Observe the twig, leaf, and flower bud shapes on deciduous trees. • Observe the seeds and cones of evergreens. • Observe the leaves and buds of broad-leaved evergreens.	• Focus on weather changes. • Draw snowflake shapes. • Observe rain patterns. • Record moon phases. • Draw constellation shapes. • Days get longer after December 22. • Draw a little landscape scene showing the tree and land shapes this time of year.	• Winter solstice • Hanukkah • Advent and Christmas • Kwanzaa • Winter and New Year festivals • Groundhog Day
• Look for the first flowers. In the North: spring bulbs of crocus, snowdrop, daffodil. In the South: cactus, amaryllis, poinsettia. • Record the first leaves and tree flowers you see. • Draw sequence of flowers blooming, in high to low elevations.	• Record signs of warm- and cold-weather changes, such as rain- and snowfall, mud conditions, and temperature fluctuation. • Look for animal tracks in mud. • Days get noticeably longer after March 21 or 22. • Draw a little landscape scene showing early signs of spring in trees and land.	• Vernal equinox • International Earth Day • Easter • Passover • May Day • Spring planting festivals • First day of summer in Celtic calendar
• Record the productivity of backyard gardens, parks, abandoned lots, fields, and meadows. • Plant your own garden and draw and record its growth. • Get out a field guide to plants and learn to identify what's growing where.	• Use your local newspaper, radio station, TV, planetarium, and almanacs to learn about weather. Document the weather daily for a month. • Days are getting shorter after June 21 or 22. • Draw a little summer landscape.	• Summer solstice • Native American Sun Dance ceremonies • August 1 is Lammas, fall in the Celtic calendar • International harvest festivals

A SAMPLING OF JOURNAL STYLES

Tuesday, October 23, 2018 @ 7:41 am Our 1st day at Little St. Simon Is,
69° 88% N 6 mph Georgia w/ Cornell Lab of
Ornithology from Sapsucker Woods
in Ithaca, NY

At beach/tidal pools there are
piping plovers and sanderlings
A bald eagle sits on driftwood...
There are numerous horseshoe crab molts
of varying sizes

8:15 am: A huge flock of swallows overhead
as we leave the beach and head to maritime forest with
10:15 am live oaks dripping w/ Spanish moss (not Spanish or moss
rather an epiphyte; an important nesting material for bats and
parula warblers. This forest is not native; was a sandbar &
the plants floated in. Red Bay/sweet bay
produces bayberry which is good forage
for birds. Ambrosia beetles are infecting
them with a fungus. It doesn't affect
the root ball but regrowth doesn't get
big enough to flower & fruit. There
is more interest in combatting
them because they also
infect avocado trees.

Armadillos are not native;
they burrow; are a host for leprosy. They
have bad eyesight & hearing but excellent
sense of smell

28-30. Blue winged
teal & pied-billed grebes on the
Altamaha River. Low webbing
is positioned to back of body;
it makes them very good
swimmers & very poor walkers.

hunkered down
black-crowned
night heron in
heavy rain

Great
Egret

spoonbill

Tall wading birds that are
colonial seem to like to nest
in alligator habitat... gators
serve as "bouncers" for
predators.

Wood Stork

Jeannine Reese; *Sanford, North Carolina*

Some of my teachers, colleagues, and students from over the years have generously shared examples from their own journals, demonstrating the wonderful diversity of nature journaling.

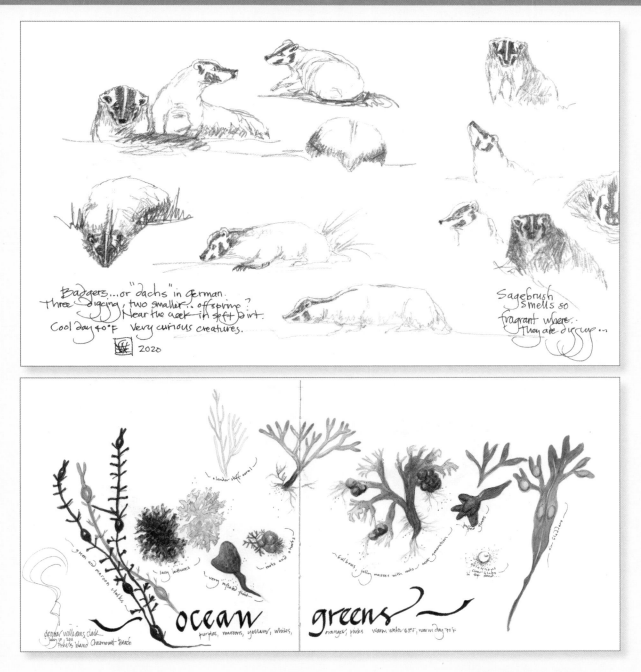

Eleanor Clark; *Bozeman, Montana*

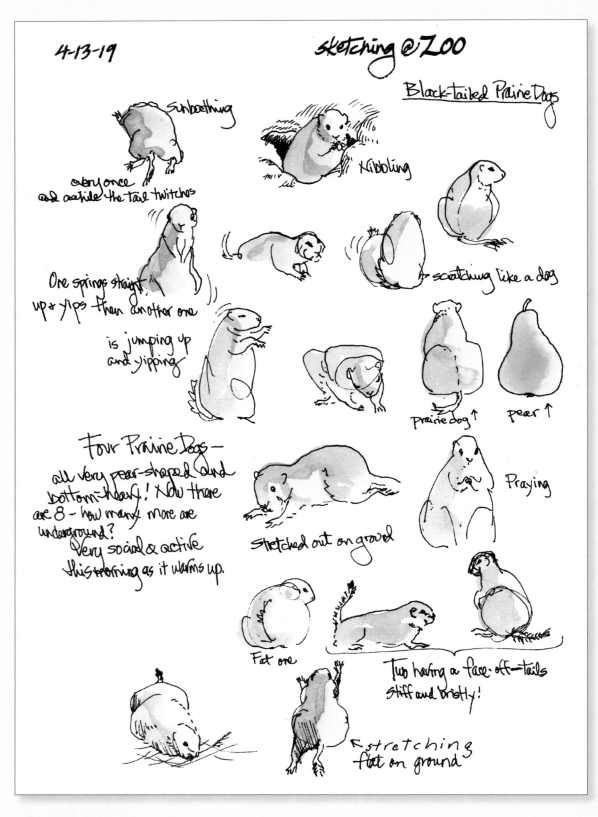

4-13-19

sketching @ ZOO

Black-tailed Prairie Dogs

Sunbathing

every once and awhile the tail twitches

Nibbling

One springs straight up & yips then another one

is jumping up and yipping

scratching like a dog

Prairie dog ↑ pear ↑

Four Prairie Dogs — all very pear-shaped and bottom-heavy! Now there are 8 — how many more are underground? Very social & active this morning as it warms up.

Stretched out on ground

Praying

Fat one

Two having a face-off—tails stiff and bristly!

R stretching flat on ground

Margy O'Brien; *Albuquerque, New Mexico*

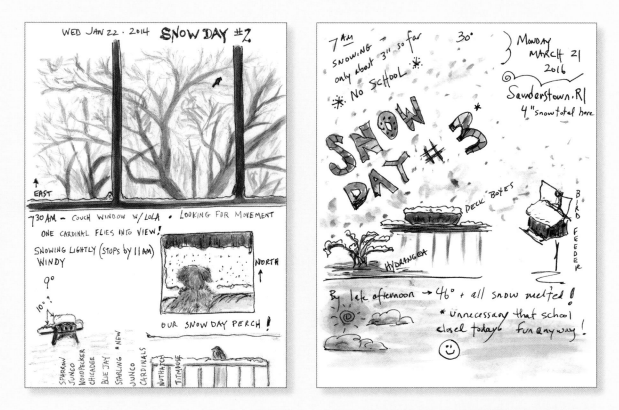

Karen D'Abrosca; *Saunderstown, Rhode Island*

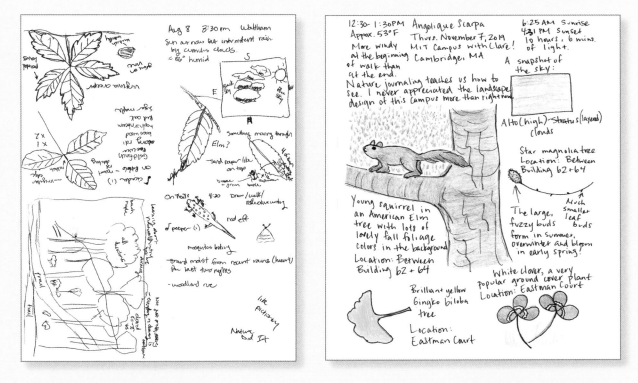

Lisa Sausville; *Vergennes, Vermont*

Angelique Scarpa; *Watertown, Massachusetts*

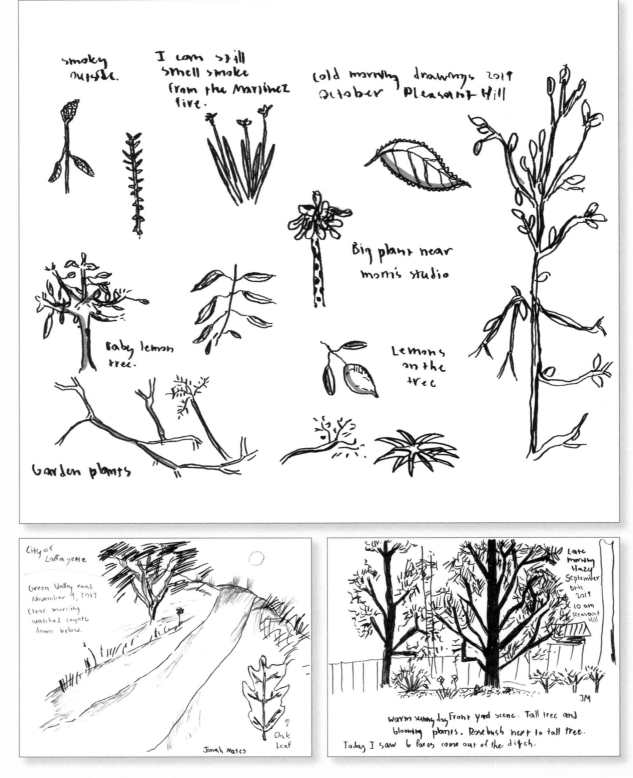

Jonah Mateo (at age 10); *Pleasant Hills, California*

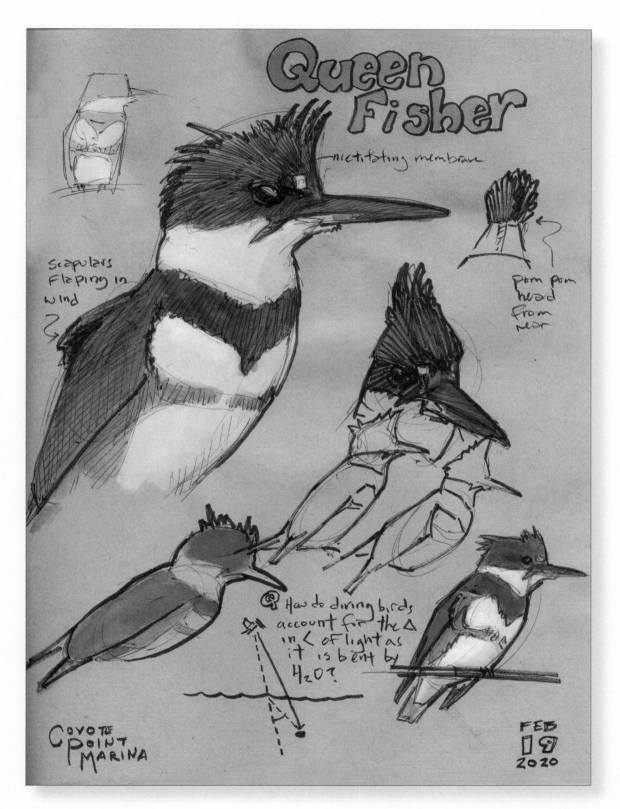

Queen Fisher

nictitating membrane

pom pom head from rear

Scapulars Flaping in wind

@ How do diving birds account for the Δ in < of light as it is bent by H_2O?

COYOTE POINT MARINA

FEB 19 2020

John Muir Laws; *San Mateo, California*

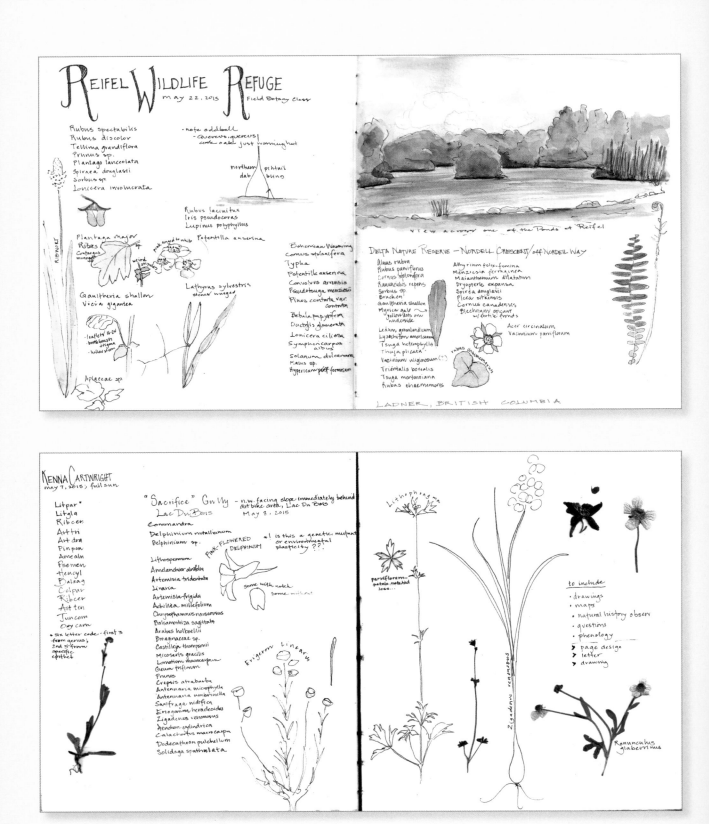

Lyn Baldwin; *Kamloops, British Columbia*

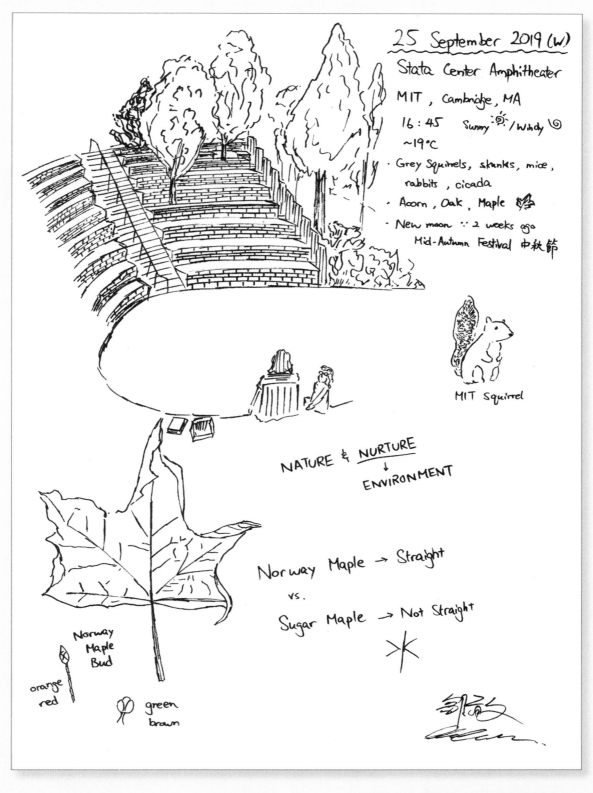

25 September 2019 (W)

Stata Center Amphitheater
MIT, Cambridge, MA
16:45 Sunny / Windy
~19°C
· Grey Squirrels, skunks, mice, rabbits, cicada
· Acorn, Oak, Maple
· New moon ∴ 2 weeks ago
 Mid-Autumn Festival 中秋節

MIT Squirrel

NATURE & NURTURE
↓
ENVIRONMENT

Norway Maple → Straight
vs.
Sugar Maple → Not Straight

Norway Maple Bud

orange red

green brown

Chun Man Chow; *Cambridge, Massachusetts*

Maria Hodkins; *Paonia, Colorado*

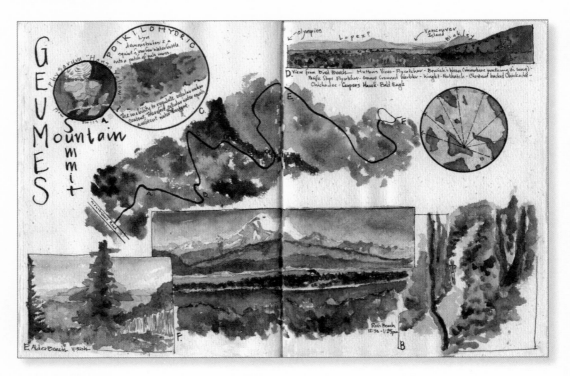

Rebecca Ries-Montgomery; *Eugene, Oregon*

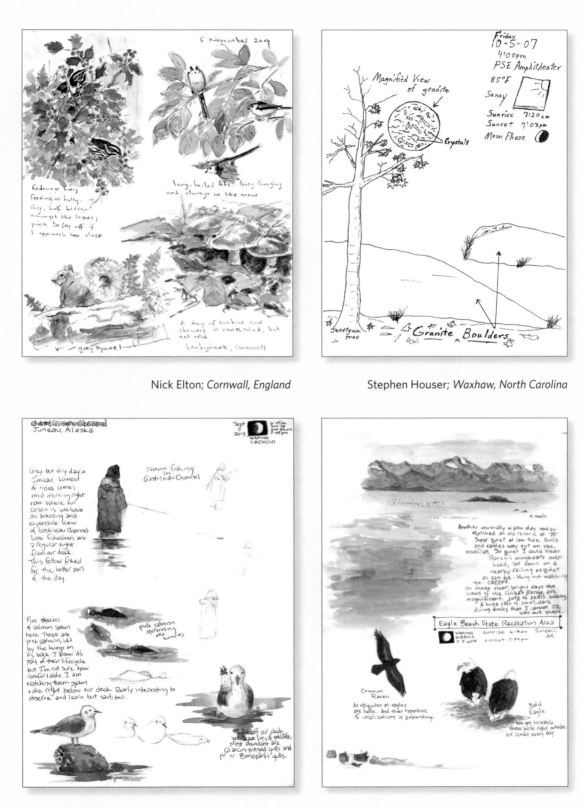

Nick Elton; *Cornwall, England*

Stephen Houser; *Waxhaw, North Carolina*

Sandy McDermott; *Intervale, New Hampshire*

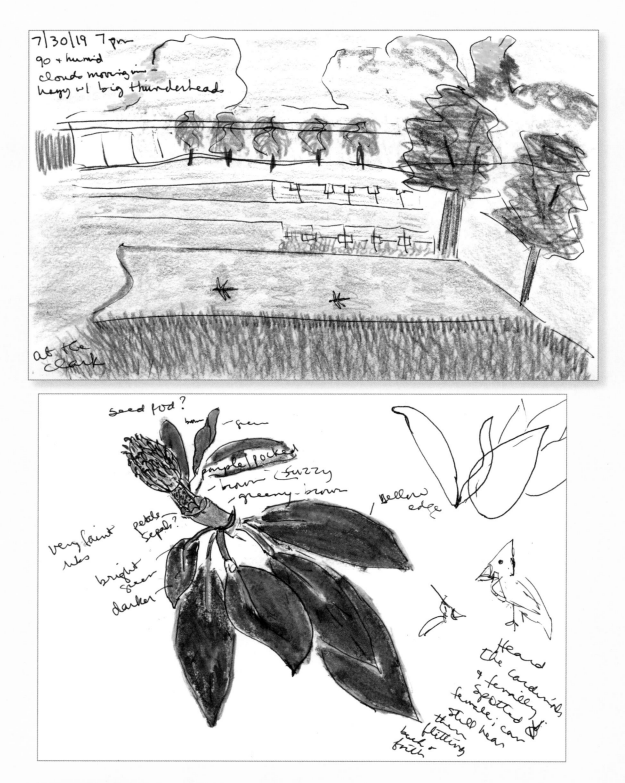

Lisa Hiley; *Williamstown, Massachusetts*

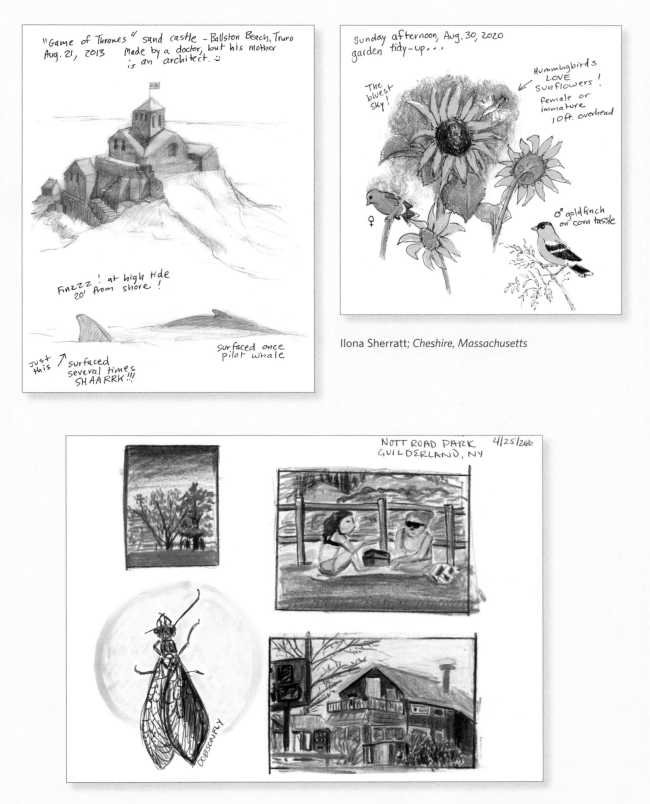

Ilona Sherratt; *Cheshire, Massachusetts*

Ash Austin; *Guilderland, New York*

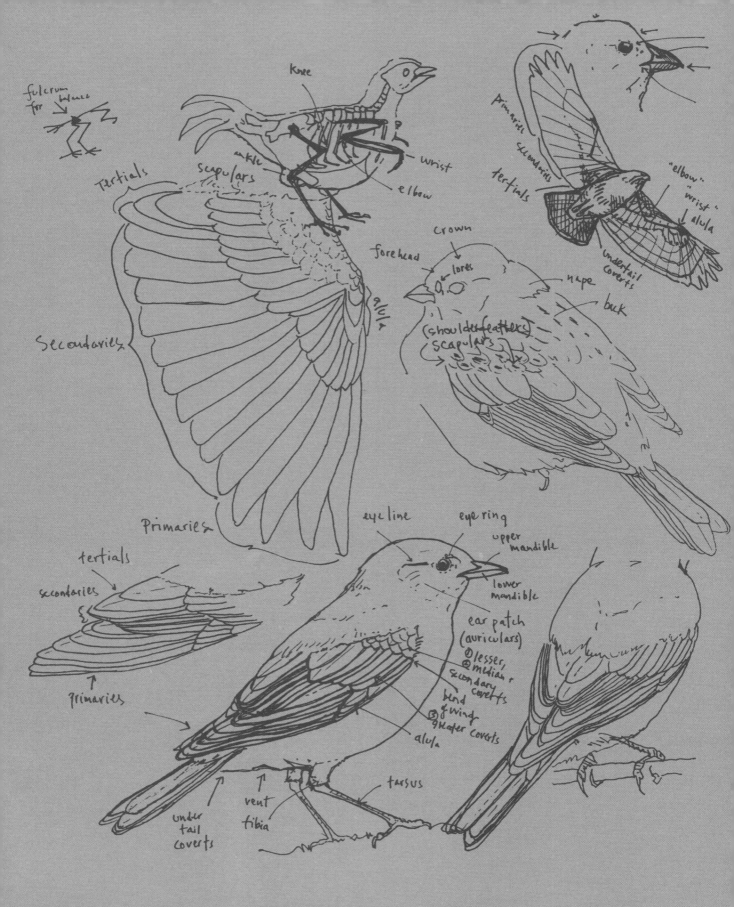

JOURNALING EXPLORATIONS

The artist's eye does have several advantages
over the camera: focus is not a mechanical problem
but a matter of thought and concentration.

— John Busby, *Nature Drawings*

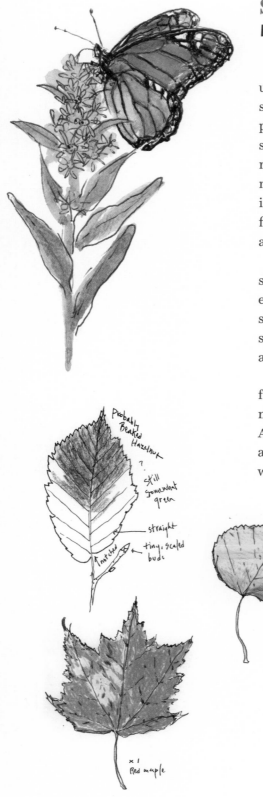

Studying the World around You

The wonderful ongoing adventure of nature journaling is learning about what you are drawing. Even more than becoming an artist of nature, you are becoming a naturalist. Your drawing reinforces your learning. In redrawing some crocuses for this book when none were in bloom, I checked photos and discovered that they have six petals, not five, and the stems are not colored as I had them. After drawing bobolinks one morning, I wanted to know where they spend their winters — northern Argentina! A quick sketch of a tree swallow in the field is one thing. Back home, I improve that sketch by referring to a field guide or online images to accurately capture their plumage and wing shape.

As you learn, you may find yourself drawn to a particular subject: birds, grasses, the shapes of different trees. It's fun to explore one topic in depth. This chapter lays out in more detail some techniques for drawing different subjects: the weather and seasons; plants and trees; birds, mammals, and other animals; and landscapes.

The main points I make when teaching are always to have fun; don't stress out about being a good artist; and realize this is more about seeing what you're looking at than drawing it well. All of this nature drawing and nature study can be done anytime and however you want. Of course, as anyone will tell you, practice will make you better at both.

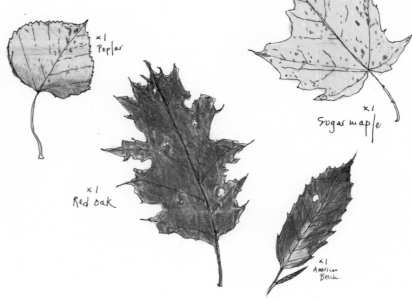

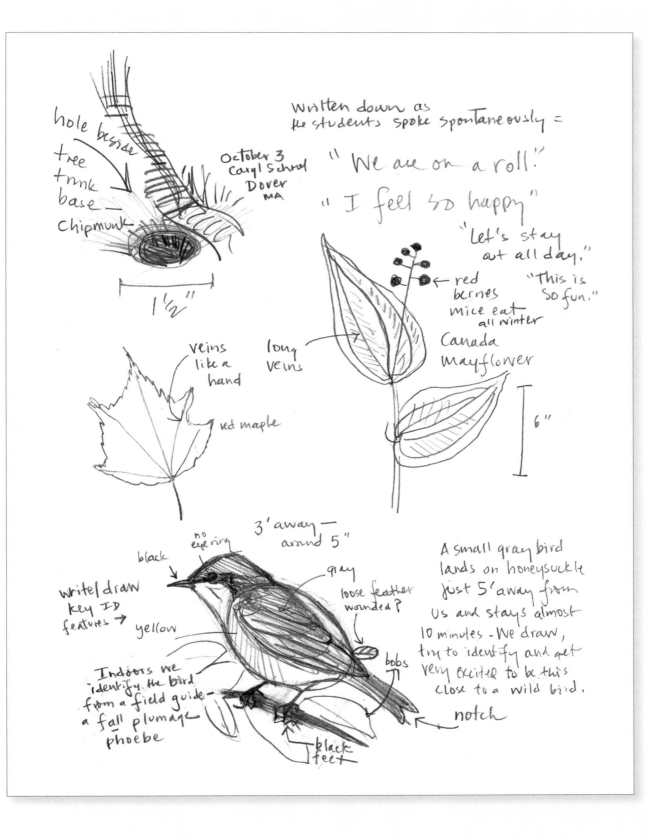

hole beside
tree
trunk
base
chipmunk

1½"

October 3
Caryl School
Dover
MA

Written down as
the students spoke spontaneously =

"We are on a roll."

"I felt so happy"

"Let's stay
out all day."

"This is
so fun."

← red
berries
mice eat
all winter

Canada
mayflower

6"

veins
like a
hand

long
veins

red maple

3' away —
around 5"

no
eye ring

black

gray
loose feather
wounded?

write/draw
key ID
features →

yellow

bobs

Indoors we
identify the bird
from a field guide—
a fall plumage
phoebe

A small gray bird
lands on honeysuckle
just 5' away from
us and stays almost
10 minutes - We draw,
try to identify and get
very excited to be this
close to a wild bird.

notch

black
feet

SEASONS AND SKY

Keeping track of the cycle of the seasons is perhaps the most obvious theme conducive to keeping an ongoing nature journal. The advantage of keeping a season-focused journal is that you can watch what changes through the months and notice how much stays the same, despite disruptive weather patterns and global climate change. The seasons always begin again, with the same pattern but different details.

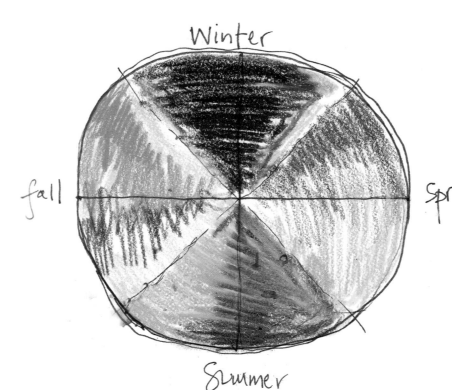

The keys to keeping a seasonal journal are to choose objects or places that are bound to go through regular change, and to set a goal of routinely recording what you see, in as much detail as you want. This can be as simple as watching a tree in your neighborhood and noting all the ways it changes through a year. Without going into detail, everything depends on the sun and our relationship to it. We have seasonal changes because our planet revolves around the sun every 365 days. As it travels through its orbit, the earth rotates every 24 hours at an angle of 23½ degrees. As we advance in this orbit, day and night lengths are always becoming either longer or shorter as the globe tilts away from or toward the sun. And, of course, the amount of light depends on where on the planet you are: Northern or Southern Hemisphere or the equator.

Climate Issues

Increasingly we are aware that weather not only impacts our individual lives but also impacts everything around us. Weather patterns are shifting as the planet's climate changes. It is important to note here that "weather" means local and short-term conditions. "Climate" means longer trends over longer periods of time and over our whole world.

I started keeping my journals in 1978, but not until the early '90s did I begin entering information about climate shifts. Now I am recording it more frequently, noticing how my local New England weather, seasons, animals, and plants have been slowly changing. Such small but vital data will be increasingly important in predicting conditions for my grandchildren.

I love going back through the pages of my journals and seeing that, yes, the seasons *do* advance and retreat and come back again. In comparing my notes from January 1984 and January 2006 and January 2020, I can review and reflect on happenings in nature as well as in my own life.

January sleeps dark

February finds one light that brightens daily

March yawns + melts

April opens to growth

May chases its tail and won't stop

June's at the summit

July becomes the elder, chasing the kids away

August blesses the land

September reminds us winter is coming

October helps us forget

November closes shop

December completes the turning cycle

THE REASON FOR SEASONS

Because our planet is tilted on its axis, the amount of sunlight available to any one spot on Earth varies with the season, as does the intensity of its energy. This has obvious impact on the activity of living things at different times of the year.

Earth's tilt means that different parts of the planet get differing amounts of daylight as the annual journey progresses. This results in the seasons we know as winter, spring, summer, and autumn or fall. The tilt also is the reason these seasons are reversed in the Southern Hemisphere.

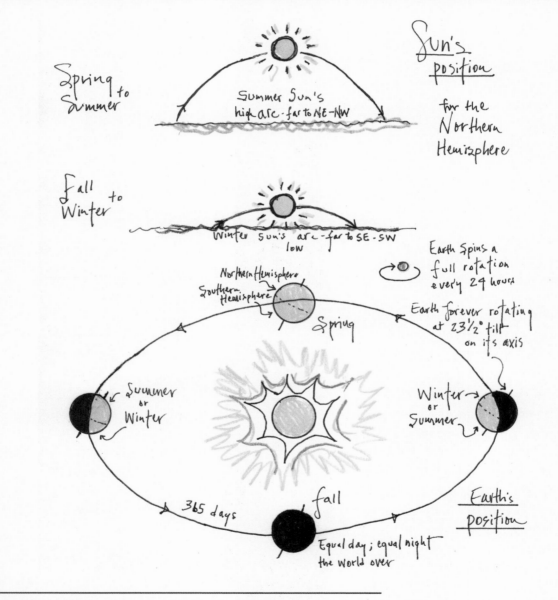

I often have students draw what I call "The Fried Egg" in their journal.

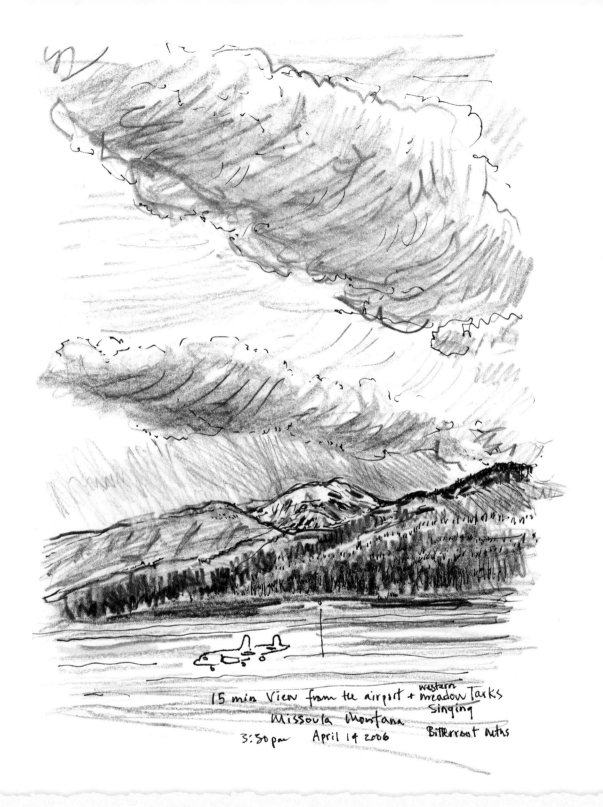

15 min View from the airport + western meadow Larks
singing
Missoula Montana
3:50 pm April 14 2006 Bitterroot mtns

One of my favorite quick drawings: unforgettable clouds while picking up
a rental car for a visit with my daughter at college.

The Moon

The moon is a constant in our lives, no matter where we live or what we are doing. Numerous cultures throughout history have governed their calendars not by solar but by lunar cycles. The phases of the moon are fun to record and easy for all ages to draw. (I find kids especially love to keep moon journals because it is something immediate they can notice.) The moon's changing shape follows the same sequence every day, every month, always rising in the east and setting in the west, repeating every 29 days.

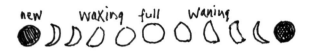

Waxing means to grow or enlarge. Waning means to shrink.

The path of the moon through our sky can be seen anywhere in the world. The shapes are opposite in the Southern Hemisphere — why?

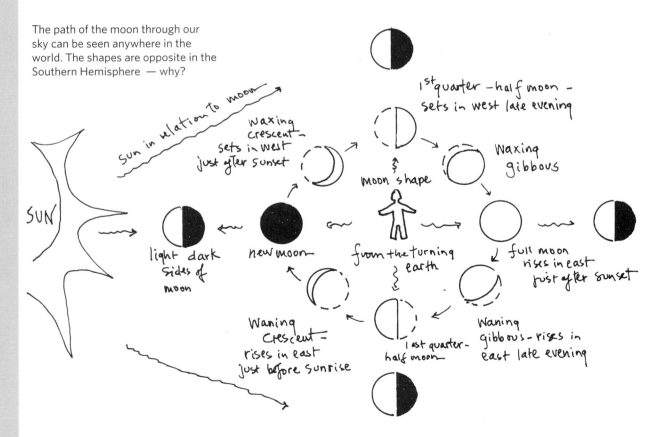

The changing shape of the moon is due to the changing position of the earth in relation to the sun and the moon. The dark side of the moon is the earth's shadow, which is blocking the reflected light of the sun.

The Sky and Sun

You can almost always see the sky, even if you're just looking out a window. Take a moment a few times a day to pause and find where the sun is (not looking directly at it, of course). How does its position change with the seasons? Recording daily sunrise and sunset times allows you to notice how they constantly change throughout the year. Notice that these times vary by longiture and latitude. Why is that?

1O MAJOR CLOUD SHAPES TO LOOK FOR

Cirrus
wispy, fair weather

Cirrocumulus
little clumps of
clouds in rows

Stratus
dense and layered

Stratocumulus
dense, layered,
piling clouds

Altocumulus
layers of rolled
clouds

Cirrostratus
low and layered

Altostratus
high and layered

Nimbostratus
layered, gathering
clouds with rain
or snow

Cumulus
puffy clouds

Cumulonimbus
thunderheads

Refer to a good field guide for
weather and clouds, or check online
sources, to learn more.

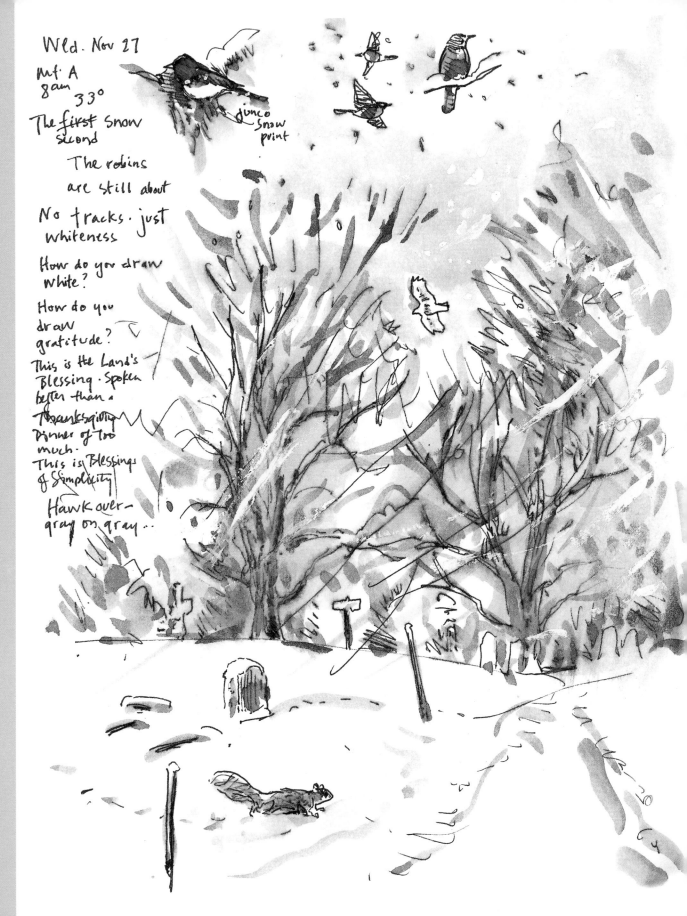

Wed. Nov 27

mt. A
8 am 33°

The first Snow
 second

 The robins
 are still about

No tracks. just
whiteness

How do you draw
 white?

How do you
draw
gratitude?

This is the Land's
Blessing. Spoken
better than a
Thanksgiving
Dinner of Too
much.
This is Blessings
of Simplicity

 Hawk over—
 gray on gray...

junco
Snow
print

These images were done sitting in my car with the wipers going. I used pen and watercolor, with white-out correction fluid for the snow!

FLOWERING AND NONFLOWERING PLANTS

Discover and draw different plants that grow in different habitats. This is a huge category to draw, but start with what comes your way, whether it is an indoor bouquet of flowers or a potted plant, flowers or vegetables in your garden, or a meadow full of wildflowers and grasses. Nonflowering plants include mosses, mushrooms, ferns, lichens, and the watery plants of algae, kelp, and the many ocean seaweeds.

You may be surprised at the variety of plants you find growing right in your own neighborhood.

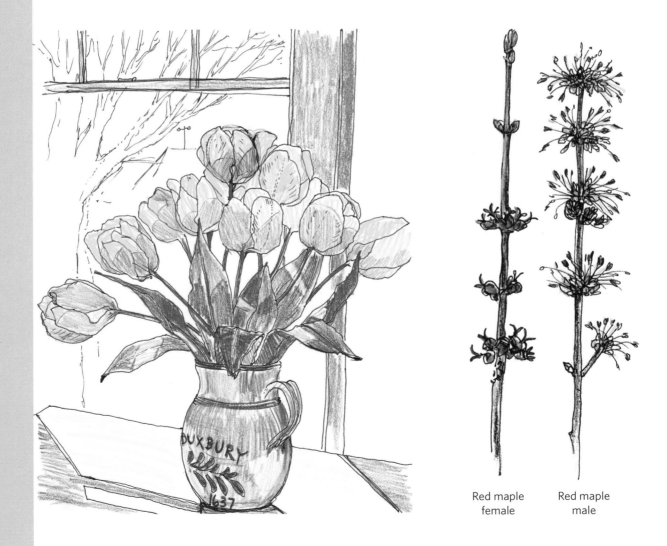

Red maple
female

Red maple
male

Drawing Flowers

Observe the basic shape first. I strongly suggest doing a modified contour drawing to help with the seeing process.

Look carefully at how the plant is put together and arranged. Where do the various flower parts or leaves or buds or fruits align or attach on the twig or stem? What parts are overlapping?

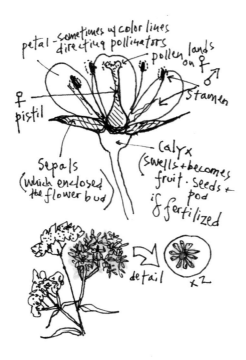

Keep the drawing simple. If you're doing a complex flower head, like goldenrod, ragweed, or aster, do only part of the whole. Refer to illustrations in plant guides or gardening magazines for ways to draw plants and flowers.

Gesture Sketch
5 seconds

Blind Contour Sketch
1 minute

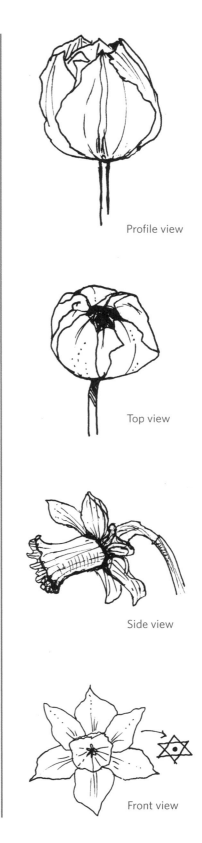

Profile view

Top view

Side view

Front view

Grasses

Focus on local grasses. You'll be surprised by how beautiful and varied they are. A field guide, such as *Grasses: An Identification Guide*, by Lauren Brown, can be helpful for learning such names as quack grass, reed canary grass, and brome.

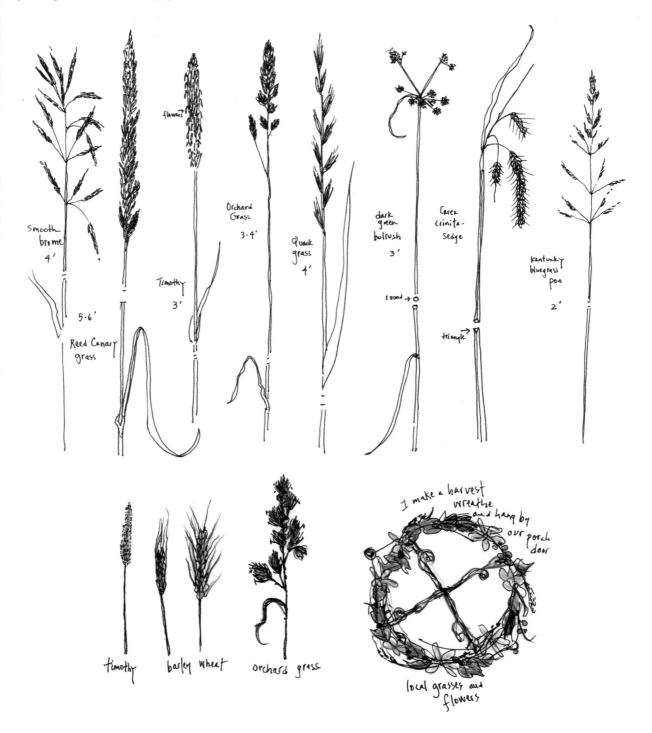

Smooth brome
4'

Reed Canary grass

5-6'

Timothy
3'

flowers

Orchard Grass
3-4'

Quack grass
4'

dark green bulrush
3'

round →

Carex crinita-sedge

triangle →

Kentucky bluegrass poa
2'

timothy

barley wheat

orchard grass

I make a harvest wreathe and hang by our porch door

local grasses and flowers

Mushrooms and Other Nonflowering Plants

The variety of plant life all around us is staggering. Once you start looking, you might develop a particular interest in fungi or lichen or ferns.

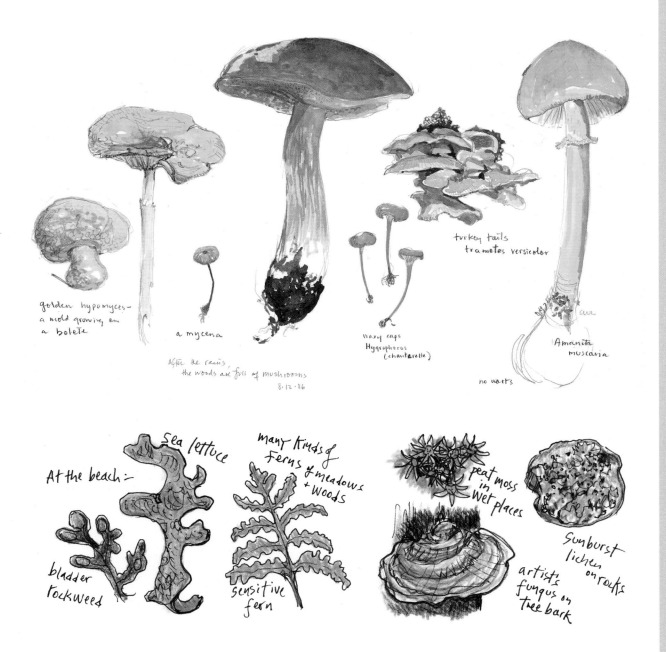

golden hypomyces—
a mold growing on
a bolete

a mycena

After the rains,
the woods are full of mushrooms
8·12·86

waxy caps
Hygrophorus
(chanterelle)

turkey tails
trametes versicolor

no warts

Amanita
muscaria

At the beach:—

sea lettuce

bladder
rockweed

many kinds of
ferns & meadows
& woods

sensitive
fern

peat moss
in
wet places

sunburst
lichen
on rocks

artist's
fungus on
tree bark

Top row: Pencil and watercolor drawings from actual specimens
Bottom row: Pen and colored pencil drawings from field guides

123

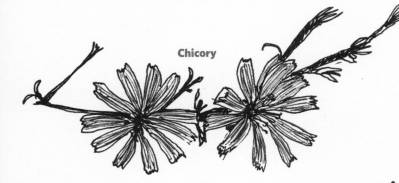

Chicory

WONDERFUL "WEEDS"

Weeds are basically wildflowers growing where people don't want them to. They are hardy, spread easily, and are often unglamorous. Many came here from Europe, hiding in grain bags or as household herbs; many were (and still are) used as food and medicine. These were all drawn in a small grassy patch at the end of our city street.

Common Plantain

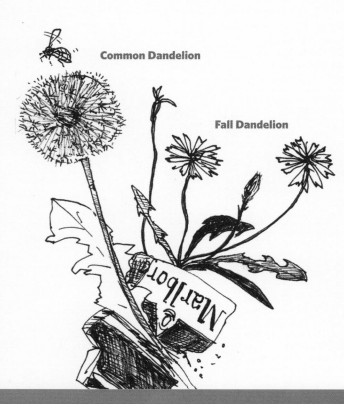

Common Dandelion

Fall Dandelion

Burdock

x³/₄

Many plants spread their seeds by prickers that catch on coats of animals and clothing of people

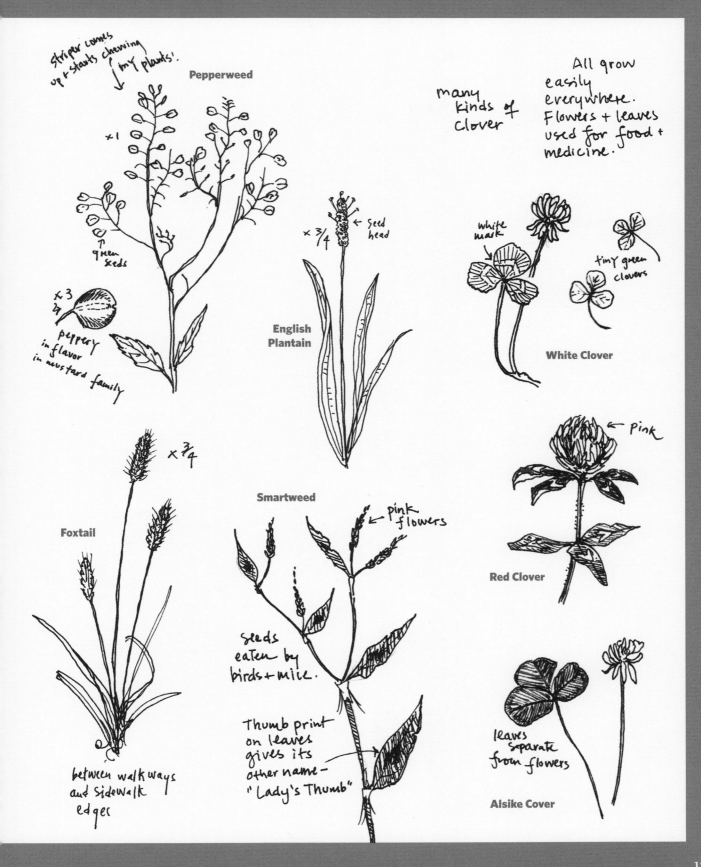

Striper comes
up + starts chewing
{ my plants!

Pepperweed

×1

↑
green
seeds

×3

peppery
in flavor
in mustard family

many
kinds of
clover

All grow
easily
everywhere.
Flowers + leaves
used for food +
medicine.

×¾
← Seed
head

**English
Plantain**

white
mark

tiny green
clovers

White Clover

×¾

Foxtail

Smartweed

← pink
flowers

Seeds
eaten by
birds + mice.

Thumb print
on leaves
gives its
other name —
"Lady's Thumb"

between walkways
and sidewalk
edges

← pink

Red Clover

leaves
separate
from flowers

Alsike Cover

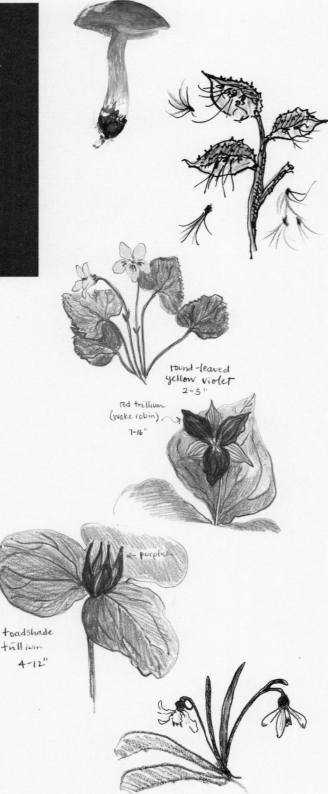

round-leaved
yellow violet
2-5"

red trillium
(wake robin)
7-16"

← purplish

toadshade
trillium
4-12"

AUTUMN PLANTS

What plants still have flowers; what have seeds? Look for late summer and early fall blooms. Keep a record of what plants are affected by first frosts. What insects are attracted to what late summer blooms? I love walking along our city street, noticing the bees, ants, and wasps foraging from fall blooming flowers as late as the end of October.

This is a good time of year for finding both lichens and mushrooms.

WINTER PLANTS

We may think that all outdoor plants are dead in the winter. Take an Adventure Walk and find out what is still green along your street or in the woods. What color is the grass? The seed pods of winter weeds are fascinating to draw. Look for milkweed, evening primrose, dock, burdock, chicory, and many grasses.

SPRING PLANTS

A fun project is to go out weekly with your journal and record the slow (or fast) advance of blooming bulbs: snowdrops, crocuses, squill, daffodils, grape hyacinths, tulips, and so on. This is a good citizen science project as bloom times are changing with the climate. You can participate in long-range data collections by recording your local bloom times.

SUMMER PLANTS

I admit, in the summer I am often busier planting vegetables and flowers than drawing them. However, garden journals can provide important information about planting times. Climatologists are turning to garden journals of the past to gather information on historic seasonal and climate changes in specific regions.

If you don't have time to draw your lettuces and bean plants, just jot down notes in your journal of planting, flowering, and fruiting dates. And draw a garden map so you remember for the next year where you planted your peas!

As you harvest or when you bring produce home from the farmers' market, take some time to draw summer beans, tomatoes, cucumbers, beets, zucchini, pumpkins.

Draw wayside plants as they bloom. Carefully notice what insects are feeding on what plants and how. Pay special attention if you spot the iconic monarch butterfly, noting date, place, time.

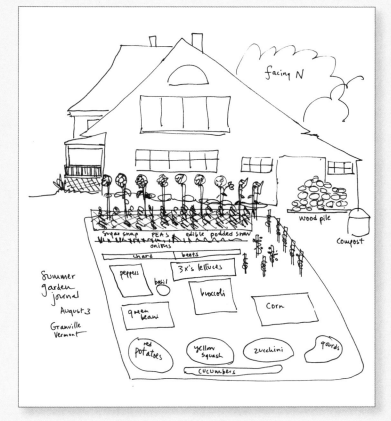

TREES AND LEAVES

A wonderful project is to learn the trees in your neighborhood, what they are, what they look like throughout the seasons, who lives in those trees, and so on.

Learn the botany between deciduous, evergreen, and broad-leaved evergreen trees, and between trees and shrubs. Learn how trees vary per habitat and how they affect both plants and animals living around them.

Drawing Leaves

Bring in leaves and draw leaf shape varieties. Learn local botany of herbaceous plants, woody trees. Look up trees and plants in field guides to learn names, only if you wish.

A Simple Way to Draw a Leaf

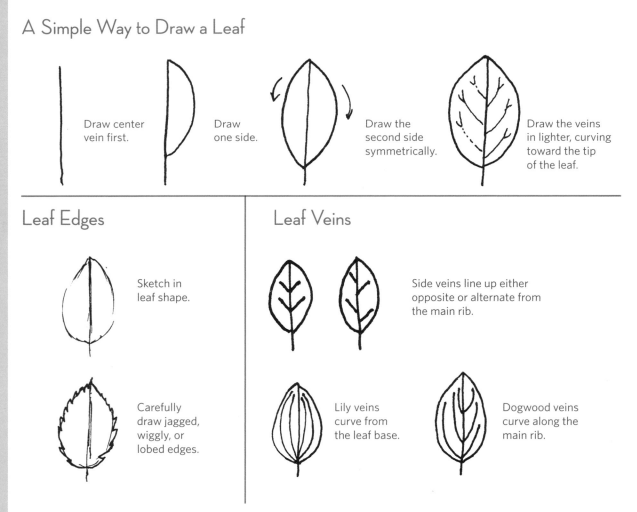

Draw center vein first.

Draw one side.

Draw the second side symmetrically.

Draw the veins in lighter, curving toward the tip of the leaf.

Leaf Edges

Sketch in leaf shape.

Carefully draw jagged, wiggly, or lobed edges.

Leaf Veins

Side veins line up either opposite or alternate from the main rib.

Lily veins curve from the leaf base.

Dogwood veins curve along the main rib.

Complex Leaf Shapes

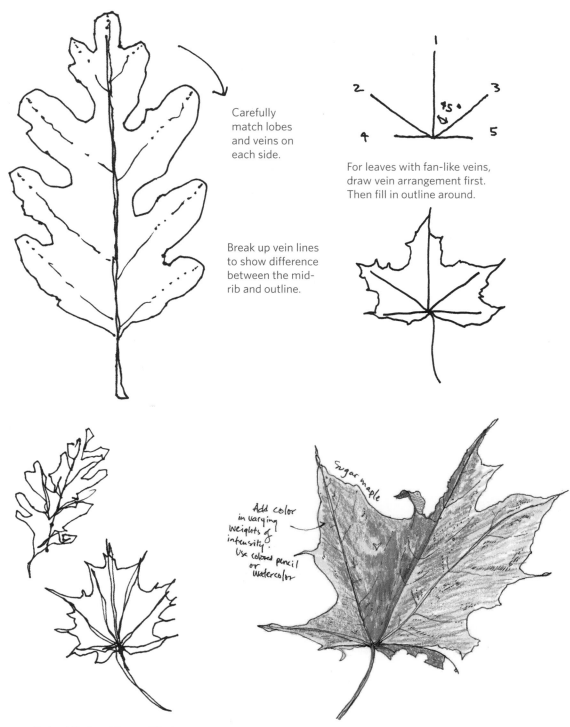

Carefully match lobes and veins on each side.

Break up vein lines to show difference between the mid-rib and outline.

For leaves with fan-like veins, draw vein arrangement first. Then fill in outline around.

Add color in varying weights of intensity. Use colored pencil or watercolor

Sugar maple

Doing blind and/or modified contours first always helps.

SHAPES
AND COLORS

Shapes of plants can be quite distinctive. Note the details of each plant you record. These are very useful when you're trying to identify the plant later in a guidebook.

If you're looking for a theme for a particular day, try focusing on colors. Look about you and note the various colors you see, then record all the objects that display each of these colors.

I collected these leaves and drew them at home during time intervals one afternoon and evening.

leaves collected off Mt. Auburn on a snowy, dark Sunday eve. The glow of crimson crabs and basswood leaves caught my eye. Color in gray....

Nov. 24
lightening skies after weekend's darkness
Sunrise : 6:46 am
Sunset : 4:16 pm
9 hrs 30 min light
6/24 = 15 hrs 17 min light
12/24 = 9 hrs 4 min light

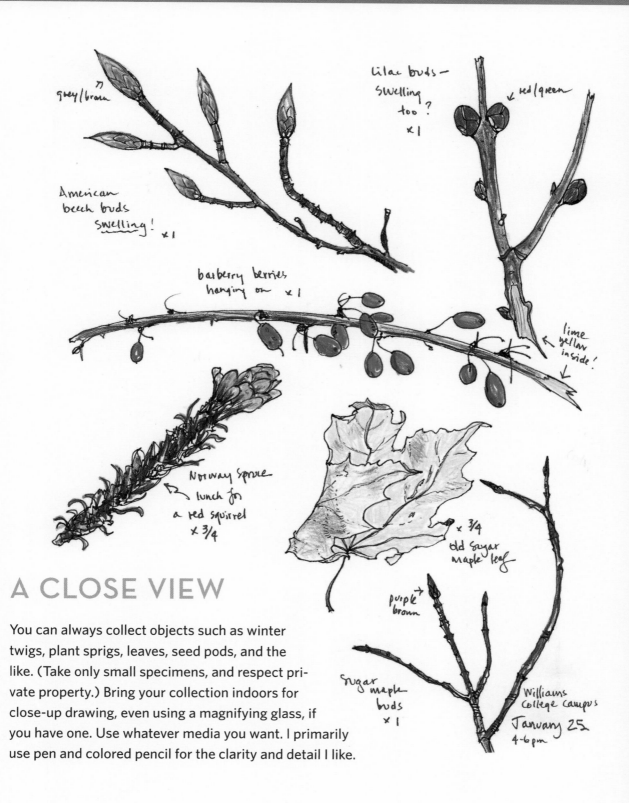

grey/brown

American
beech buds
swelling! ×1

lilac buds—
swelling
too?
×1

← red/green

barberry berries
hanging on ×1

lime
yellow
inside!

Norway spruce
lunch for
a red squirrel
×3/4

×3/4
old sugar
maple leaf

purple
brown

sugar
maple
buds
×1

Williams
College campus
January 25
4–6 pm

A CLOSE VIEW

You can always collect objects such as winter
twigs, plant sprigs, leaves, seed pods, and the
like. (Take only small specimens, and respect pri-
vate property.) Bring your collection indoors for
close-up drawing, even using a magnifying glass, if
you have one. Use whatever media you want. I primarily
use pen and colored pencil for the clarity and detail I like.

Deciduous Trees

Deciduous trees have leaves that fall off each autumn to save water loss in winter and to prevent extra weight in ice and snow storms. Broad-leaved evergreens have thick leaves that can stay on all winter.

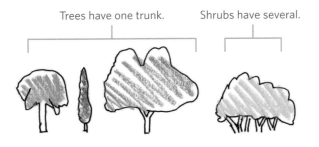

Trees have one trunk. Shrubs have several.

1. Observe the overall shape first.

2. A contour drawing can help see shapes.

3. Now draw the trunk up from the base of the ground, to where leaves begin.

4. On your paper, make marks no more than 6 or 7" (a full page takes too long) and draw the tree within those marks.

5. Shade out in a ring to get a sense of roundness on your flat piece of paper.

messy stick nest in tree is made by crows

leaf nest in tree is made by squirrels

6. Draw major leaf masses as they catch light and dark shadows. Draw in branches as they appear between leaf masses. Put in shadows, if you want, on the trunk.

7. Draw parts of the tree:
- Buds and twigs
- Seeds and fruits
- Leaves
- Evidence of animal activity

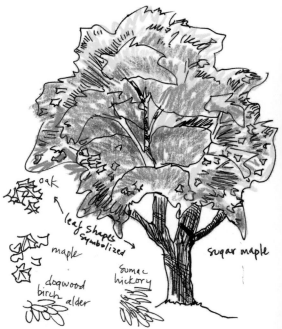

oak

leaf shapes symbolized

maple

dogwood birch alder

sumac hickory

sugar maple

132

Winter Deciduous Trees

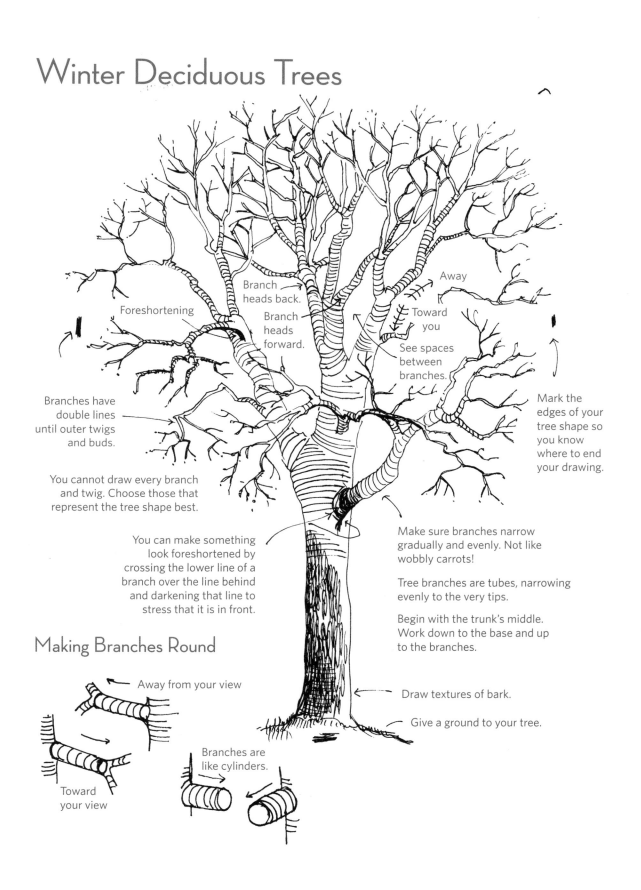

Foreshortening

Branch heads back.

Branch heads forward.

Away

Toward you

See spaces between branches.

Branches have double lines until outer twigs and buds.

You cannot draw every branch and twig. Choose those that represent the tree shape best.

You can make something look foreshortened by crossing the lower line of a branch over the line behind and darkening that line to stress that it is in front.

Mark the edges of your tree shape so you know where to end your drawing.

Make sure branches narrow gradually and evenly. Not like wobbly carrots!

Tree branches are tubes, narrowing evenly to the very tips.

Begin with the trunk's middle. Work down to the base and up to the branches.

Making Branches Round

Away from your view

Toward your view

Branches are like cylinders.

Draw textures of bark.

Give a ground to your tree.

Evergreens

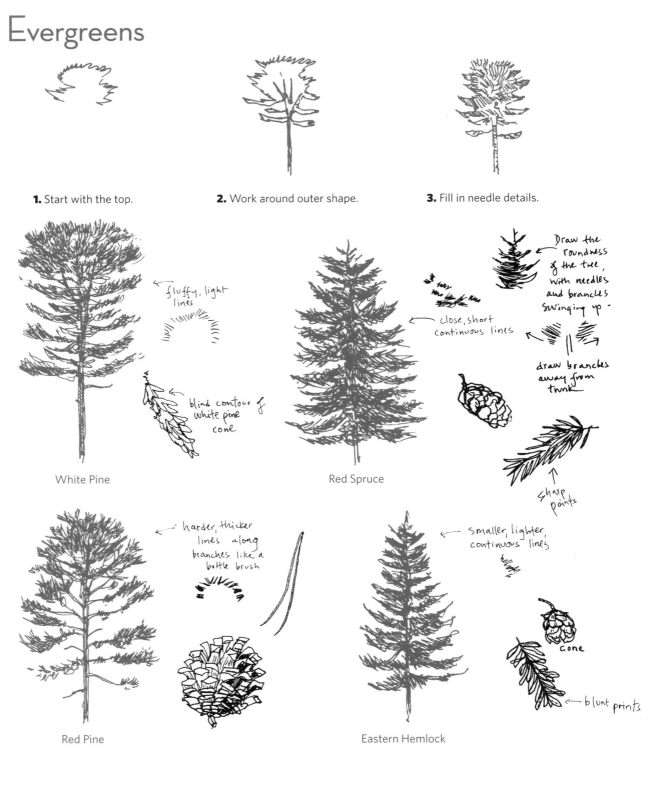

1. Start with the top.

2. Work around outer shape.

3. Fill in needle details.

fluffy, light
lines

blind contour of
white pine
cone

White Pine

close, short
continuous lines

Draw the
roundness
of the tree,
with needles
and branches
swinging up.

draw branches
away from
trunk

sharp
points

Red Spruce

harder, thicker
lines along
branches like a
bottle brush

Red Pine

smaller, lighter,
continuous lines

cone

blunt prints

Eastern Hemlock

4. Finish the sketch.

Check a field guide for diagrams and species variations.

Marks for Drawing Trees and Landscapes

 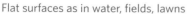

Flat surfaces as in water, fields, lawns

Vertical surfaces as in buildings, trees in the distance

All surfaces are at an angle — vary the angle of lines depending on the angle of slope, plane, surface.

Experiment with line type and density.

Leaf Shapes

Get to know the general shape of leaves so that you can quickly draw a mass of them.

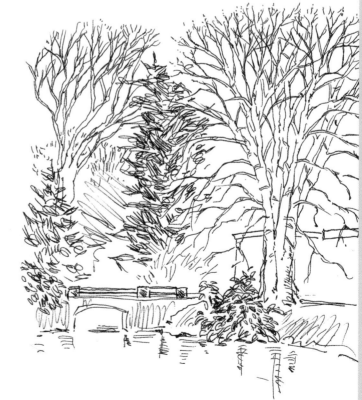

Practice getting down the overall shape and appearance of different trees.

Pine

Maple/Sycamore

Fir/Spruce

Oak

Yew

Apple/Dogwood

Juniper

Willow/Chestnut

Ash/Walnut

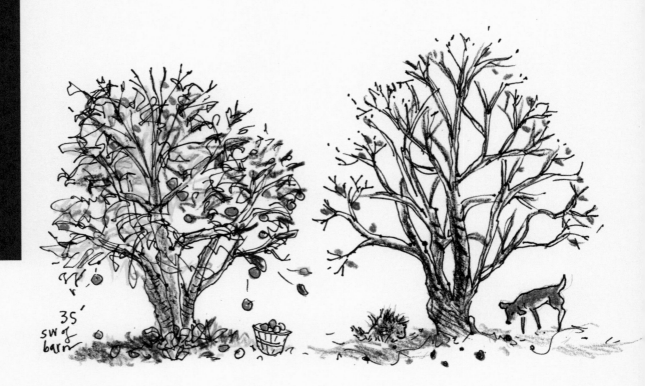

AUTUMN TREES

What trees turn color? Draw five different leaves with different colors and shapes. Do trees of the same kind all have the same colors? Do different kinds of trees each have their own fall color change? Read about fall foliage changes. Identify and draw seeds, fruits, and nuts of trees and shrubs. Draw the differences between evergreen and deciduous trees. Draw five tree shapes near you and identify the trees. Which trees are native to your area and which have been imported?

WINTER TREES

Make an inventory of the trees that grow in your area. Draw full-tree silhouettes and details of the twigs, buds, seeds, and dried leaves as best you can.

What creatures are spending the winter or roosting in a particular tree? Which trees in the area are healthy and which are not? What might be happening?

Draw the silhouettes of different evergreen and deciduous trees, getting to know their distinct shapes. Are there broad-leaved evergreens around you? Look at bark patterns of trees; can you learn to recognize a number of trees from their bark alone?

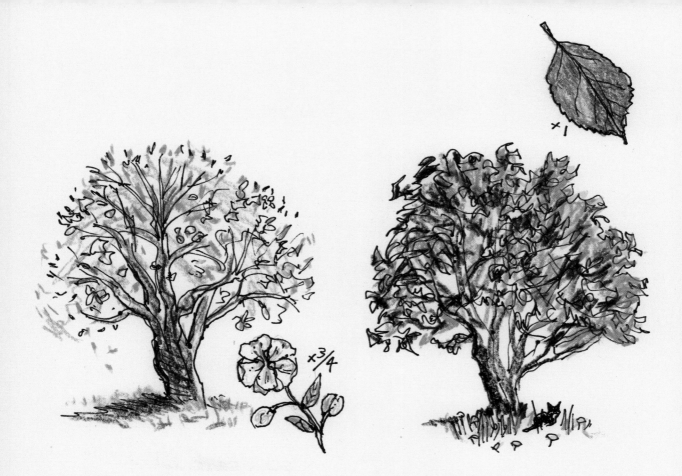

SPRING TREES

Draw buds as they expand and come
into bloom. Date your daily observations.
What do new leaf shapes and colors look
like? Where do trees leaf out earlier —
in sunny warm places, or colder darker
places? Cut branches of forsythia, apple,
pussy willow, dogwood. Bring them in and
put them in water, then watch the leaves
and flowers open and expand, recording
the activity as it happens.

SUMMER TREES

If you are visiting a new place, get to know
the trees there by drawing five different
tree shapes you see. Keep the drawings
small. Do you have similar kinds of trees
at home?

Bird-watching has become an increasingly popular outdoor activity. Solo or with a group, with little equipment other than binoculars and a good field guide (of which there are many), you can go most anywhere to find and watch a variety of birds. In most places, you can easily count a dozen species on a morning or evening walk.

If you've never drawn birds before, don't be overwhelmed. Spend some time just watching them and taking in details. Drawing from field guides and photographs is good practice. Don't be discouraged if out in the field you can only capture a tail or part of a head or back. Even with such active subjects, you will enjoy being outdoors and will learn more every time.

PEOPLE IMAGINE [birds] to be cheery little songsters with the freedom to roam the world, but in fact they're driven by instinct that burns with white-hot intensity.

— **Kenn Kaufman,** *A Season on the Wind*

Drawing Birds

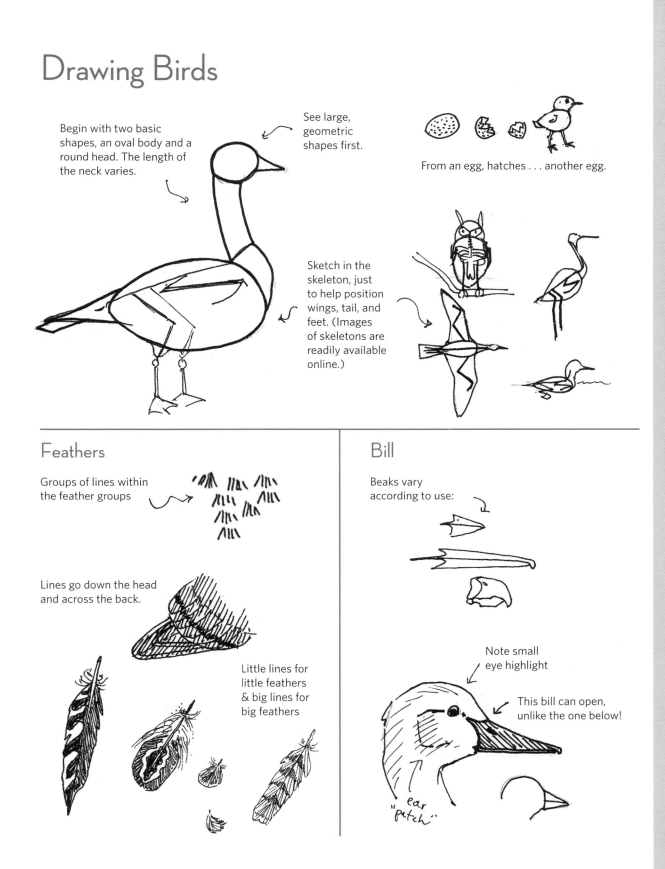

Begin with two basic shapes, an oval body and a round head. The length of the neck varies.

See large, geometric shapes first.

From an egg, hatches . . . another egg.

Sketch in the skeleton, just to help position wings, tail, and feet. (Images of skeletons are readily available online.)

Feathers

Groups of lines within the feather groups

Lines go down the head and across the back.

Little lines for little feathers & big lines for big feathers

Bill

Beaks vary according to use:

Note small eye highlight

This bill can open, unlike the one below!

ear "patch"

Eyes

Live eyes are curved and reflect light, so your drawing must show that. A lack of highlight in the eye makes the animal look dead. Show the highlight in the upper part of the eye, indicating a major light source. Notice the highlights in the eyes of the birds on the opposite page.

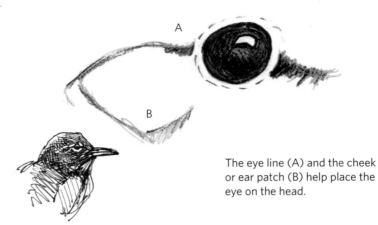

The eye line (A) and the cheek or ear patch (B) help place the eye on the head.

Natural reflective light on a convex lens

Indicates light from a flash camera (i.e., drawn from a photo)

Feet

The shape of the feet and the length of legs vary according to habitat.

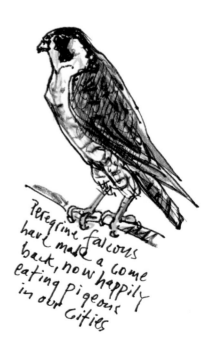

Peregrine falcons have made a come back, now happily eating pigeons in our cities

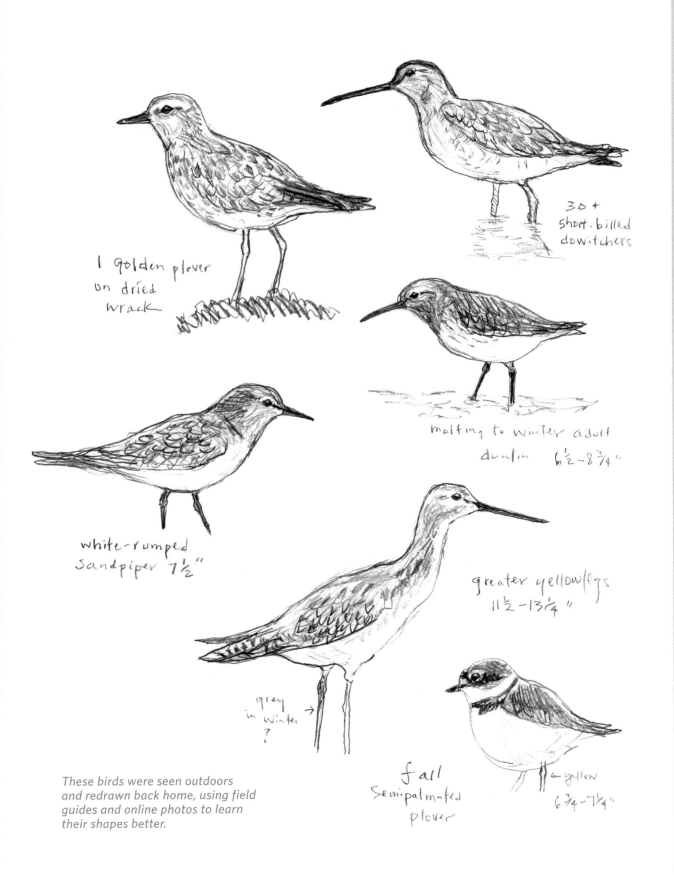

1 golden plover
on dried
wrack

30+
short-billed
dowitchers

molting to winter adult
dunlin 6½-8¾"

white-rumped
sandpiper 7½"

greater yellowlegs
11½-13¼"

grey
in
winter
?

fall
semipalmated
plover

yellow
6¾-7¼"

*These birds were seen outdoors
and redrawn back home, using field
guides and online photos to learn
their shapes better.*

Understanding Anatomy

Birds are easier to draw if you learn their basic anatomy and something about the kind of bird you are working with. All birds have the same basic skeletal parts, whether a heron or a titmouse.

Incidentally, most bird guides identify groups of bird species from the least evolved (most ancient) to the most evolved (most recent). First listed are loons, then grebes, fulmars (tube-nosed seabirds), pelicans, ducks and geese, hawks, grouse, herons, cranes, shorebirds and gulls, doves, owls, parrots, woodpeckers, and last, all the little songbirds.

When drawing any animal, it's best to begin with a clear profile. As shown in most field guide illustrations, this gives you the best understanding of shape, proportion, and detail.

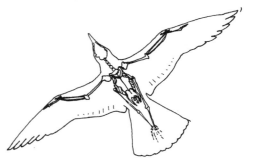

Bones are hollow so birds can fly. Their greatest weight is in the chest where large flight muscles develop.

Birds balance their weight at this point.

The only part of the leg you see is from the heel down!

feet set back as paddles

Birds rarely cooperate by presenting you with their best profile!

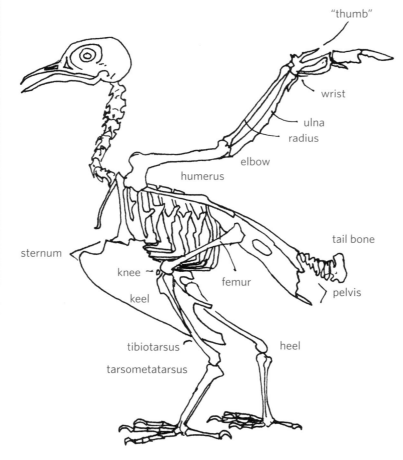

"thumb"

wrist

ulna

radius

elbow

humerus

tail bone

sternum

knee

femur

pelvis

keel

tibiotarsus

heel

tarsometatarsus

Feather Groupings

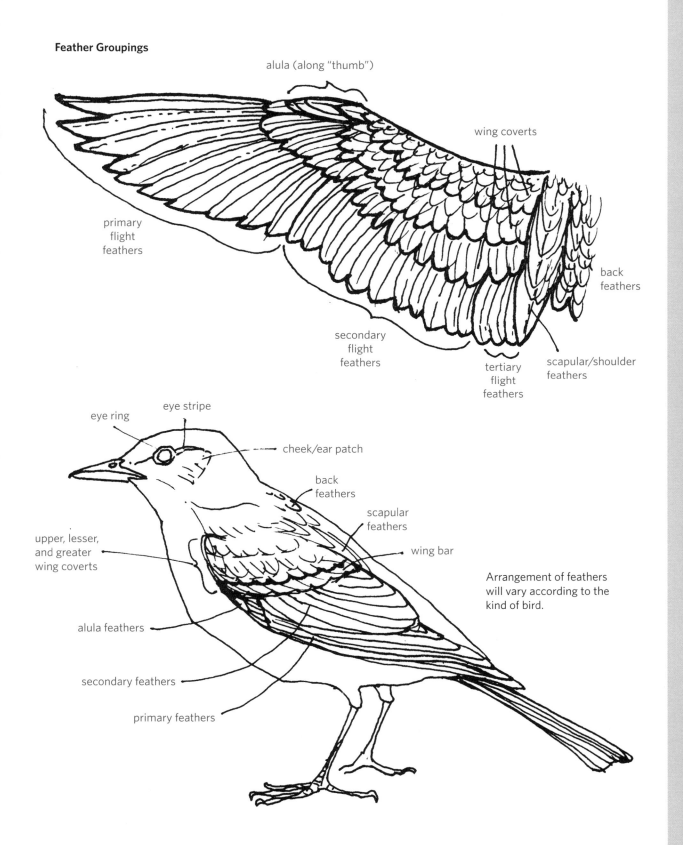

alula (along "thumb")

wing coverts

primary
flight
feathers

back
feathers

secondary
flight
feathers

tertiary
flight
feathers

scapular/shoulder
feathers

eye ring

eye stripe

cheek/ear patch

back
feathers

scapular
feathers

wing bar

upper, lesser,
and greater
wing coverts

alula feathers

secondary feathers

primary feathers

Arrangement of feathers
will vary according to the
kind of bird.

Drawing Birds at a Bird Feeder

The helpful thing about learning to draw birds at a feeder, or even a local pond or city park, is that they remain relatively close and return repeatedly to the same position, even if they frequently fly off. Begin with quick contour or gesture sketches (see chapter 3). Get part of one bird done. Begin another if it leaves. Go back to it if it returns. As you gain experience, you'll know the bird well enough to add details.

Basic lines I begin with

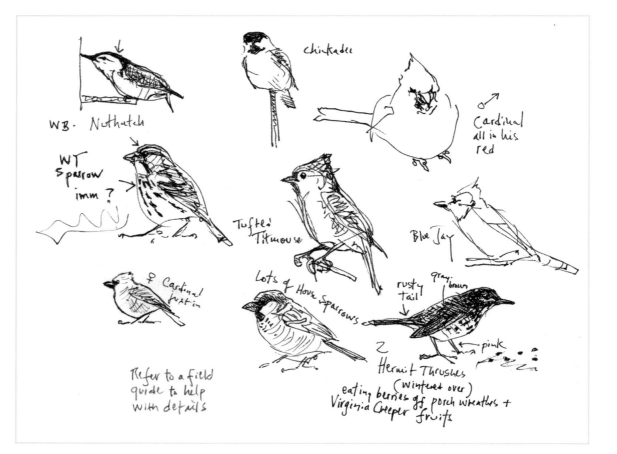

WB. Nuthatch

chickadee

Cardinal all in his red ♂

WT Sparrow imm ?

Tufted Titmouse

Blue Jay

♀ Cardinal just in

Refer to a field guide to help with details

Lots of House Sparrows

rusty tail

gray brown

pink

2 Hermit Thrushes (wintered over) eating berries of porch wreaths + Virginia Creeper fruits

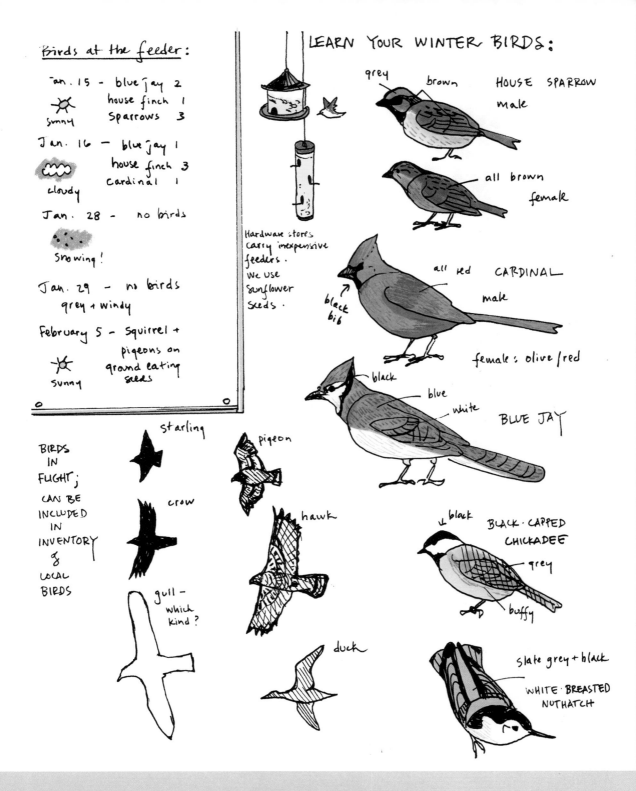

Birds at the feeder:

Jan. 15 – blue jay 2
house finch 1
Sparrows 3
☀ sunny

Jan. 16 – blue jay 1
house finch 3
Cardinal 1
☁ cloudy

Jan. 28 – no birds
Snowing!

Jan. 29 – no birds
grey + windy

February 5 – Squirrel +
pigeons on
ground eating
seeds
☀ sunny

LEARN YOUR WINTER BIRDS:

grey brown HOUSE SPARROW
male

all brown female

Hardware stores carry inexpensive feeders. We use sunflower seeds.

all red CARDINAL
male
black bib
female: olive / red

black blue white BLUE JAY

BIRDS IN FLIGHT; CAN BE INCLUDED IN INVENTORY OF LOCAL BIRDS

starling

pigeon

crow

hawk

gull – which kind?

duck

↓ black BLACK-CAPPED CHICKADEE
grey
buffy

slate grey + black
WHITE-BREASTED NUTHATCH

One day when I was walking home from school, I heard the birds chirping. They were flying from tree to tree. Then I thought to myself, "If they cut down the trees in Somerville, they and the other animals will have no place to live."

— 6th-grade student

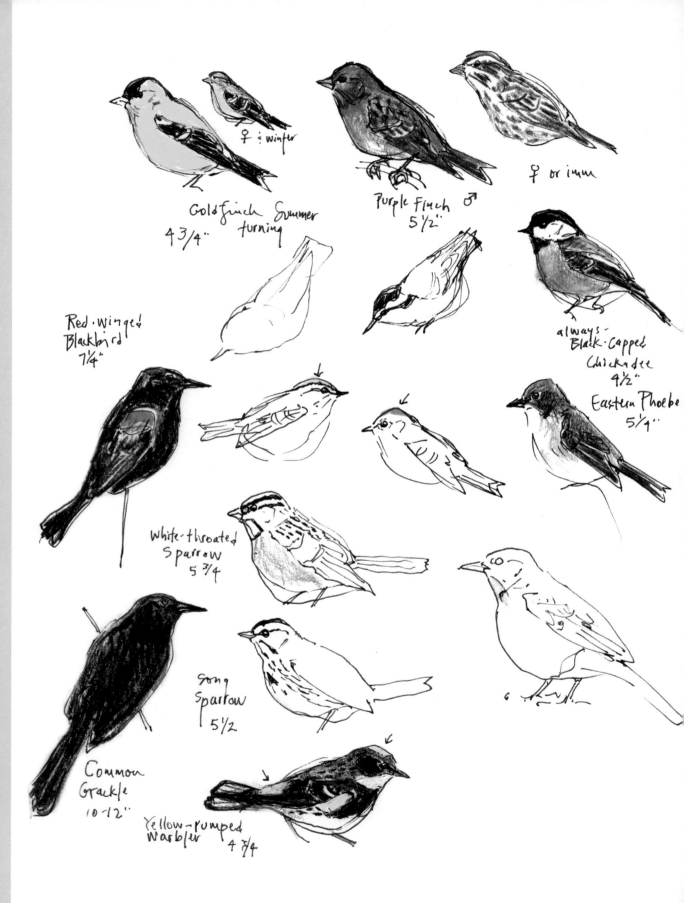

Goldfinch Summer
turning
4 3/4"

♀ ♂ winter

Purple Finch ♂
5 1/2"

♀ or imm

Red-winged
Blackbird
7 1/4"

always-
Black-Capped
Chickadee
4 1/2"

Eastern Phoebe
5 1/4"

White-throated
Sparrow
5 3/4

Song
Sparrow
5 1/2

Common
Grackle
10-12"

Yellow-rumped
Warbler
4 3/4

A PIGEON REPORT

The birds that live right under your nose provide a marvelous opportunity to observe and record their behavior.

Pigeons were first brought to this country to raise for their meat and to carry messages. Their relatives, the rock doves, nest on cliffs and have abilities to fly through narrow spaces and land on almost anything. Because of their adaptability, pigeons have easily adapted to our cities.

Pigeons can clap their wings in take-off as a kind of courtship message.

couples make messy stick, string, paper nests in various enclosed places. They generally begin courting + nest building in late January but interactive couple behaviors can be observed all year long.

PIGEON POSTURES IN A NEARBY PARK

1. Male lowers head, puffs out feathers to show power to mate or group.

2. Male struts about, feathers puffed, and tail down. Showing off to group or possible mate.

3. Male chases female around, within or away from a group of pigeons. Rather like male showing off his female to the group.

4. Female puts bill inside male's mouth. Together their heads bob up and down. Part of a courtship pattern.

5. Female and male preen head feathers as a courtship pattern.

This page originally appeared as "Notes from a Field Sketchbook," an ongoing feature I wrote for the Massachusetts Audubon Society's magazine *Sanctuary*.

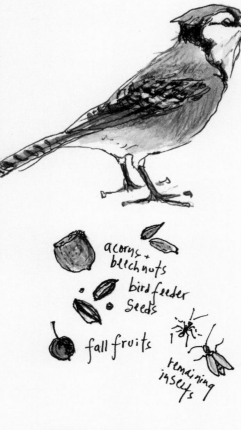

acorns + beechnuts

bird feeder seeds

fall fruits

remaining insects

AUTUMN BIRDS

What birds live near you? What birds will migrate? What birds will stay nearby all winter? Draw from life, or from photographs, a few local birds, such as grackle, robin, blue jay, pigeon, kestrel, Canada goose, chickadee, and wood duck. Do they stay around or leave? Where do they go?

WINTER BIRDS

Study five birds that do not leave your area in winter. Where do they find shelter? What do they eat? Do they travel in single-species flocks or in mixed-species flocks? How do they communicate in winter?

Notice that on bright, sunny days more birds are out singing and flying about. By February, birds such as pigeons, cardinals, great horned owls, and mourning doves are actively courting. Late winter is pair-forming time for various duck species. Watch them in patches of open fresh or salt water and record their courtship behavior.

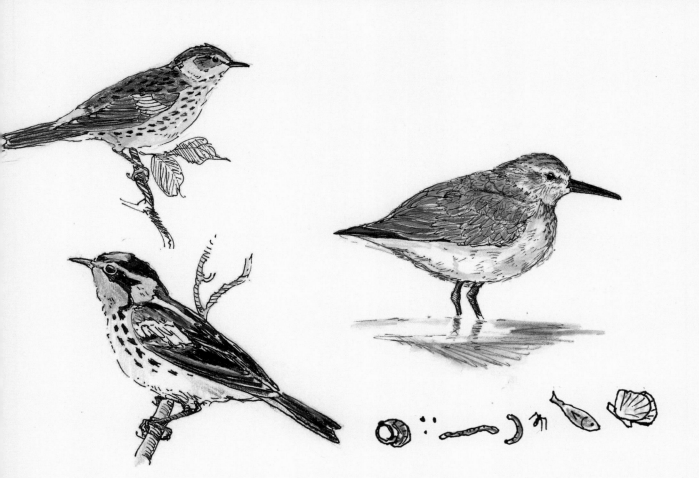

SPRING BIRDS

What birds have been with you all winter? What new birds appear first as part of the spring migration? What are the dates of the first bird of each species that you see returning in spring? Look for the brightly colored males in breeding plumage; they may be very different looking than when they passed southward in fall.

There are numerous local birding groups that are eager to have you join. They will even share their binoculars or telescopes.

SUMMER BIRDS

What five birds are in your habitat? Are they year-round residents or do they arrive in spring and leave in fall? Are these shorebirds, water birds, pelagic birds (i.e., seabirds), hawks, owls, woodpeckers, or songbirds? Take the time to learn to use a field guide and binoculars for observation. Perhaps you can find a nesting bird and, without disturbing the parents, observe and record the growth of the youngsters. Find a friend, join a group, and go birding with companions.

MAMMALS, DOMESTIC AND WILD

Mammals are lots of fun to draw, especially if you have a cat or dog, or even a guinea pig or hamster in your house to practice with. If not, find some photographs from field guides, calendars, postcards, or magazines. Or visit your local science or natural history museum to study mounted or model animals in various habitat dioramas. At the zoo, you can usually see local animals wandering around, as well as those in enclosures. And, of course, depending on where you live, outside you might find a squirrel, chipmunk, raccoon, skunk, deer, coyote, elk, moose, or pronghorn.

Start with Basic Shapes

It helps to begin with the profile, as that gives you the clearest view of the proportions. As you practice contour drawings and begin to understand foreshortening of shapes, you can draw different positions.

Important shoulder line

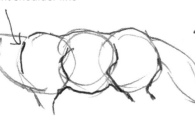

1. Begin with circles for the shoulder, belly, and hip.

2. Define muscle, leg articulation, and belly.

3. Once proportion and shape are correct, add details and fur, angled front to back as it lies naturally.

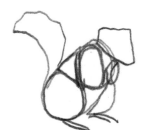

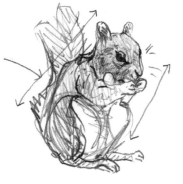

1. Checking the angles and shape of the space around the animal helps, too.

2. As you draw, keep adjusting the angle of the posture to get it right.

3. The shape and position of the eye must be correct. Keep erasing till you find the right distance between nose and ear.

Practice with Pets

Drawing household pets is good practice for drawing all sorts of animals. They're a ready subject in the evening, if it's rainy out, or when you want an indoor project.

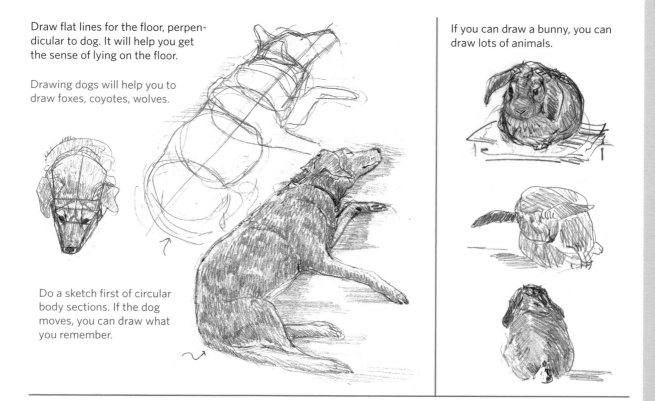

Draw flat lines for the floor, perpendicular to dog. It will help you get the sense of lying on the floor.

Drawing dogs will help you to draw foxes, coyotes, wolves.

Do a sketch first of circular body sections. If the dog moves, you can draw what you remember.

If you can draw a bunny, you can draw lots of animals.

Drawing cats is good practice for bobcats, pumas, jaguars, lions, and others in the feline family.

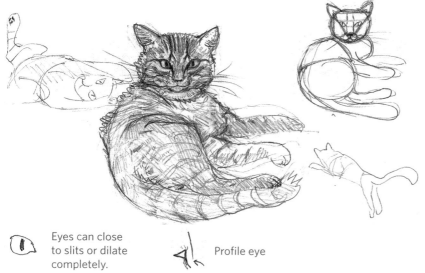

Eyes can close to slits or dilate completely.

Profile eye

Do sketches first, getting basic shape and facial symmetry. Study the head carefully. Cats' eyes are in the front of the skull, not the sides! As cats move a lot, draw differing positions.

Much of this was sketched from memory as the kitty moved.

1. Get shape first.

2. Characteristics of individual cat: eyes, stripes & coloring.

3. Lay in fur from head to tail; usually shorter at the head, longer on the back, legs, and tail.

151

Drawing Animals in Action

When animals are moving, look hard at overall form. Do several combination contour and gesture sketches, getting major geometries. When the animal moves, go to another drawing. You can have several sketches going at once, moving from one to the other as the animal takes those positions again. When you are familiar enough with the form, you can draw the details in from memory.

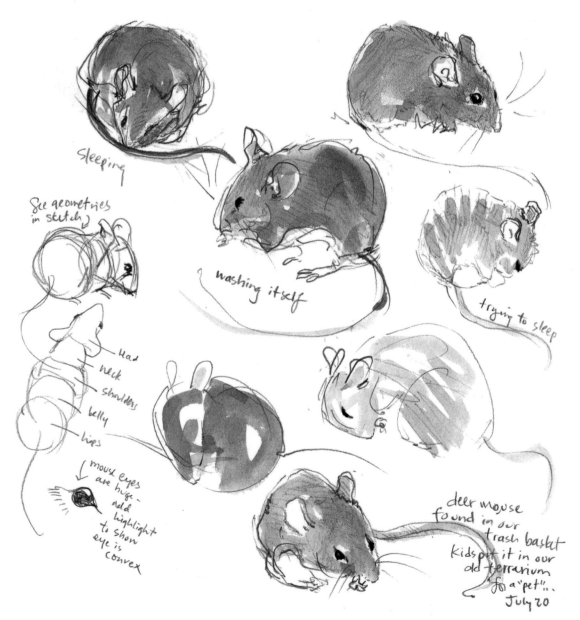

sleeping

See geometries in sketch

washing itself

trying to sleep

Head
neck
shoulders
belly
hips

mouse eyes are huge — add highlight to show eye is convex

deer mouse found in our trash basket. Kids put it in our old terrarium for a "pet"...
July 20

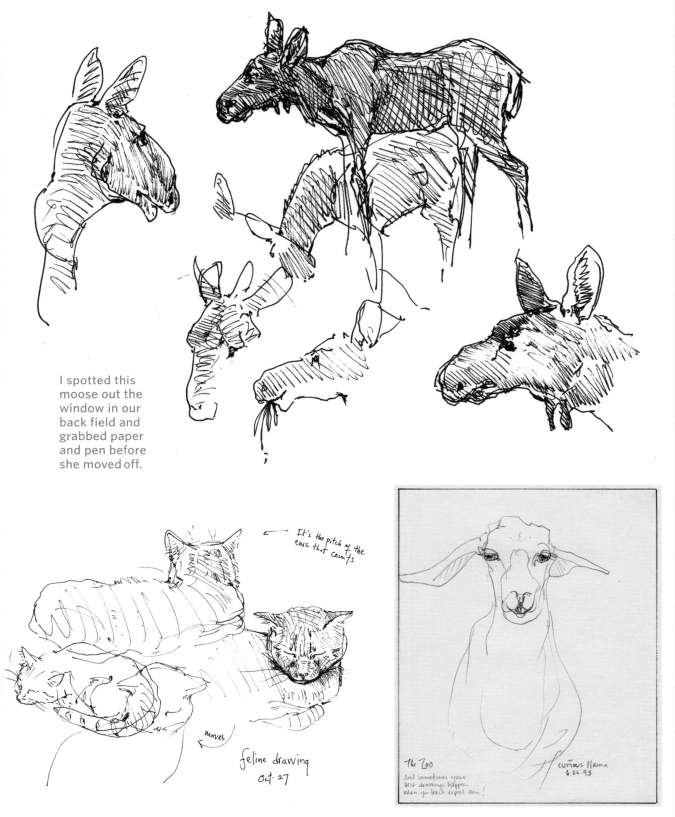

I spotted this moose out the window in our back field and grabbed paper and pen before she moved off.

It's the pitch of the ears that counts

moves

feline drawing
Oct. 27

The Zoo
And sometimes your best drawings happen when you least expect them!

curious llama
6.22.95

A quick study of a sleeping cat

Take a small notebook or scraps of paper to the zoo for making quick sketches.

Understanding Anatomy

It can be very useful to draw from field guide photographs and illustrations; just remember that shadows, camera distortion, and quality of image can affect what you are seeing and thus the accuracy of your drawing. It is best to draw an animal first in full profile and with as little shadowing as possible. This way you can see all the parts clearly delineated and not confuse shadow with color pattern, or tall grass with a missing leg.

Once you know the parts of the animal and its basic shape, then you can foreshorten it, draw it moving, or portray it lying down in the grass.

A full understanding of skeletal structure can really help any drawing.

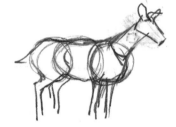

Basic Shape

Animals are built on a system of three circles — shoulder, belly, hip — plus neck, head, legs. Draw these circles, and your animal has structure.

Spot Studies

Do smaller drawings that focus on details.

Once you have shape the way you want, begin putting in fur, roundness of lights and darks, and details of eyes, ears, antlers, hooves.

Imagine you are patting the animal from back to front, and put in fur along that tracking, as it is called.

I start fur and detail from the rear, as I am left-handed. You do not want to smear fur. Angle fur lines head to tail.

Fur begins as small lines and gets larger along the body.

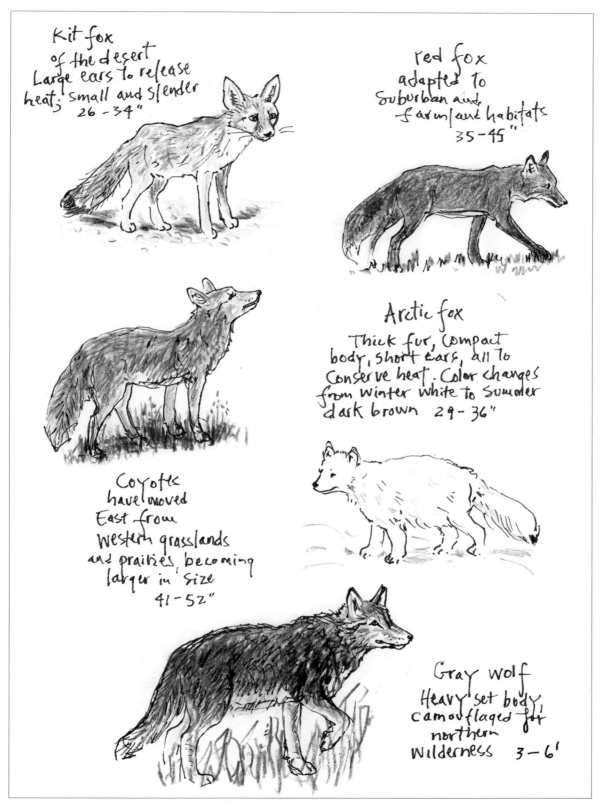

Kit fox
of the desert
Large ears to release
heat; small and slender
26 - 34"

red fox
adapted to
suburban and
farmland habitats
35 - 45"

Arctic fox
Thick fur, compact
body, short ears, all to
conserve heat. Color changes
from winter white to summer
dark brown 29 - 36"

Coyotes
have moved
East from
Western grasslands
and prairies, becoming
larger in size
41 - 52"

Gray wolf
Heavy set body
camouflaged for
northern
wilderness 3 - 6'

These drawings were made from a field guide in preparation for a teaching trip to Galena, Alaska.

SET UP A RESEARCH PROJECT

Studying a particular animal is a fun project for schools, individuals, or families. In addition to making your own observations, read books, study online sources, and watch nature videos to learn more about your chosen animal. Ask questions: Why do skunks spray? How do porcupines release their quills?

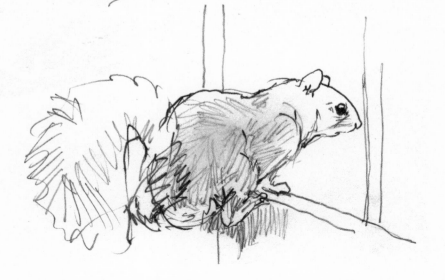

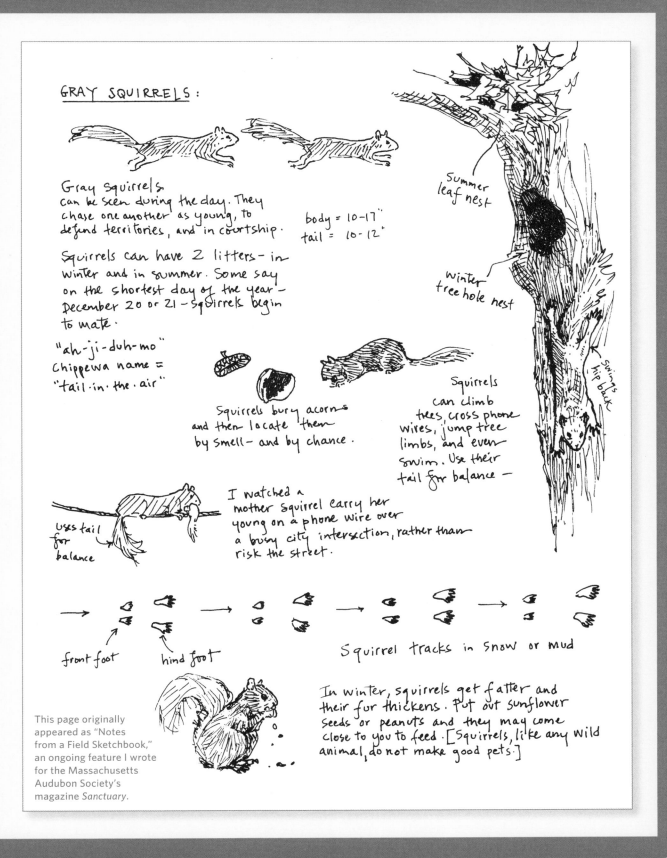

GRAY SQUIRRELS:

Gray squirrels
can be seen during the day. They
chase one another as young, to
defend territories, and in courtship.

body = 10-17"
tail = 10-12"

Squirrels can have 2 litters – in
winter and in summer. Some say
on the shortest day of the year –
December 20 or 21 – squirrels begin
to mate.

"ah-ji-duh-mo"
Chippewa name =
"tail-in-the-air"

summer
leaf nest

winter
tree hole nest

swim's
hip back

Squirrels bury acorns
and then locate them
by smell – and by chance.

Squirrels
can climb
trees, cross phone
wires, jump tree
limbs, and even
swim. Use their
tail for balance –

uses tail
for
balance

I watched a
mother squirrel carry her
young on a phone wire over
a busy city intersection, rather than
risk the street.

front foot hind foot

Squirrel tracks in snow or mud

In winter, squirrels get fatter and
their fur thickens. Put out sunflower
seeds or peanuts and they may come
close to you to feed. [Squirrels, like any wild
animal, do not make good pets.]

This page originally
appeared as "Notes
from a Field Sketchbook,"
an ongoing feature I wrote
for the Massachusetts
Audubon Society's
magazine Sanctuary.

AMPHIBIANS AND REPTILES

Although we may not often see amphibians and reptiles, they are around in many locations. Get to know your local turtles, lizards, frogs, snakes, and salamanders, as they are part of this whole family of life. It is easier to begin drawing amphibians and reptiles from a field guide or photographs. If you see a frog or salamander outdoors, make a quick sketch and work in the details from a photo later.

Drawing Amphibians and Reptiles

1. Notice and draw the basic geometric shapes first.

2. Sketch the posture and angle of the backbone.

3. When the shape seems right, add in details.

Pickerel Frog
2–3½"

American Toad
2–4"

If you are a righty or a lefty, you may like to face your drawings going in the "correct" direction!

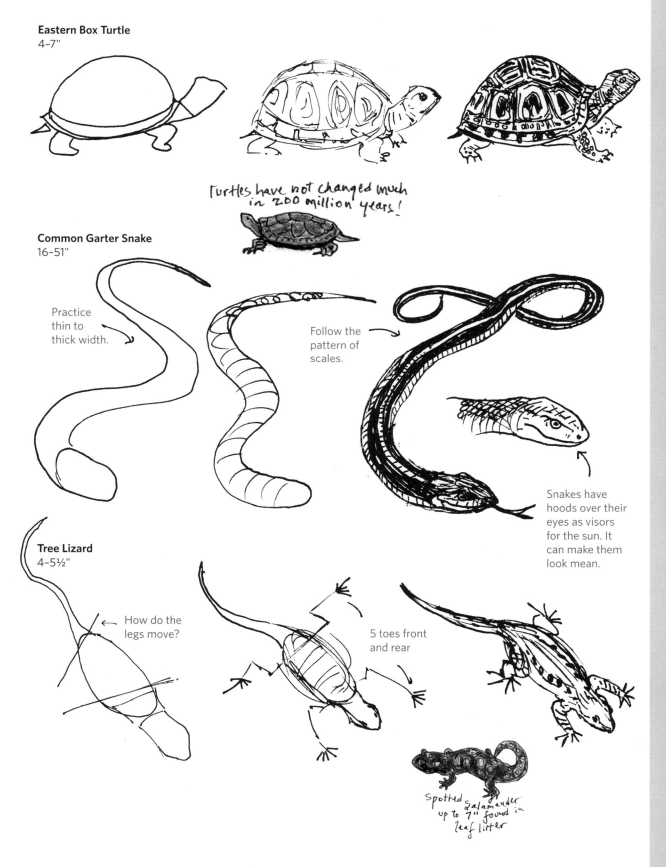

Eastern Box Turtle
4–7"

Turtles have not changed much in 200 million years!

Common Garter Snake
16–51"

Practice thin to thick width.

Follow the pattern of scales.

Snakes have hoods over their eyes as visors for the sun. It can make them look mean.

Tree Lizard
4–5½"

How do the legs move?

5 toes front and rear

spotted salamander up to 7" found in leaf litter

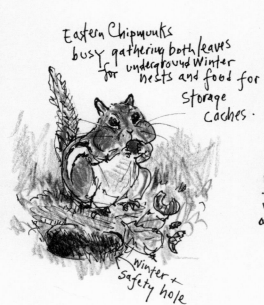

Eastern Chipmunks busy gathering both leaves for underground winter nests and food for storage caches.

winter + safety hole

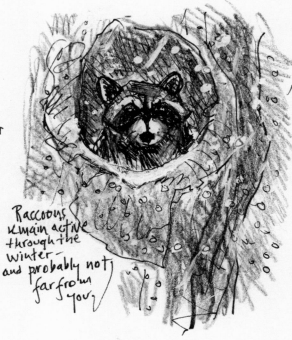

Raccoons remain active through the winter — and probably not far from you.

AUTUMN ANIMALS

Read about and draw a few common animals you know live near you: rabbits, squirrels, foxes, frogs, salamanders, turtles, and so on. Draw from life, when possible; otherwise, use photographs or take a trip to the zoo. Learn animal tracks from a field guide, and see if you can find and draw them outdoors. Learn which animals are more active during the day and which move around at night. Which make their own nests and which use nests made by other animals? Which animals might be moving into your home for the winter?

WINTER ANIMALS

Which of your local animals stay active all winter? Which ones sleep some of the time? Which ones enter a deep sleep, and which truly hibernate? (What's the difference?) Which ones can you observe directly, or indirectly by the signs they leave?

Become a careful investigator of the area you live in and record all signs of animal activity, including tracks, chewed seeds, and dens. Draw what you see, and label it by name, where you found it, and what it tells you.

? chewed

Wood frogs winter buried in leaf litter and can survive partially frozen.

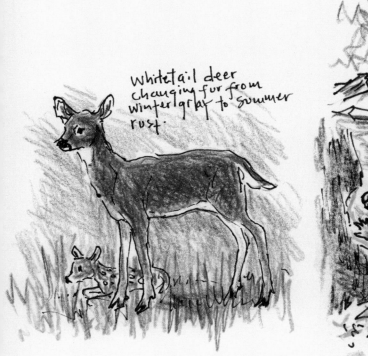

whitetail deer changing fur from winter gray to summer rust.

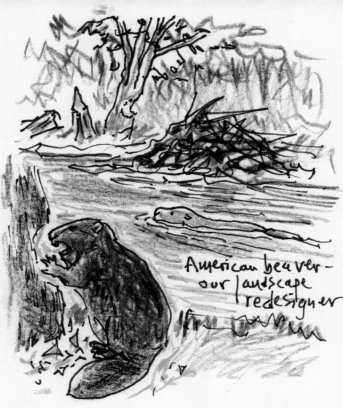

American beaver — our landscape redesigner

SPRING ANIMALS

As daylight increases, what are the animals around you doing? Skunks mate in February and are out more at night, as are raccoons. Gray squirrels around us have courted in late December through January, and are raising young in April. Listen for the beginning of the annual chorus of mating frogs. Which kinds do you hear earliest in the year? When do other species join the chorus? What evidence of animals can you find: holes, burrows, chewed branches?

SUMMER ANIMALS

Whatever your habitat — city, suburbs, desert, woods, mountains — what are the animals around you doing now? Go to a library and read about five that interest you. Search for clues that these animals are living in your area, and make notes about them in your journal drawings. You may find clues like tracks, chew marks, holes, or scat (droppings), even if you don't spot the animals themselves.

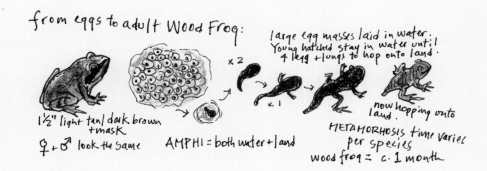

from eggs to adult Wood Frog:

x 2

large egg masses laid in water. Young hatched stay in water until 4 legs + lungs to hop onto land.

x 1

now hopping onto land.

1½" light tan/dark brown + mask

♀ + ♂ look the same

AMPHI = both water + land

METAMORHOSIS time varies per species

wood frog = c. 1 month

A huge proportion of animals, including all insects, are invertebrates, meaning they lack an internal skeleton. I always tell my granddaughters and students that we need to love all insects, even the annoying ones! Mosquitoes, flies, moths, and caterpillars are important food sources for birds and other animals. Many different insects are vital pollinators for a huge variety of plants, from apples and tomatoes to orchids and milkweed. As we learn of drastic declines in worldwide insect populations, it becomes increasingly urgent for us to record and draw the ones that live around us.

Insects are a good subject, as they are always doing something and they are usually around in both the warm and cold months, indoors and out. Have a field guide with either photographs or drawings to help you with details of wing shape, color patterns, size, and, of course, identification.

Drawing Insects

Insects are bilaterally symmetrical , meaning they are the same on both sides.

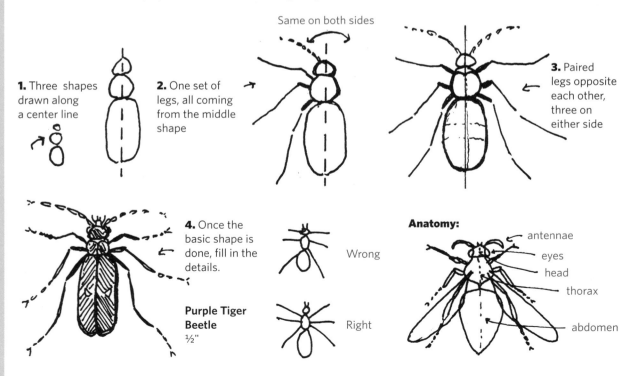

1. Three shapes drawn along a center line

2. One set of legs, all coming from the middle shape

Same on both sides

3. Paired legs opposite each other, three on either side

4. Once the basic shape is done, fill in the details.

Purple Tiger Beetle
½"

Wrong

Right

Anatomy:
antennae
eyes
head
thorax
abdomen

A Few Other Invertebrates

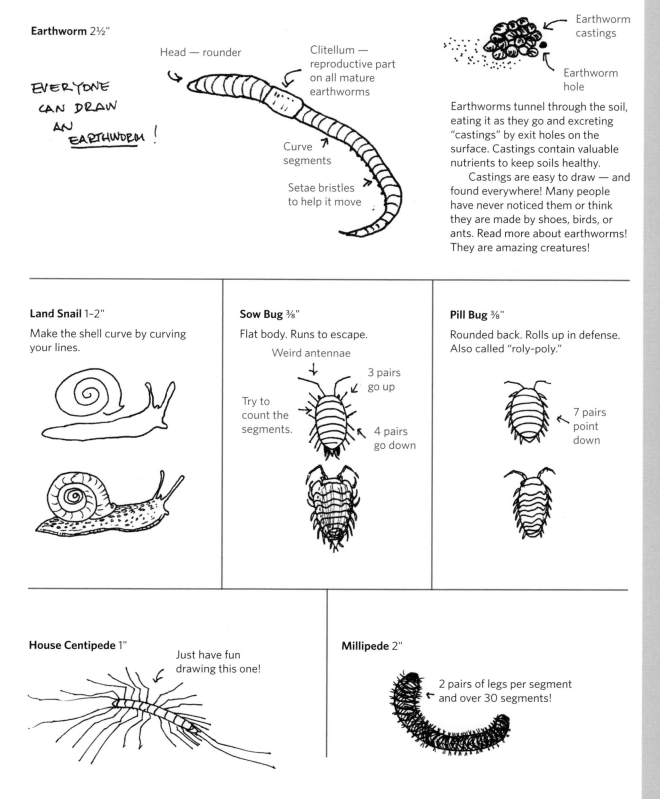

Earthworm 2½"

EVERYONE CAN DRAW AN EARTHWORM!

Head — rounder

Clitellum — reproductive part on all mature earthworms

Curve segments

Setae bristles to help it move

Earthworm castings

Earthworm hole

Earthworms tunnel through the soil, eating it as they go and excreting "castings" by exit holes on the surface. Castings contain valuable nutrients to keep soils healthy.

Castings are easy to draw — and found everywhere! Many people have never noticed them or think they are made by shoes, birds, or ants. Read more about earthworms! They are amazing creatures!

Land Snail 1–2"

Make the shell curve by curving your lines.

Sow Bug ⅜"

Flat body. Runs to escape.

Weird antennae

Try to count the segments.

3 pairs go up

4 pairs go down

Pill Bug ⅜"

Rounded back. Rolls up in defense. Also called "roly-poly."

7 pairs point down

House Centipede 1"

Just have fun drawing this one!

Millipede 2"

2 pairs of legs per segment and over 30 segments!

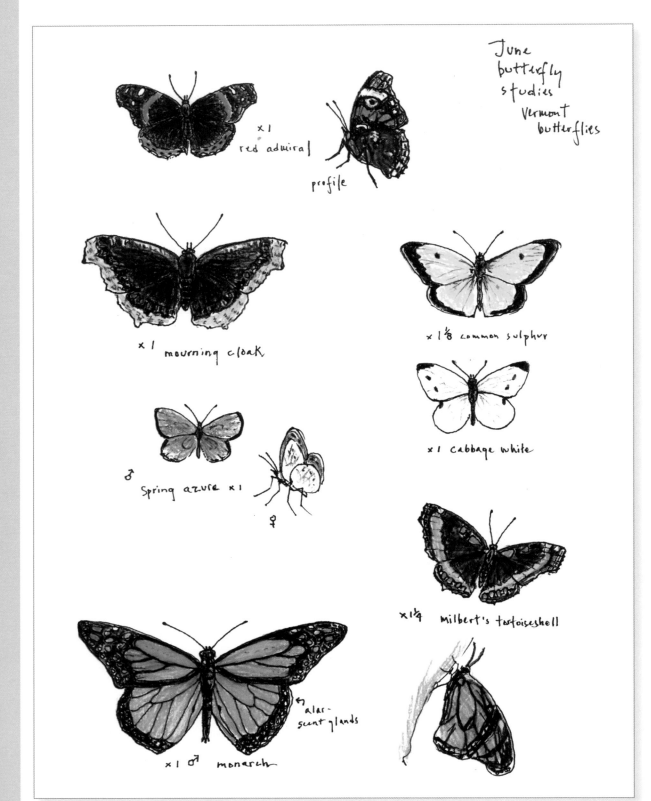

June
butterfly
studies
Vermont
butterflies

x1
red admiral

profile

x1 mourning cloak

x1⅛ common sulphur

x1 cabbage white

♂ Spring azure x1

♀

x1¼ milbert's tortoiseshell

x1 ♂ monarch

alar-
scent glands

Studies done from a field guide

WE NEED OUR INSECTS

There is growing international concern regarding the considerable population decrease of most, if not all, insect species. As insects are a vital part of the web of life, any hole in the web is concerning. The presence or absence of monarch butterflies has been a huge learning opportunity for schoolchildren in all of North America, down to Mexico, where monarchs winter. Wonderfully, many people are now planting milkweed and asking nurseries and gardeners not to use the chemicals that are so directly affecting many insects. There are several organizations through which you can learn more; try Journey North and the Xerces Society websites. Doug Tallamy's book *Bringing Nature Home* is an excellent resource.

Insects belong to the phylum Arthropoda. All species in this largest group of animals have an external skeleton and jointed legs.

INSECTS INCLUDE:

Orthoptera — "straight wing"

Hemiptera — "half wing" true bugs

Homoptera — "same wing" shape

Coleoptera — "sheath winged" beetles

Hymenoptera — "membrane wings"

Lepidoptera — "scale wings"

Diptera — "two wings"

Odonata — "tooth jaws"

Insects are not bugs. Only Hemiptera are bugs! Ladybugs are really ladybird beetles.

INSECT ORCHESTRA

On slow summer days, go for a ramble or just sit outdoors and listen to the insect orchestra. Try to observe the individual players so you can match the sound to the player. You can use field guides and recordings to learn which ones make which sound. If you get a chance, watch the insects make their courtship calling sounds. Look for edges of wings being rapidly vibrated back and forth, or legs rubbing on wings.

1¼" — pale green

" Katy · did · she · didn't · she · did "

¾–1¼" — green/brown

"tzzip - zipp" crackly sound

TRUE KATYDID
The male sings by rubbing rasps & ridges of outer wings rapidly back & forth. A tree dweller looking like part of a leaf. Very long antennae. A number of different species.

RED-LEGGED GRASSHOPPER
Land dwellers, moving by short vertical flights. Makes a "tzzip" crackling sound with its wings as it flies up. Short antennae. Makes rasping sound rubbing femur of hind leg across hardened veins on forewings.

⅝" — black

"treat · treat · treat"

¾" — soft green

"churr · churr · purrrr · churr"

1¼" — dark brown

"bzzzzzz" very loud

FIELD CRICKET
Largely nocturnal, makes chirping sounds by rubbing slightly raised wings back & forth across one another. Likes warm places — even buildings.

SNOWY TREE CRICKET OR "TEMPERATURE CRICKET"
Males make a soft, slurred call from trees and bushes. The number of "chirps" in 15 seconds, plus 40, gives approximate local Fahrenheit temperature. The colder the temperature, the slower the call.

ANNUAL OR "DOG DAY" CICADA
On hot days, a long and rising crescendo of buzzing emerges from somewhere in a tree. Males make the sound with "voices" boxed at the base of their abdomen, not by wings.

Drawing Spiders

Most of us know that spiders are arachnids, not insects. Spiders are the largest order in the class Arachnida, which also contains scorpions, ticks, daddy longlegs (harvestmen), and solifuges, also known as camel spiders or wind scorpions. In 2019, horseshoe crabs were classified as arachnids.

They each have distinctive numbers of body sections and legs. All legs attach to the cephalothorax in spiders. Insect legs attach to the thorax.

Anatomy:

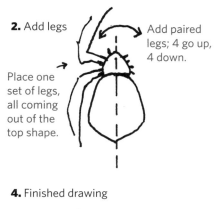

jaws
palps
eyes
head &
cephalothorax
abdomen
spinnerets

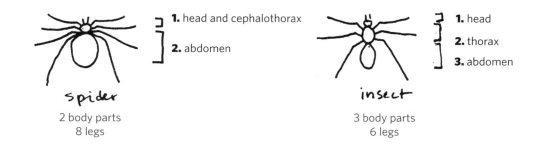

1. head and cephalothorax
2. abdomen

spider
2 body parts
8 legs

1. head
2. thorax
3. abdomen

insect
3 body parts
6 legs

Like insects, spiders are bilaterally symmetrical.

1. Basic shape

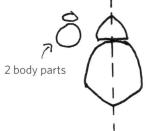

2 body parts

2. Add legs

Place one set of legs, all coming out of the top shape.

Add paired legs; 4 go up, 4 down.

3. Refined sketch

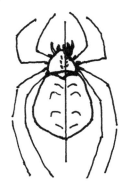

4. Finished drawing

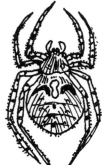

Araneus saevus, **an orb weaver**
½"

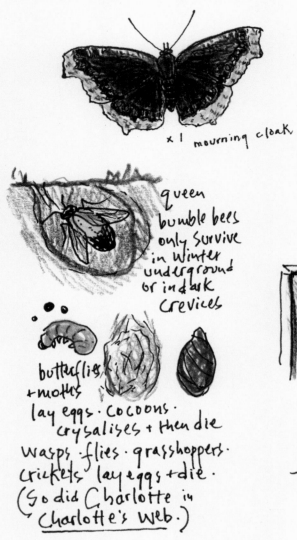

×1 mourning cloak

queen bumble bees only survive in winter underground or in dark crevices

butterflies + moths lay eggs. cocoons. crysalises + then die. wasps. flies. grasshoppers. crickets. lay eggs + die. (So did Charlotte in Charlotte's Web.)

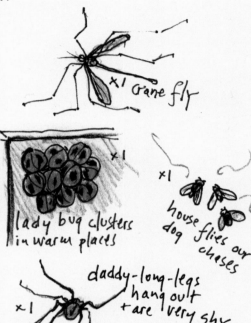

×1 crane fly

×1
lady bug clusters in warm places

×1
house flies our dog chases

×1
daddy-long-legs hang out + are very shy

often missing a leg –?

FALL INSECTS and OTHERS

The insect choristers indicate fall is coming. Try to learn them by their calls and learn how they make those rasping and scraping and chirping sounds. Is it leg against wing or wing against wing? Learn how insects prepare for the winter months — many die off, but others migrate south (some dragonflies and monarch butterflies), and others somehow survive as egg, larva, or adult.

WINTER INSECTS and OTHERS

Look around your house to see who might be sharing the warmth with you: daddy longlegs (harvestmen), spiders, centipedes, millipedes, houseflies, craneflies, and ladybugs. They are harmless and shy and mostly stay out of your way.

Early bird
Catches the worm

many birds
eat mostly flying insects

Luna moth and
underwing moth
drawn at my desk
using field guides

SPRING INSECTS and OTHERS

Make a list of the local insects as they
emerge on early spring days: solitary bees
and other species, including honey bees,
and early butterflies (in New England, our
first are the mourning cloak and the spring
azure). Ants become more active, as do
sow bugs and earthworms.

In many places, you will have black-
flies, mosquitoes, and deerflies. Instead
of swatting, try drawing them! We need
to remember that these pesky insects
are important food for fish, turtles, frogs,
snakes, birds, and many other animals.

SUMMER INSECTS and OTHERS

Get to know your butterflies, dragonflies,
damselflies, beetles, bees, moths, grass-
hoppers, and crickets as well as the stages
they all go through, from egg to adult.
Definitely draw them using field guides
and other photographs, as well as sketch-
ing in the field.

LANDSCAPES

Landscapes are complicated to draw; that's why I leave them for last when teaching and in my books. With a flower or shell or twig, you draw what you see. With a landscape, what you leave out is as important as what you put in. Landscapes give you a big-picture view of the area you are journaling in, whether it's your backyard or a view of a coastline, prairie, or mountain. There are some basic rules to follow in planning a landscape drawing and getting a satisfactory enough sense of perspective. On your flat piece of paper you need to create the illusion of depth, distance, and space. Notice the differing angles of lines and strokes used to create the sense of mountains, rock faces, trees, and water.

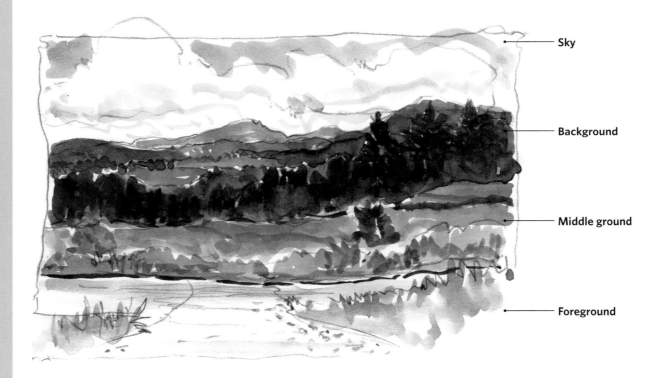

Sky

Background

Middle ground

Foreground

Drawing Landscapes

I learned how to draw landscapes by spending a lot of time watching others draw them and studying books and looking at paintings in galleries. (See pages 68–69 for more about perspective.)

1. Keep your early landscapes small, no more than 5×7".

Which shape do you want? Draw one of these shapes on your paper. Then set up your landscpe inside it like a picture in a frame.

2. Suggested divisions:

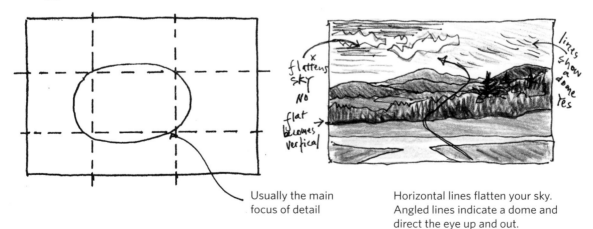

Usually the main focus of detail

Horizontal lines flatten your sky. Angled lines indicate a dome and direct the eye up and out.

Creating Shapes and Distance

Drawing starts by making lines. The angle of your lines creates shapes, planes, distances, and the illusion of a deep landscape on a flat surface. This is the huge challenge — and as I call it, the magic — of producing depth in art. Until painters of the Renaissance, like Leonardo da Vinci, Filippo Brunelleschi, and Andrea Mantegna, artists struggled with achieving this on their canvasses.

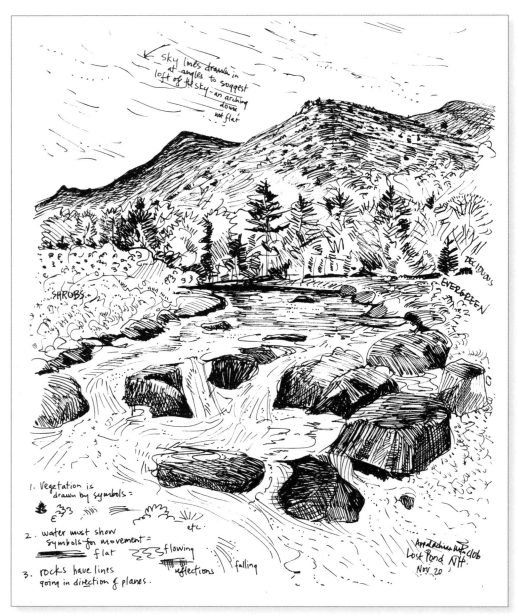

study clouds shapes
and draw what
you see
draw in direction
of wind

horizon
line is
flat

flat land
forms

objects for
perspective

keep water lines flat
curve of river very flat

In distance
lines closer
together

follow angles of rock
faces

Try
wet finger or
water on brush
for a TONE

follow the flow as
water moves -
slow. fast.
pooling. falling

Experiment with these lines and see how
the angle of the line affects the angle of the
plane: vertical, horizontal, angled at 15 or
60 degrees, going to the left or right.

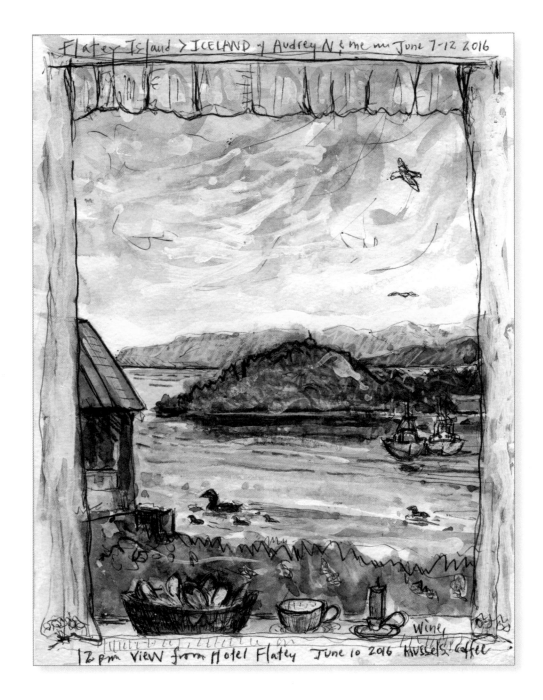

A Favorite Place

A landscape can be a wonderful reminder of a vacation or a place you love. This was done while eating a delicious lunch on a trip to Iceland with a friend. I sketched it with ballpoint pen and watercolor; later I added more detail with colored pencil and some white-out correction fluid.

How to Draw Buildings

Find a building that interests you. This is a sugarhouse,
where maple sap is boiled into syrup. I was using a felt-tip pen,
so I had to be very careful with my lines, as I couldn't erase.
(Students often find that when they are using a pen, they see
more accurately!) As I drew this in June, the farmer drove by in
his tractor — sugaring season long past and haying season
in full swing.

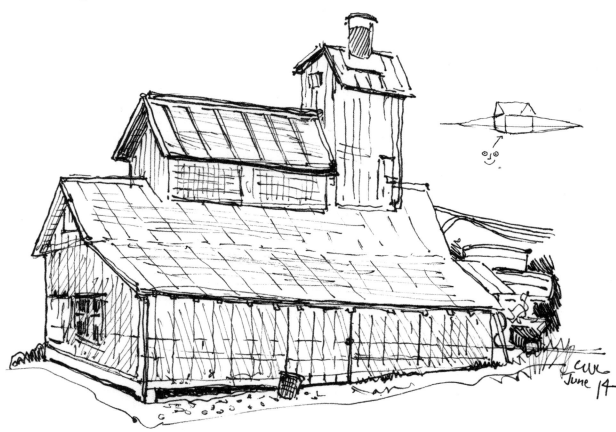

To get the right angle
of the building, hold up
your pen and squint
one eye to line it up.

June 25 - July 3
(Bits + pieces from a sketched journal
while on a Nature Canada trip to Baffin + Bylot Islands - eastern Canada's NUNAVUT Territory)
 8 of us = 6 Canadian women, 1 Australian man, me, tour guide
 5 local Inuit guides
I went why? Because I wanted to see the conditions of the eastern Arctic
for myself (having been to the Western Arctic of Alaska...)

* Thicker ice
more polar bear
local Inuit still hunt
 Bowhead
 Walrus
 Polar Bear
 Seals
 Narwhal
 birds + their eggs
Caribou

on and off
rain

melting ice

high 20's
down to 10's

("Ice now leaving earlier +
coming in later..."
 Elijah)

Parasitic
Jaegers

snow
geese

our water
comes from
ice bergs

melt water on top
of 5' of ice

CWL drawing
out on ice + in tent
when raining

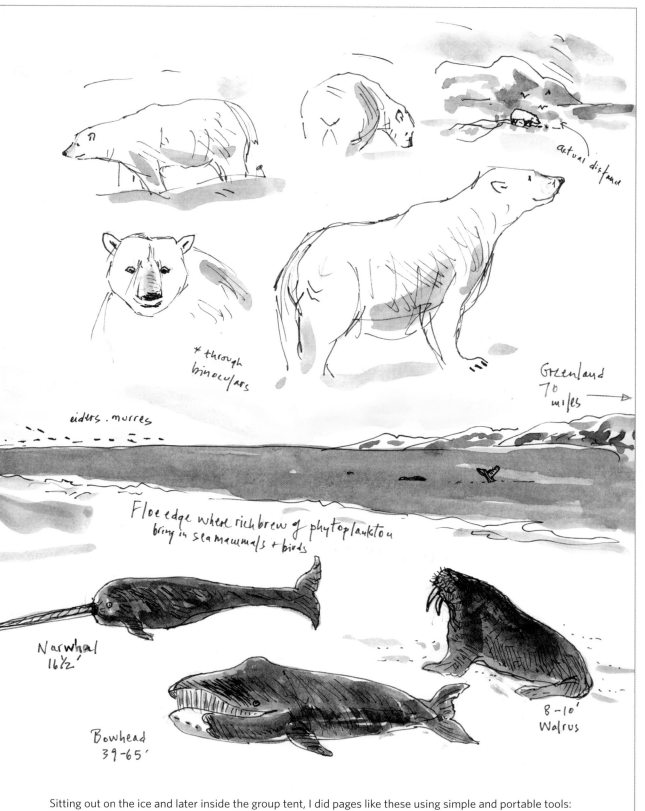

actual distance

* through
binoculars

Greenland
70
miles →

eiders. murres

Floe edge where rich brew of phytoplankton
bring in sea mammals + birds

Narwhal
16½'

Bowhead
39-65'

8-10'
Walrus

Sitting out on the ice and later inside the group tent, I did pages like these using simple and portable tools: Prang watercolor set, small brushes, water cup, felt-tip pens, and local field guides.

NOW GO FORTH

Working on this new edition of *Keeping a Nature Journal*, I realized how much has changed since 1999 and how much has not. Some 20 years later, nature journaling has become popular all over the world, with many now teaching it and endless online postings about it. I recently published *A Year in Nature: A Memoir of Solace* (Green Writers Press), a compilation of my journal pages from 2017 to 2020 formatted into a single year.

I am deeply touched by how many of us are finding that this simple combination of curiosity, word, and image gets us outdoors, being with nature. During a time of environmental, political, medical, and social unrest, the joy of even the smallest connections with nature can give us calmness, humor, and courage. As my good friend John Threlfall wrote to me from Scotland, "The garden blackcap is back. I'm grinning with delight. Part of me has returned."

And so ends this Journal,
as it began on that
snow remaining January
winter's day; still
with Wonder
reverance,
the solace of silent
watching;
always renewed with
HOPE by this onward
record keeping.

In Mt A I sit clothed in the
annual brilliance of remaining colors.

A moment of solitude otherwise
surrounded by family and other
noise.
No one knows I am here.
Only the squirrels
Oct 28
2019

Appendix:
Teaching Nature Journaling

SCHOOLS are so pressed for time that getting kids outdoors has become a real challenge in the busy school day's curriculum. For this reason, I discuss integrating the nature journal's intentions into all aspects of the curriculum and for all grades from pre-K to 12. (See A Curriculum Web for Nature Journaling, page 192.) Teachers can use the nature journal in their classwork with any subject: writing, drawing/art, science/nature study, geography/mapping, history, math, even physical activity/wellness.

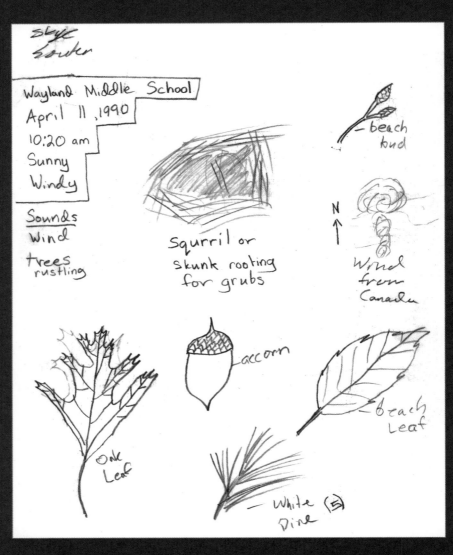

Notes from a 4th-grade nature class

For over 40 years, I have been teaching my format for setting up a nature journal in all sorts of places across the country, and my books are used across North America and abroad. What is the popularity? People are eager to connect with nature, wherever they are, and the format is an easy one. Former students of mine are teaching in pre-K to grade 12 classrooms, with homeschoolers, in college environmental study programs, on camping trips, in retirement communities, in hospitals, in prisons, and in rehab and recovery facilities.

The foundation for keeping a nature journal is to develop and continue our curiosity about where we live and about the community of nature that lives right beside us. As our climate changes, we must encourage this engagement with our nonhuman neighbors, as we are all in this together.

Starting a nature journal is so easy. You need little equipment, there's no right or wrong, you can take just three minutes to jot down a picture of a cloud, flower, moth, or hopping rabbit. Outdoors, you are standing, walking, moving about looking for stuff, quickly jotting down, and mostly in silence separated from your classmates. No one judges anyone's drawings. It's what you have *observed* that we are eager to share, not how well you have drawn or written.

Over my many years of teaching in a very wide variety of settings, I am continually astonished at how engaged, how curious, how happy folks are after even just a short time outdoors or even looking out a window, just focusing on nature. We are all so hungry for such an immediate, fun, and deep connection.

In all my classroom workshops, I require that the teachers participate. Why? Because teachers are mentors for their students. If teachers participate, they too become engaged in observing and, likewise, engaged with their students' learning. I particularly enjoy it when teachers are embarrassed by how "bad" their drawings are. It puts them in a position their students often may be in, and letting their students see their drawings means they can all laugh together. Their kids' drawings are often better than theirs are, but, as I am quick to remind the class, that is not the point. The point is their teacher is learning along with them.

When we had to go back indoors, one little boy said, **"This is so cool. Can we skip lunch and stay outside?"**

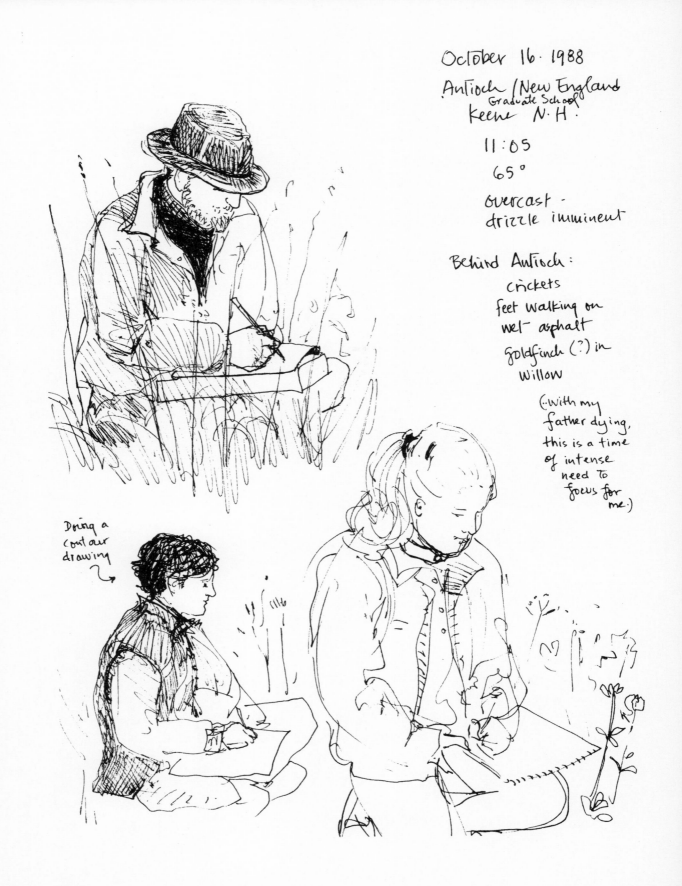

October 16 · 1988
Antioch / New England
 Graduate School
Keene N.H.

11:05

65°

overcast -
drizzle imminent

Behind Antioch:
 crickets
 feet walking on
 wet asphalt
 goldfinch (?) in
 Willow

(·With my
 father dying,
 this is a time
 of intense
 need to
 focus for
 me.)

Doing a
contour
drawing

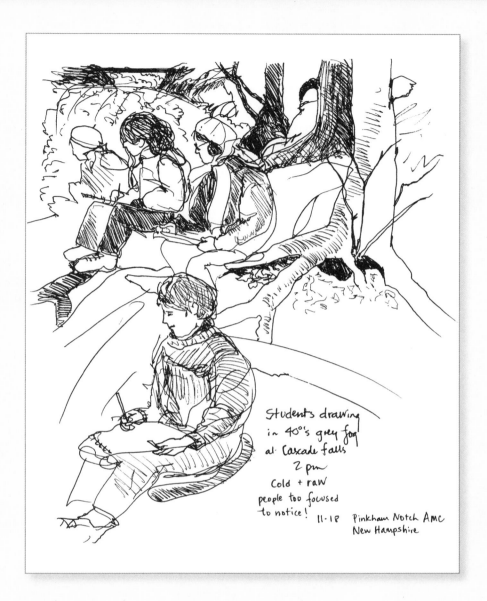

Students drawing
in 40°'s grey fog
at Cascade falls
2 pm
Cold + raw
people too focused
to notice! 11-18 Pinkham Notch AMC
New Hampshire

NATURE JOURNALING AND MINDFULNESS

Nature journaling is a wonderful tool for teaching mindfulness, as well. When folks of all ages are outdoors, their focus is only on seeing nature and recording it — nothing else. After one afternoon teacher workshop with 30 adults outdoors, in silence and for just 10 minutes doing nothing other than quietly recording the nature in the schoolyard, I had them return indoors to comment on their experience. One teacher was in tears. I asked her what had happened. She said to me, "No one has given me this amount of time to just stand and listen and watch."

Getting Going

The format I use for initially setting up a nature journal is so simple, it works with children beginning at age six or seven. I do not use this format with kindergarten or pre-K classes. We still go outside and notice nature and record, but we use crayons or colored pencils on little sheets of paper, focusing on the colors of nature. We do listen, and notice bees, clouds, birds, a scampering chipmunk. But we don't make notes unless the teacher suggests it.

When I am asked into a classroom, the teacher and I first introduce why I am there. We talk about what a naturalist is. (Naturalists are curious and study everything about the world from trees to rocks, cloud patterns to coyotes.) My purpose for coming is to inspire students to become better naturalists, and the nature journal is an easy way to begin. If I only have 45 or 50 minutes in a classroom, we begin after just this five-minute introduction.

If the students don't already have science notebooks or writing journals, they are given pencils and two or three sheets of white 8½×11 computer paper on a clipboard. Often, high school or college students have their own writing tools that they prefer. Nothing fancy needs to to used, as expensive equipment may get lost and students don't need to be worrying about which implement to use while outside.

backyard bunnies

KIDS NOTICE THINGS!

Often, when I go into a classroom, a teacher will say, "These kids take the bus to school. They don't spend time outdoors. It is hard to get them to notice the nature where they live." I find this is absolutely *not* true. Many have parents or grandparents who take them hiking or camping. Some kids go fishing or hunting or help in the garden. Some kids go to summer nature camps and some still walk to school. Given the chance to say what they see, I am always amazed at how much they *do* notice.

We begin our journal pages either together at our desks or outdoors in a group standing or sitting on the ground. We write down the following information. (See also page 53.)

NAME: (If pages are being handed back to the teacher.)

DATE: Discuss why this is important.

TIME OF DAY: Discuss likely animal and plant activity, sun position, what would it be like here at different times of day/night. Add times of sunrise and sunset and moon phase (optional).

PLACE: Where we are, the geography of this area, what nature we think is here (even making a list of daffodils, ants, maple trees, gray squirrels, etc.). We might make a map of our state and locate our town on the map.

WEATHER/WIND/SKY: If indoors, what do we notice out the window? When outdoors, the first drawing we do is a little box of the sky, adding wind direction, sky color, any clouds. Often, we notice changes in the sky and the weather and talk about why we think they happen.

Before we begin recording our observations, we briefly discuss what we might hear, see, locate, and why we must be quiet while we study our surroundings. "So we can hear nature" is the understood reply. Then, with clipboards and pencils in hand, we go outdoors or, if we're already outside, we turn our attention to our surroundings in silence. And I repeatedly find, especially with teenagers (and most teachers!), that requiring a small time spent not talking and just being quiet is a huge relief in an otherwise constantly noisy school day.

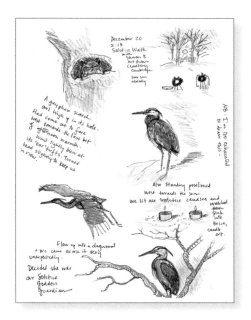

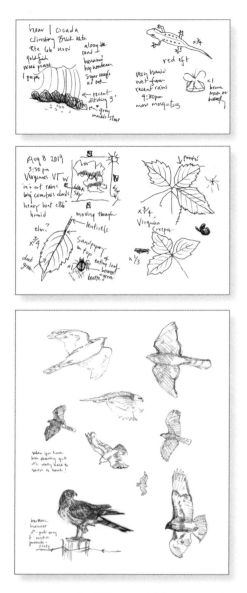

I call these quick images made walking around "markings on paper," like those made when playing Pictionary. When you have more time, you can make a more detailed drawing on the same page.

Outdoor Recording

The format I suggest is flexible, which is why it endures. Here are some ways I typically encourage students to begin making notes and doing little drawings as we observe our surroundings. Your time outdoors can vary from 30 minutes to hours, to days, depending on who you are with and your intentions.

- Notice three sounds we are hearing, three colors we are seeing.
- Look for plants or other nature items at ground level, at waist height, above your head.
- If a bird flies overhead, draw that! If you see interesting tracks in the mud, draw them.

I call this time a scavenger hunt or say that we are like Sherlock Holmes looking for evidence or clues of nature. We talk about being lawyers, proving that we saw fox tracks, a noisy crow, an amazing sunset because we have drawings of them. We talk about how early explorers did not have cameras or fancy digital equipment — they recorded their discoveries in illustrated journals. With older students, we discuss the essential use of nature journals for noting subtle evidence of climate change, as well as becoming concerned citizen scientists and the importance of phenology records.

At the end of our time outdoors, and depending on the time we have left, we gather in a quiet place and are silent while we write down our impressions, feelings, and what we've learned, using any form from a list to a haiku to a paragraph. Often students want to read these to the class, which is interesting and fun for all to share.

One 4th-grade teacher said to me, standing with her students out in their playground, watching her busy, engaged, and happy students, **"How can you test for joy?"**

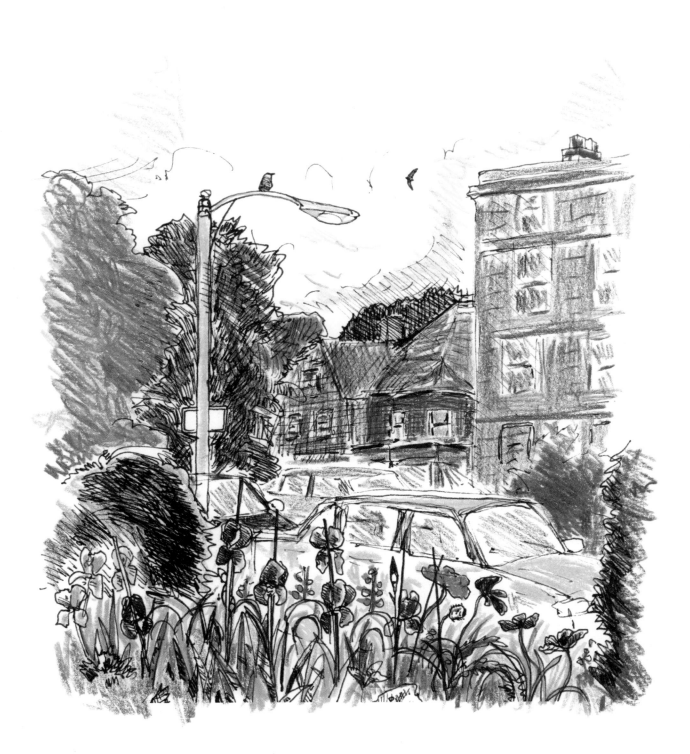

A quick drawing to see what's here: done on Linnaean Street, Cambridge, June 6, 11:30 a.m., sunny.

Nature Journaling with Different Age Groups

As I said previously, setting up and keeping a nature journal with very young children may not work. They may want to play or do random drawings. In homeschool situations, with parents and children working together, setting up a nature journal may work better. Families could keep track of their backyard through the seasons, record observations on a family trip, or have adults and children draw on the same page. (I often do this with my now five- and eight-year-old granddaughters.) If they don't want to draw, you can all explore, listen, observe, and write down together what you notice on that particular day, adding time, weather, and even mood if you feel like it.

As I say in my teacher/parent workshops, the best thing you can do for your children, for your students, is to *go out with them*. Explore with them; be curious with them; record with them. It doesn't matter if you don't know the name of that bird, that flower, that mushroom. You can find all that out later — together.

With older children and adults, more complicated concepts and aspects of natural history can be introduced. Very gently, I will also introduce some simple drawing techniques (as described in chapter 3).

You may have students who are very good at drawing who are eager to show their skills. You may have students who really do not want to draw. Emphasize that these drawings are more what I call "making marks" or even like the game Pictionary. (In doing demonstrations, I purposefully draw really simply, to show that you can just jump in.) In a longer program, students absolutely do get better at drawing as they feel more confident and improve their observation skills.

I always make it clear that I have been drawing for over 60 years. Of course, I should be good! Drawing, like skateboarding or windsurfing or knitting, is a skill that takes time to learn. One rule is to *not* make fun of your own drawings or anyone else's. As the teacher, I am very quick to support even the vaguest of scribbles as long as the participant is present and trying.

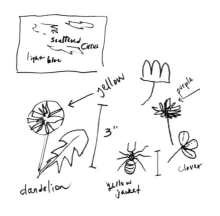

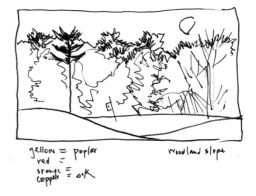

I also emphasize, over and over, when working with students indoors, that they do several of the beginning drawing exercises described in chapter 3. These can be done using field guides, photographs, or real objects from nature brought in for study (flowers, leaves, acorns and other nuts, ferns, and the like). I especially recommend loosening up and having fun with those crazy-looking blind contour drawings (page 56).

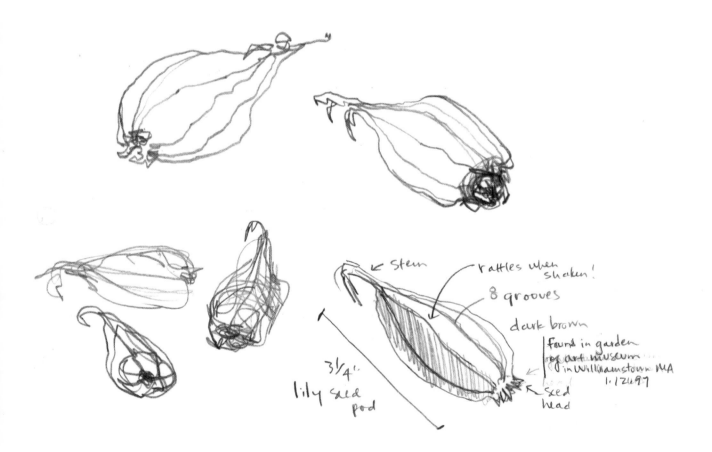

← stem

rattles when shaken!

8 grooves

dark brown

found in garden of art museum in Williamstown MA 1.12.97

3 1/4"
lily seed pod

← seed head

When demonstrating drawing in front of a group, I'm often drawing on a large pad on an easel or drawing upside down or from an odd angle. My examples are simple and fun to follow.

TIPS AND TRICKS FOR
TEACHING NATURE JOURNALING

- Be very clear why we are doing these pages. Remind students that a nature journal is not a diary. A nature journal is for recording observations and thoughts about nature, whereas a diary is for personal observations and thoughts that you may or may not want to share. When I show my own journals, I am quick to say that I do, in fact, include bits and pieces about my own family life and friends, and about political and social and environmental concerns. However, these are not intimately private entries.

- *Be with your students*, making mistakes and learning stuff together. I often show my own ongoing journals, displaying various methods, as in the examples throughout this book.

- Don't lose touch with connecting to nature by becoming too concerned about producing a pretty page. I am very low key about page layout, design, penmanship, scrapbooking styles, even the percentage of writing versus drawing.

- Look at other nature artists whose works you admire. Read books about nature. (See Suggested Reading and Resources, page 197.)

- Encourage your students to keep their journals nearby, even in the car. Always be ready to draw something interesting, even if it takes just a few minutes. Keep looking outside when you are in, always asking, "What is going on in nature, right now?"

Don't take time outdoors to identify what you don't know. Take notes and use field guides later.

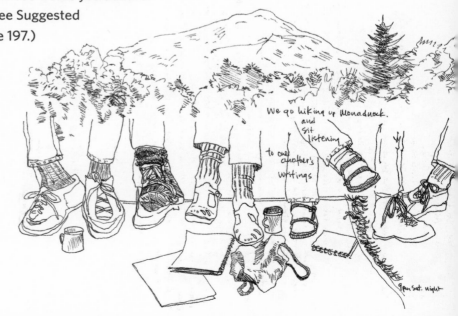

EYES TO THE SKY

A good example of journaling as part of a school program is the For Spacious Skies project founded in the 1980s by Jack Borden and still in existence. Writer Elizabeth Levitan Spaid described the program in 1994 in the *Christian Science Monitor*:

On an overcast spring day, Elaine Messias's fifth-graders at the Mitchell Elementary School in Needham, Mass., file out their classroom door clutching chairs, notebooks, and pens. In a grassy yard they scatter like wildflowers across a meadow, as they plop their chairs down in different spots. Soon, the chattering stops as they begin what has become a ritual: observing the sky and writing what they see in their "sky journals."

After 15 to 20 minutes of pensive silence, they return to the classroom to share their poems and verse.

"The clouds look like a white sheet on a bed," Melissa Volpe says. "There are gray spots on the sheet. When the gray clouds fade away, it's like a sheet that has been washed."

"It's like a gray arena, motionless, lifeless," one boy writes.

For these children, looking up is an integral part of their curriculum. Whether it is creating cloud charts for science, finding sky references in literature, or observing the kind of skies that provide background in Van Gogh or Monet paintings, the sky is woven into nearly every activity or lesson.

This particular writing exercise "gives students time to really reflect on their own, to be still," says Mrs. Messias, who has integrated the sky in her teaching for the past 10 years. . . .

At the Harvard University Graduate School of Education, researchers in 1985 and 1986 tested elementary students in Needham who had participated in the For Spacious Skies program against those who had not. They concluded that kids who were exposed to the program scored 37 percent higher in music appreciation, 13 percent higher in literary skills, and 5 percent higher in visual arts skills.

A Curriculum Web for Nature Journaling

Those of us who have been teaching nature journaling in classrooms across the country know how important it is that we fit into the state standards and the national STEM requirements. And we do! Susan Stranz, a teacher in Barnstable, Massachusetts, drew this chart to demonstrate to schools and teachers how nature journaling can fit into any school's curriculum. You may wish to develop your own web.

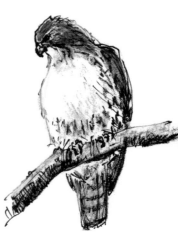

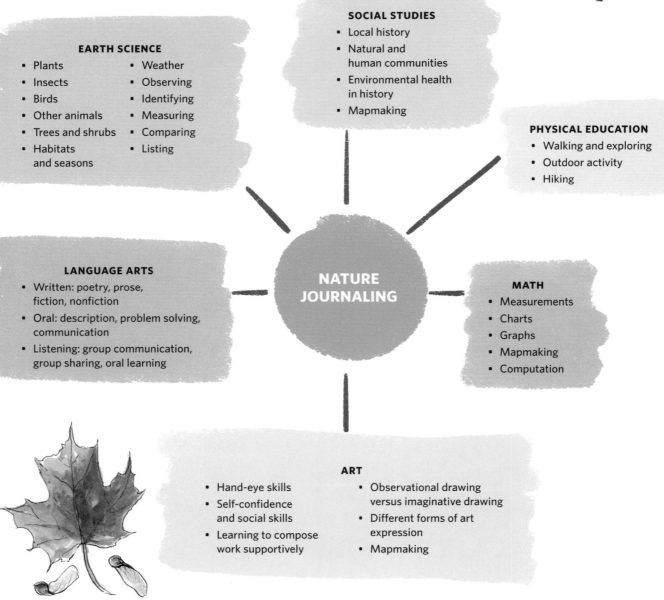

EARTH SCIENCE
- Plants
- Insects
- Birds
- Other animals
- Trees and shrubs
- Habitats and seasons
- Weather
- Observing
- Identifying
- Measuring
- Comparing
- Listing

SOCIAL STUDIES
- Local history
- Natural and human communities
- Environmental health in history
- Mapmaking

PHYSICAL EDUCATION
- Walking and exploring
- Outdoor activity
- Hiking

NATURE JOURNALING

LANGUAGE ARTS
- Written: poetry, prose, fiction, nonfiction
- Oral: description, problem solving, communication
- Listening: group communication, group sharing, oral learning

MATH
- Measurements
- Charts
- Graphs
- Mapmaking
- Computation

ART
- Hand-eye skills
- Self-confidence and social skills
- Learning to compose work supportively
- Observational drawing versus imaginative drawing
- Different forms of art expression
- Mapmaking

A WAY OF LEARNING

Teachers have found much value in having students set up and keep their own nature journals. There is flexibility not only in the subjects that can be included, as shown on the opposite page, but also in styles of learning. A nature journal is a student's own "workbook," not a handout or work sheet. Learning is judged not by how pretty the drawings are or how much writing there is, but by what has been learned.

I have had students who love their journals so much that it is the first thing they pull out of their desk every day. And given the formatted nature of most homework that parents see, it is also often the work that they most enjoy as well. Why? Because it contains only their child's work, which, hopefully, shows over time progress in learning, as well as drawing and writing.

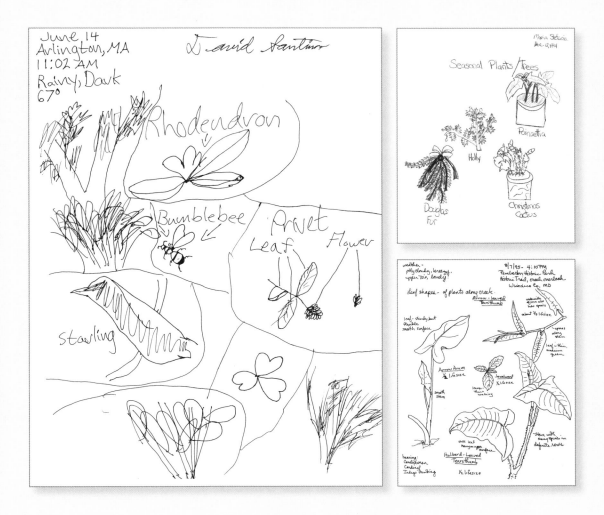

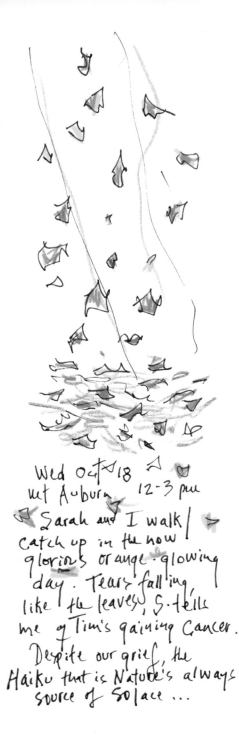

Wed Oct 18
mt Auburn 12-3 pm
Sarah and I walk/
catch up in the now
glorious orange-glowing
day. Tears falling
like the leaves, S. tells
me of Tim's gaining Cancer.
Despite our grief, the
Haiku that is Nature's always
source of solace ...

Encouraging Learning and Reflection

Older students are aware of mounting climate change issues. Some are increasingly worried, concerned, even anxious. It is very important for teachers, mentors, and adults to speak of the positive actions, research, and people involved all over this country and the world. It is all right to be concerned. It is also all right — and empowering — to find out what you can do as an individual. The Jane Goodall Institute's Roots & Shoots program, for kids of all ages, is a model for actions we can all take. Even if it is just changing from plastic to paper straws, picking up the trash on your street, putting up a bird feeder, or joining the national Christmas Bird Count.

Having students keep their own nature journals helps them not only to learn about nature but also to see how they can actively get involved and protect the environment. More and more students are joining nature centers, birding groups, and youth conservation corps; writing to government officials; and taking part in climate marches as they learn that they have a voice in the future of the planet.

Here are some ways to incorporate nature journaling into the classroom.

A SPECIAL SPOT. Encourage students to find a place they can return to, over and over, to observe and reflect. This might be a nearby park or a corner of the schoolyard, sitting on a big rock or under a tree in their backyard, or even looking out their bedroom or kitchen window.

WRITING. This can be a report on a specific animal or plant or outdoor place. It can be an essay on a time spent outdoors or a particular experience. It can be a poem, a haiku, even a piece of music.

ART. Have students do a drawing, mural, clay model, or sculpture based on an animal or plant. They should try to be as accurate as possible, using field guides and photographs for reference. Some schools even create specific field guides to their property as a group project. A trip to any local art museum is a terrific opportunity to talk about artists who have used nature in their art, throughout history and today.

SCIENCE. Students can create a science research project based on observations and questions they recorded in their journals. They might get help from a local scientist, naturalist, park ranger, or even a parent.

HISTORY. Learn about both the natural and human history of the land where your town is. What was here before the land was developed? Draw a map of the town, indicating where businesses and housing areas are and showing schools, churches, and roads, as well as the open spaces. What is the proportion of open space to developed space?

MATH. This can relate to the history project by bringing in measurements and mapping skills. You might have students gather data to monitor environmental impact issues, such as your school or town's use of renewable vs. nonrenewable energy sources.

MUSIC. Wonderful recordings of natural sounds can be found online or on apps or CDs. The Cornell Lab of Ornithology has an excellent library of recordings of birds, amphibians, and even insects. Have students create their own natural sounds, explaining what subject inspired them: wind, waves, thunder, birds, a snorting deer, or falling snow.

HEALTH AND WELLNESS. Many students struggle with anxiety and depression. Repeatedly, scientists, parents, and guidance counselors have found that "an ounce of nature" can really perk kids up. (And all of us adults as well.) A former student who teaches high school health classes often has her students do yoga outdoors; she says those are her best classes. A number of schools now teach meditation and mindfulness practices. Take your students outdoors and let them walk about in silence. Have them stand still, breathing deeply, just listening. Have them record their feelings in their journals, once back indoors or even while still outside.

> YOU CANNOT HEAL the Earth's suffering unless you feel it too. You cannot feel the Earth's joy unless you feel it too.
>
> — **Joanna Macy**
> Council of All Beings
> Workshop, 1990

A REFLECTION PAGE

From my original collaborator, Chuck Roth, comes this suggestion to provide your students with a page every week or two that asks them to review what they have put in their journal and to summarize on those pages what they think are the most important things they have observed or learned. They may put their thoughts into prose, poetry, or a detailed drawing that summarizes their experiences.

Reflection Page

Read your journal pages. Think about the questions below and write or draw your thoughts about the questions.

What were the most interesting things I observed over the time period we have been keeping this set of journal entries?

What are the big ideas that I have learned from this set of journal entries?

What skills do I plan to improve upon over the next set of entries?

Which of my observations and comments would I most like to share with others?

From the Journal of _____

Date: _____ Time: _____
Location: _____
Temp: _____ Humidity: _____
Pressure: _____
Percent cloud cover: _____

Session task: Look around for things that are in the process of changing. Describe the object or event and indicate how it is changing.

Suggested Reading and Resources

When I first became interested in keeping an ongoing nature journal, I didn't know how to use a field guide or even binoculars. But I found people who could teach me, and I read and read and read everything I could about nature, in books written by scientists and naturalists but also poets and other artists. Listed here are just some of the books and resources I've used over the years. There are many more out there — may this begin your journey of discovery as well!

Field Guides

Field guides generally do not go out of use as they age, but updates keep being published. Classic ones include Peterson, National Audubon Society, Golden, National Geographic, and Stokes, but there are many more available now. Some have photographs; some are illustrated. As I often use field guides to draw from as well as teach with, I chose ones with clear illustrations of all features, preferably in profile, with good identification as well as regional differences.

Look for guides relevant to your particular interest and location, whether it's birds, nonflowering plants, insects, amphibians, weather, geology, mammals, or fresh- and saltwater creatures. Local nature centers can often provide good recommendations for useful guides to particular areas. (And, of course, now much can be learned online, with clear photos, videos, and accurate information available on a variety of reliable websites. See page 202 for a few of them.)

General Nature Study

A good place to find these authors and other resources is in the Nature/Science section of your library or local bookstore. Children's books on nature are often a great introduction to specific topics. Check used bookstores or online sources for older titles that may be out of print.

Anderson, Lorraine, and Thomas Edwards. *At Home on This Earth: Two Centuries of U.S. Women's Nature Writing.* University of New England Press, 2000.

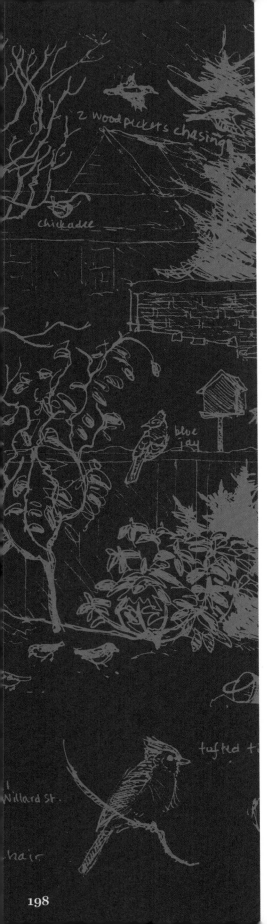

Bonta, Marcia Myers. *Women in the Field: America's Pioneering Women Naturalists*. Texas A&M University, 1991.

Cavalier, Darlene, Catherine Hoffman, and Caren Cooper. *The Field Guide to Citizen Science: How You Can Contribute to Scientific Research and Make a Difference*. Timber Press, 2020.

Cherry, Lynn. *How We Know What We Know about Our Changing Climate: Scientists and Kids Explore Global Warming*. Dawn Publications, 2008.

Dungy, Camille T., ed. *Black Nature: Four Centuries of African American Nature Poetry*. University of Georgia Press, 2009.

Finch, Robert, and John Elder. *Norton Book of Nature Writing*. Norton, 1990.

Hannibal, Mary Ellen. *Citizen Scientist*. The Experiment, 2017.

Kaufman, Kenn. *A Season on the Wind*. Houghton Mifflin, 2019.

Lanham, J. Drew. *The Home Place: Memoirs of a Colored Man's Love Affair with Nature*. Milkweed Editions, 2017.

Lorenz, Konrad. *King Solomon's Ring*. Thomas Crowell, 1952.

National Audubon Society. *The Practical Naturalist*. DK Publishing, 2010.

National Geographic Society. *The Curious Naturalist*. National Geographic, 1991.

The Old Farmer's Almanac. Yankee Publishing, Inc. This little magazine is printed every year (and there's a hole for hanging it in the outhouse!). I keep it in my bag and refer to it continually for times of sunrises, sunsets, and moon phases, as well as bits of interesting nature information.

Reader's Digest Association. *Joy of Nature: How to Observe and Appreciate the Great Outdoors*. Random House, 1977.

Roberts, Elizabeth, and Elias Amidon, eds. *Earth Prayers*. HarperCollins, 1991.

Savoy, Lauret. *Trace: Memory, History, Race, and the American Landscape*. Counterpoint, 2016.

Tallamy, Doug. *Bringing Nature Home*. Timber Press, 2009.

———. *Nature's Best Hope*. Timber Press, 2020.

Teale, Edwin Way. *A Walk Through the Year*. Dodd, Mead, 1987.

Williams, Brian, et al. *The Visual Encyclopedia of Science*. Kingfisher, 1994.

Nature Writers to Know

There are thousands of wonderful nature writers and poets, too many to list in one place. Here are a few, some from centuries past, some who may be familiar to you already, and others who may become good companions in your explorations.

Edward Abbey	Robert Frost	John Muir
Jennifer Ackerman	Jane Goodall	Mary Oliver
Wendell Berry	Thich Nhat Hanh	Robert Michael Pyle
Henry Boston	Lyanda Lynn Haupt	Carl Safina
Sally Carrighar	Bernd Heinrich	Henry David Thoreau
Rachel Carson	Robin Wall Kimmerer	David Wallace-Wells
Ann Hawthorne Deming	J. Drew Lanham	Scott Weidensaul
Emily Dickinson	Aldo Leopold	Walt Whitman
Annie Dillard	Richard Louv	E. O. Wilson
Gerald Durrell	Helen Macdonald	Peter Wohlleben
John Elder	John Hanson Mitchell	Ann Haymond Zwinger
Robert Finch	Sy Montgomery	

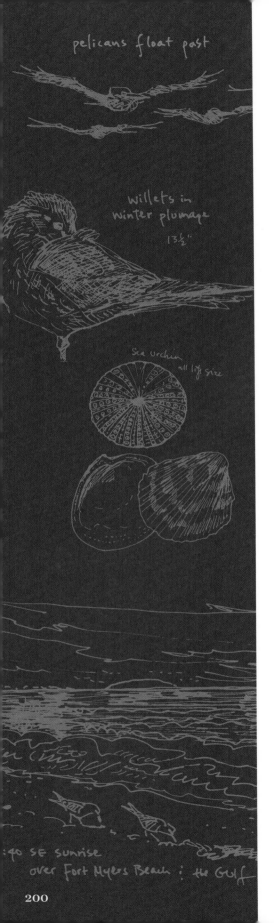

pelicans float past

willets in winter plumage 13½"

Sea Urchin all life size

:40 SE sunrise over Fort Myers Beach : the Gulf

Nature Drawing Techniques

Some useful and inexpensive beginning drawing books can be found in arts and craft stores, and in some stationery and bookstores. There are not that many good books specifically about drawing nature.

Most of us who draw nature and keep nature journals are self-taught, learning best by continual practice, copying good field guide artists, and studying the work of other nature artists. Of course, you can do no better than by learning from the masters, like Michelangelo, Degas, Ingres, Homer, Wyeth, and many others who drew birds, plants, landscapes, and skies.

Adams, Norman, and Joe Singer. *Drawing Animals*. Watson-Guptill, 1979.

Amberlyn, J. C. *The Artist's Guide to Drawing Animals*. Watson-Guptill, 2012.

Borgeson, Bet. *The Colored Pencil*. Watson-Guptill, 1983.

Busby, John. *Drawing Birds*. Gardners Books, 2004.

Johnson, Cathy. *The Sierra Club Guide to Sketching in Nature*. The Sierra Club, 1997.

Laws, John Muir. *The Laws Guide to Nature Drawing and Journaling*. Heyday Publishing, 2017.

———. *How to Teach Nature Journaling: Curiosity, Wonder, Attention*. Heyday Publishing, 2020.

Leslie, Clare Walker. *The Art of Field Sketching*. Kendall Hunt, 1995.

———. *Nature Drawing: A Tool for Learning*. Kendall Hunt, 1980.

Scheinberger, Felix. *Dare to Sketch: A Guide to Drawing on the Go*. Watson-Guptill, 2018.

Simo, Juan Varela. *Sketching and Illustrating Birds*. Barron's, 2015.

Illustrated Nature Journal Books

Many older — even historic! — books of writing and drawing about nature are hard to find but worth looking for in used bookstores and online. In addition to the ones listed here, look for the works of Keith Brockie, Gunnar Brusewitz, John Busby, Eric Ennion, Mairi Hedderwick, Cathy Johnson, Lars Jonsson, John Muir Laws, Sue Lewington, Rien Poortvliet, and Beatrix Potter, as well as artists affiliated with the European-based Artists for Nature Foundation.

Canfield, Michael. *Field Notes on Science and Nature.* Harvard University Press, 2011.

Foster, Muriel. *Muriel Foster's Fishing Diary.* Viking Press, 1980.

Hedderwick, Mairi. *Highland Journey: A Sketching Tour of Scotland.* Canongate Press, 1992.

Hinchman, Hannah. *A Life in Hand.* Salt Lake City: Peregrine Smith Books, 1991.

———. *A Trail through Leaves: The Journal as a Path to Place.* W. W. Norton, 1997.

Holden, Edith. *The Country Diary of an Edwardian Lady.* Holt, Rinehart, and Winston, 1977.

———. *The Nature Notes of an Edwardian Lady.* Arcade Publishing, 1991.

Leslie, Clare Walker. *A Year in Nature: A Memoir of Solace.* Green Writers Press, 2020.

Lewis-Jones, Huw, and Kari Herbert. *Explorer's Sketchbooks.* Chronicle Books, 2016.

Wheelwright, Nathaniel T., and Bernd Heinrich. *The Naturalist's Notebook.* Storey Publishing, 2017.

Zickefoose, Julie. *Baby Birds: An Artist Looks into the Nest.* Houghton Mifflin, 2016.

———. *Letters from Eden.* Houghton Mifflin, 2006.

Organizations and Online Resources

These are just a few of hundreds of wonderful organizations that support and study nature. Many of them have print and/or online magazines or journals that are packed with good writing and excellent photos.

In addition to these national groups, there are thousands of places to explore and learn. Wherever you are, look for nature centers, parks, natural history museums, arboretums, observatories, and the like. An online search for "nature journaling" will bring up many sites.

American Museum of Natural History
www.amnh.org

Appalachian Mountain Club
www.outdoors.org

Children & Nature Network
www.childrenandnature.org

Citizen Science
www.citizenscience.gov

Cornell Lab of Ornithology
www.birds.cornell.edu/home

Family Nature Summits
www.familynaturesummits.org

For Spacious Skies
www.forspaciousskies.net

Guild of National Science Illustrators
www.gnsi.org

The Jane Goodall Institute
www.janegoodall.org

National Audubon Society
www.audubon.org

National Geographic Society
www.nationalgeographic.com

National Parks and Conservation Association
www.npca.org

The Orion Society
www.orionmagazine.org

The Sierra Club
www.sierraclub.org

3 pm High Pines
 Duxbury Beach Sept. 13 '07

pink

blackberry

mint balm

pungent!

Sitka Spruce
c. 60'

Sitka Spruce
+ 3" cone

Index

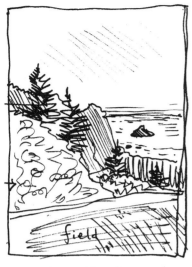

View West to Pacific Ocean from Sitka

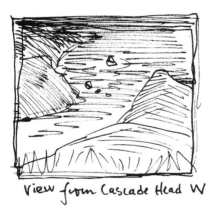

View from Cascade Head W

View N to Cascade Head

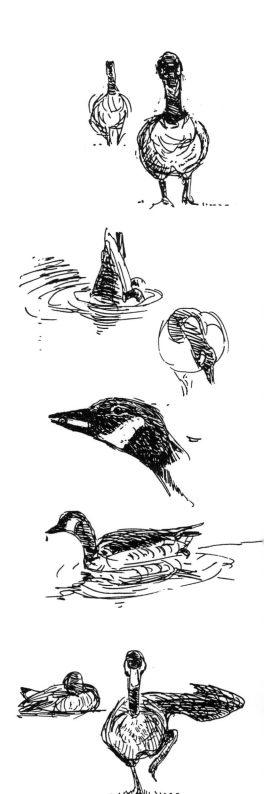

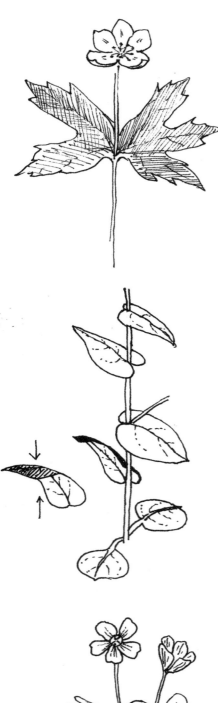

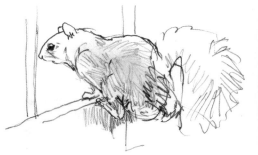

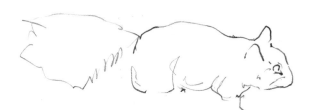

See Nature in New Ways with More Books by Clare Walker Leslie

The Curious Nature Guide
Step outside and reinvigorate your senses with help from this guide to expanding your creativity. Use prompts, facts, beautiful photography, and inspiring artwork to navigate through nature and see the world anew.

Drawn to Nature
Through endearing sketches and thought-provoking observations, this inspirational guide invites you to share in the pleasure of nature watching and to experience the joy of seeing and connecting with nature wherever you live.

The Nature Connection
Dozens of interactive projects keep kids engaged in every season, with fun prompts to record daily sunrise and sunset times, draw a local map, keep a moon journal, or collect leaves to identify.

Nature Journal
With inspirational quotes, instructions for identifying and drawing natural objects, and ample room to record observations, this volume transforms an ordinary diary into a unique journey.